EASTERN STATE PENITENTIARY

A HISTORY

PAUL KAHAN

FOREWORD BY
DR. RICHARD FULMER

Published by The History Press
Charleston, SC 29403
www.historypress.net

Copyright © 2008 by Paul Kahan
All rights reserved

Cover design by Natasha Momberger

First published 2008
Second printing 2010
Third printing 2011
Fourth printing 2015

Manufactured in the United States

ISBN 978.1.59629.403.5

Library of Congress Cataloging-in-Publication Data

Kahan, Paul.
Eastern State Penitentiary : a history / Paul Kahan.
p. cm.
Includes bibliographical references and index.
ISBN 978-1-59629-403-5
1. Eastern State Penitentiary of Pennsylvania. 2. Prisons--Pennsylvania--Philadelphia. I. Title.
HV9481.P52K35 2008
365'.974811--dc22
2008032142

Notice: The information in this book is true and complete to the best of our knowledge. It is offered without guarantee on the part of the author or The History Press. The author and The History Press disclaim all liability in connection with the use of this book.

All rights reserved. No part of this book may be reproduced or transmitted in any form whatsoever without prior written permission from the publisher except in the case of brief quotations embodied in critical articles and reviews.

CONTENTS

Foreword, by Richard H. Fulmer, PhD ... 5
Introduction ... 9

Chapter 1 "The Worst Argument in the World" ... 12
Chapter 2 Early Years ... 29
Chapter 3 "Inflexible Disciples" ... 48
Chapter 4 From Chaos to Classification ... 75
Chapter 5 The Return of Rehabilitation ... 96

Conclusion ... 111
Notes ... 113
Index ... 125
About the Author ... 127

FOREWORD

What explains the American public's fascination with prisons? Is it in any way connected to the fact that we are the nation with the highest incarceration rate in the world? How does the deinstitutionalization trend for mental hospitals and schools for persons with mental retardation relate to this increase in prison populations? Do citizens of European countries, where incarceration is not the default political response to crime, have the same attitudes and levels of interest as Americans? How much of the interest is based on the pursuit of danger, excitement and risk taking thought to be characteristic of criminal offenders? To this extent, is the fascination with prisons like going to the zoo to see the animals? Or does it stem from the question: are prisoners really as different from "us" as they are thought to be, or would we behave like them in similar situations?

Another thing to consider is whether the perceived nature of prison life itself—dark, dreary, oppressively routine, dangerous and lacking privacy—so frightens us "freedom-fixated" people that it's the place, not the people, that draws so much attention. There is, however, no question that the market for this book will be large, and there will be many reasons for that level of demand. Some will be morbid, some academic, some interested in the minutiae of Eastern State Penitentiary's history and others will be looking for names of friends and relatives being mentioned. Whatever purpose you may have in reading this foreword, and the book, be assured that you will find full satisfaction.

Eastern State Penitentiary (ESP) has been written about in books, magazines, pamphlets, posters, letters to the editor, newspaper columns and investigative reports since even before it was opened in 1829. What Paul Kahan's book does is present—in the words of Paul Harvey—*The Rest of the Story*. Individuals who are "just like us" are replete in these pages, as are many sociopathic and psychotic men and women who raped, robbed and murdered both outside and inside prison walls. Prisoners who kept pets and had meaningful intimate relationships (therapeutic, religious, platonic and sexual) with visitors, staff and other inmates are presented as fully developed characters, just as if you were reading a first-rate novel. Prison life, with all of its complexity and contradictions, is explained over and over and over again in this book without judging, preaching, summarizing or whitewashing.

Foreword

No single publication could include even a small sample of the stories lived out at Twenty-second Street and Fairmount Avenue during the 140 years of its operation. The best that can be done on a page is to capture the atmosphere and culture that wafted through the vaulted corridors at different times, and for different people, whose stories created what began as Eastern State Penitentiary and ended as the State Correctional Institution Philadelphia (SCIPHA). (Although Paul does a very good job in just under two pages, a full explanation of the reasons for and consequences of the 1954 name change would fill volumes.)

From its opening in 1829, it took only thirty-three years for ESP to become overcrowded and begin to experience that major factor that dictates how prison life is experienced today—by both staff and inmates. As it is in every correctional institution on the planet, the culture I referred to above in ESP's beginning years was a combination of administrative/managerial agenda and the personal characteristics of the staff and inmates. The "agenda" was the solitary confinement system, and it is well presented by the author as a remedy for one form of institutional abuse—the jail. As with all things, there was a competing remedy to the jail, and the fierce, decades-long competition between the Pennsylvania (solitary) and the Auburn (congregate) systems is well chronicled. The most important aspect of this competition was how advocates, administrators and managers of ESP were subtly forced to be extreme in their adherence to the solitary system's principles. Virtually without regard for the realities of life in the institution, it was necessary for them to present an aggressive, constant defense of their ideals and distort, or at least minimize, practices and problems that are universal in prisons. The effects of such a "double life" are presented in this book, and it is left to the reader to decide how much was right and how much was wrong. The change in society's approach to penology at the end of the nineteenth century is also presented as an explanation for the end of the competition between the solitary and congregate "camps."

The personal characteristics of the staff and inmates are presented in the same powerful, but nonjudgmental way, and it gradually becomes clear that the interactive effect between these personal characteristics and the architectural/philosophical principles of ESP made failure to reach their goals inevitable. Wardens and senior managers were selected and trained more on the basis of adherence to principles than what was necessary for the daily operation of an eleven-acre institution housing hundreds of prisoners. Left to their own interpretations of the principles, there were huge differences in decision making from one situation to another at all levels of management. Both women and men were housed in the institution for the first ninety-four years, and this presented another conceptual hurdle for management. Again, Paul Kahan gives the reader example after example of both the managerial difficulties and the thousands of ways inmates took advantage of the disorder caused by this confusion of goals. The tension and frustration on the part of both sides is evident in these examples, and the motivations, as well as default-based reactions to events, are obvious. Through this "window," the reader is allowed to feel, in a palpable way, the fears, hopes and dreams that created and defined the institutional culture at ESP in the nineteenth century.

This writing style is also used to present internal contradictions and conflicts over all of the years at ESP. While every warden and member of the board of trustees claimed

to be acting in the best interest of the inmates' successful return to society, the practices they endorsed (and the brutality they sometimes exercised) showed dramatically different definitions of what was seen as necessary to prepare prisoners for release. Robert McKenty and William Banmiller are identified as wardens in the early and mid-twentieth century (respectively) who felt that paternalistic guidance, a helping hand and a second chance were the best approaches to changing prisoners for the better. Herbert "Hardboiled Herbie" Smith, Walter Tees and John Groome are other twentieth-century wardens who are described as believing in the opposite approach. They felt it was their responsibility to ensure strict discipline, provide military regimentation and control every possible aspect of the prisoners' days and nights.

The end of the solitary/congregate debate led to increased training for managers and staff, so it was now possible to actually implement *parts* of an administrative agenda. The different approaches of the wardens and boards of trustees made a big difference in how life at ESP was experienced by all involved and, as before, Paul Kahan demonstrates these differences with numerous little "insights" into these experiences. Individual staff members are mentioned by name; some for exemplary service under either kind of philosophy/policy and others for mistakes or behaviors that sometimes cost them their jobs or their lives. Some misbehaviors resulted in criminal prosecutions, and there is a record of former ESP staff (along with other Pennsylvania government officials) coming in the front door as inmates.

My reference above to "*parts* of an administrative agenda" is in recognition of the utter futility of any attempt to totally control any organization or endeavor involving human beings. It is no different in a prison than in an office, a school or a church congregation. With appropriate recognition to the intent, effort and levels of success by ESP administrators over the years, Paul Kahan has mined story after story from numerous sources that show the small and large things prisoners did to maintain their individuality and "play the game" with their keepers. The largest, of course, is escapes and escape attempts. From both official records and published accounts, he has compiled a lengthy list, some with quite thorough step-by-step descriptions, of many successful and aborted escape attempts at ESP. Smaller diversions (also still common to every prison) are making wine, gambling, homosexuality, smuggling contraband of all sorts and working the institution grapevine with facts, rumors, personal issues and outright lies. This last is a powerful force in any organization of people and is especially important in prisons. Since inmates, by definition, have no structural authority or power to regulate their own lives, gaining and controlling access by others to any form of information is the only power available to them. The stories that Paul Kahan tells in his book represent *life* in a prison and especially demonstrate how staff and inmates work together to keep the institution as safe, secure and predictable as possible.

Paul Kahan's commitment to correct the errors he found in other collections of stories about and from ESP has produced an important alternative view of "the Queen of Penitentiaries." As stated above, there is no way that every angle has been covered and every story told, but this book gives a much more personal and context-relevant picture of the prison than most of what I have read. Paul will also be the first to admit that there are certainly errors in what he has presented. This is the nature of historical narratives,

Foreword

and what is really important is that readers evaluate every version of "the truth" they can find and be sure to trust themselves to make the decision—temporary, never final—on which version makes the most persuasive arguments. Paul's presentation is, I believe, especially persuasive because it is written in a way that reflects his willingness to allow you, the reader, to be the final evaluator of his arguments, one way or the other.

This preface has been written by a man who admits to loving Eastern State Penitentiary. As strange as that may sound to the average reader, there are any number of us who were connected to ESP during its last years of operation who express nothing but appreciation and affection for the experience we had inside those walls. It is especially important to point out that this group included both staff and inmates. They were not all happy or even positive times, but, looking back, they were seminal in creating both the professional and person I have become in the last thirty-eight years. Numerous contributors to the ESP oral history project say the same kind of thing, and, since 1994, there have been well-attended reunions of SCIPHA alumni. I have never heard of another prison holding reunions for staff and inmates, and I submit that whatever it was that was so unique about ESP is responsible for such a phenomenon.

The end times at ESP would never have occurred without the history presented in Paul's book, and reading it has been an emotional experience. There were times when my initial reaction was anger and denial, but other times it felt like he had captured the "culture" I remembered. He has woven together a strong sense of continuity in chronicling the number of changes that were benchmarks during the almost century and a half of the prison's operation. All prisons, including ESP, are difficult places to live and work and even harder to explain to civilians. Paul has done an admirable job at attempting this cross-cultural communication, and I applaud his research and presentation skills. I was immensely honored when he invited me to write the foreword and very much appreciate the opportunity to contribute, in any small way, to this significant new contribution to the lore of Eastern State Penitentiary.

<div style="text-align:right">
Richard H. Fulmer, PhD

Professor of Social Work

Millersville University of Pennsylvania
</div>

INTRODUCTION

I can still remember the first time I saw Eastern State Penitentiary. It was a surprisingly warm day in March 2005. I was on my way to a lunch meeting at a coffeehouse at Twenty-first Street and Fairmount Avenue, a part of Philadelphia I had never visited. As I walked east on Fairmount, I approached what appeared to be a castle and was awed by the towering walls and overwhelmed by a profound sense of gloom. During an incredibly uncomfortable meeting, I found my attention wandering out the window, toward the building that dominated that little Philadelphia neighborhood. As I was leaving the coffee bar, I asked the barista, "What is that building over there?"

She replied, "Eastern State Penitentiary. I think it was the first prison in the world."

I was naturally intrigued, and like a good scholar, I set out to learn everything I could about this amazing relic. Unfortunately, there was not much: a few books, most of them out of print, and a few hundred websites of varying quality. I put my research aside and took up other projects, hopeful that I would get a chance to come back to Eastern State in the near future.

My chance came the following year, when I was offered a part-time job as a tour guide at the penitentiary. A graduate student at the time, I was glad to have a job in my field, even if (as the site manager promised me) the penitentiary is "very cold in winter and sweltering in summer." I threw myself into research, reading everything I could about prisons in general and Eastern State in particular, so that I would appear knowledgeable and interesting to the thousands of tourists who visit the penitentiary every year. Unfortunately, there was no single source available. Information about the penitentiary was scattered across hundreds of obscure articles, out-of-print books and little-used oral histories. I decided, sometime in the summer of 2006, to write a book about Eastern State that collected all of those materials and corrected the vast amount of misinformation circulating. *Eastern State Penitentiary: A History* is my attempt to do that.

One of my professors in graduate school defined history as "the study of change over time." I respectfully disagree; my research for this book indicates a shocking amount of *continuity* in Eastern State's history. The problems that contemporary prison administrators face—overcrowding, violence, escapes—were the same problems that confronted Eastern

Introduction

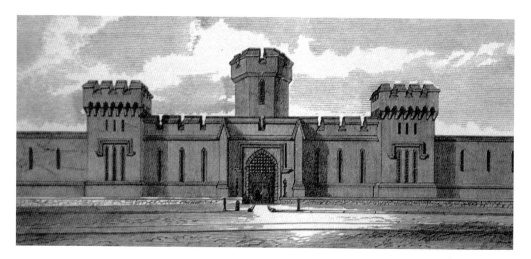

Eastern State's façade was designed to deter potential criminals by evoking in them fear and dread.

State's founders in the 1820s. The question of whether prisons should be punitive or reformative institutions is as hotly debated today as it was nearly two centuries ago, when Eastern State first opened. This points, I think, to the contradictory and ambivalent nature of what Eastern State's history "means." As a professional historian, every project I take on starts with an important question: "So what?" In the case of Eastern State, the question is really, "Why should we care about this massive penitentiary in the middle of Philadelphia?" Eastern State's history has a great deal to teach today's penal reformers about the possibilities and limits of rehabilitation, and therefore continuity over time, rather than change, is one of this book's central themes.

In researching this book, I utilized a number of different sources, each with its own strengths and limitations. The most important sources, by far, were the newspapers—the *Philadelphia Inquirer*, the *New York Times*, the *Philadelphia Bulletin* and others—which offered excellent contemporary accounts of life at Eastern State. In addition, Eastern State's collection of oral histories is an excellent source of information and anecdotes, though it is important to remember that some of those oral histories need to be taken with (at least) a grain of salt. Published memoirs, particularly George Appo's *A Pickpocket's Tale* (edited by Timothy Gilfoyle), Willie Sutton's *I, Willie Sutton* and *Where the Money Was* and Joe Corvi's *Breaching the Walls* were invaluable in providing (sometimes contradictory) accounts of life at Eastern State in the late nineteenth and early twentieth centuries. One of the best sources is regrettably unpublished as of this writing: Richard H. Fulmer's incomparable manuscript, which he generously shared with me, "The House: The Twentieth-Century History of Eastern State Penitentiary." Other important books include Norman Johnston's *Crucible of Good Intentions*, which replaced Negley K. Teeters and John Shearer's *The Prison at Cherry Hill* as the definitive book on Eastern State Penitentiary. Last but not least is the *Historic Structures Report*, an incredibly detailed study of the penitentiary's physical structure; though there are a few errors of both fact and interpretation (as my research makes clear), this is an important study for anyone seriously interested in Eastern State Penitentiary.

Introduction

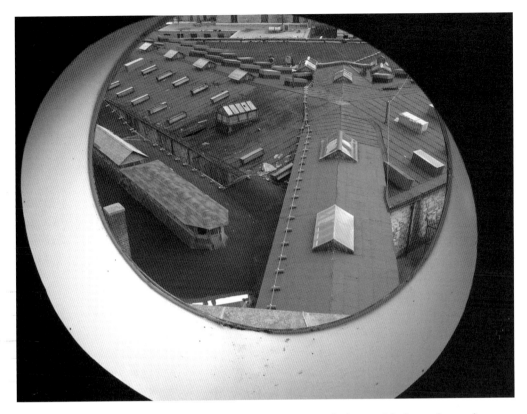

The view from a hole in the guard tower where the penitentiary's clock once ticked away inmates' sentences. *Photo courtesy of Dr. Jennifer Murphy.*

Naturally, I also rang up quite a few debts during this project, as all researchers do. I must thank Dr. Fulmer for sharing both his manuscript and pieces from his personal collection, as well as for reading a draft of this manuscript. Andrea Reidell, Eastern State's assistant program director for education, provided me with valuable source material and also read a nearly completed draft of this book and made several important and substantive suggestions. My parents willingly offered to watch my son, Alec, taking him to their house on the weekends during the seemingly endless months of writing and rewriting, freeing me to stay up way too late in order to finish "one more paragraph!" Dr. Jennifer Murphy, whose encouragement and friendship spanned the entire process of this project, contributed both much-needed pictures and support; without her, I would still be writing chapter one.

By far, the most important debt I owe is to my son. Alec never once complained that Daddy was too busy to play Xbox or have a catch with him during the six months that I was seriously writing. His understanding and pride ("My daddy is writing a book about his jail!") made completing this project much sweeter. Therefore, I dedicate *Eastern State Penitentiary* to him.

CHAPTER 1

"THE WORST ARGUMENT IN THE WORLD"

William Penn and the Origins of Eastern State Penitentiary

When William Penn's trip to Ireland in 1666 convinced him to renounce his father's religion and join the Society of Friends, his father, Sir William Penn, stopped supporting his son financially. These acts also made the young man a target of England's criminal justice system. Penn, inflamed by the certainty of the new convert, journeyed to see the Duke of Buckingham to urge "better things for dissenters than stocks and whips and dungeons and banishments"; he was sent to the Tower of London for heresy. Dispatched by the king to reform Penn, Bishop Stillingfleet returned with a message: "The Tower to me is the worst argument in the world."[1]

After nine months in the tower, Penn's father interceded with the Duke of York for his son's release. His freedom, however, proved brief, and Penn was convicted of speaking at a Quaker meeting. He was sent to England's most infamous prison: Newgate. Originally constructed in 1188 at the behest of Henry II, the prison was modified and expanded over the following centuries and eventually burned down during the Great Fire of London in 1666. It was rebuilt the following decade and housed some of England's most important and notorious inmates, including Daniel Defoe, Ben Johnson and Sir Thomas Mallory.

Contemporary descriptions convey some of the misery prisoners at Newgate experienced. Though inmates had access to the second-floor hall during the day, at night they were locked in a large room, where they slept in hammocks attached to pillars. "Under the lower range of hammocks, by the wall sides were laid beds upon the floor, in which the sick and weak prisoners lay. There were many sick, and some very weak."[2] Sanitary conditions could be had for a price, which left many imprisoned vulnerable to sickness and death. Penn's experience as a religious prisoner in the Tower and Newgate created an enduring legacy, and when he founded Pennsylvania in 1681, he envisioned a haven of religious tolerance that would be a model for the rest of the world. While there is no direct line from William Penn to Eastern State Penitentiary, Penn's humanitarianism left a lasting impression on the colony he founded and was embodied in the penitentiary it spawned.

Incarceration in Pennsylvania's penal institutions goes back to 1682, when Penn mandated that the colony would have houses of correction, inmates of which would be required to work, though Pennsylvania's Quaker character bled into the legal system

in the sense that judges often sought informal resolutions and encouraged plaintiffs to do the same.[3] Ultimately, Penn's code was not long-lived; by May 1718, Pennsylvania was operating under the much harsher English Criminal Code, a system that lasted until independence. Death was the preferred sanction under the English Criminal Code. According to historian Harry Elmer Barnes, "the penalties imposed were such that there was little need for such penal institutions as were adapted to the substitution of imprisonment for corporal punishment."[4] The harshness of the new legal code is reflected in the fact that Pennsylvania only executed .6 people per 100,000 colonists between 1692 and 1719, but following the introduction of the English Criminal Code, that number more than doubled to 1.4, a rate that was not exceeded until the 1770s.[5] The shift toward execution made prisons unnecessary, and there was therefore little incentive to construct them between 1719 and the Revolution.

Because prisons were rarely used, they were poorly funded in both the colonies and Britain; thus, conditions in eighteenth-century prisons, jails and workhouses were deplorable. Moreover, jailors extorted their living by charging inmates for food, clothing and liquor. The jails themselves were squalid, disease-ridden places where more inmates died from illness than from the hangman's noose.[6] The buildings themselves were ramshackle, unsecured places that required prisoners to be shackled at night so they could not escape.[7] There were even a few jails where "the windows were left unbarred, or gaps in walls remained unrepaired, so escapes were frequent."[8]

For this reason, a number of prominent thinkers and philanthropists began agitating for prison reform. These men argued that governments should not torture inmates, but instead could use prisons to punish and deter criminal behavior in a more humane way. The best known of these reformers was John Howard, an English aristocrat who investigated Europe's jails and published his observation in *The State of the Prisons in England, and An Account of the Principal Lazarettos of Europe*. This book exposed the shocking conditions prisoners endured while waiting for trial.

Howard was born in 1726. His mother died when he was only five, followed by his father a decade later. His first experience with prisons came when he was captured by a French privateer. His experience as a prisoner of war fermented a desire to ensure that no one would ever have to suffer as he had. In 1773, Howard became sheriff of Bedfordshire, which was more of a "social distinction than an occupation" because those elected normally delegated the actual work to an undersheriff.[9] Recognizing that his new position gave him an opportunity to effect change, Howard examined the prison himself. He found innocent prisoners still imprisoned because of the debts they had incurred to the jail keeper, as well as horribly unsanitary conditions.[10]

Over the winter of 1773-74, Howard toured other English county prisons and was dismayed to find women and men incarcerated together, as well as classes of prisoners (debtors, those only indicted and convicts) undifferentiated. D.L. Howard, a sympathetic biographer, wrote that "when Howard visited a prison, what offended him most was the evidence of disorder and inattention, the failure to post rules, the indiscriminate mixing of inhabitants, and the unregulated boundary between the prison and the community."[11] Howard's solution to these problems was to recommend that prisoners be placed in separate cells to eliminate the spread of disease, and that they be classified according

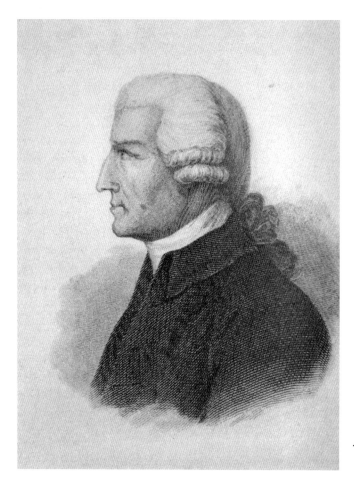

John Howard. *From the* Journal of Prison Discipline and Philanthropy.

to offense, to prevent "hardened" criminals from passing on their trade to juveniles and debtors. Howard also strongly argued against jailors charging fees for basic necessities, recommending that they receive a regular wage. Finally, he argued that prisons should reform inmates through healthy food, labor and religious services.[12] To achieve these ends, Howard "formulated a system of prison discipline that borrowed from both workhouses and monasteries to include a regimen of hard labor during the day and solitary confinement at night."[13]

Howard was the most prominent promoter of the idea that incarceration was the "natural" and humane form of punishment.[14] The *State of the Prisons in England* contributed to the Penitentiary Act of 1779, which provided for the construction of two penitentiaries around London, managed by three men appointed by the Crown. These men, in turn, appointed a governor (warden) and overseers. Drawn up by William Blackstone and William Eden, the Penitentiary Act incorporated many of Howard's suggestions, including salaried administrators, separate confinement for prisoners at labor and religious instruction.[15]

Britain's Penitentiary Act, and similar legislation in the colonies, was spurred by two trends: first, a growing revulsion toward capital punishment incited by the Enlightenment

and the desire to break with English tradition, and second, the explosion in crime caused by the dislocations of the Revolution and its aftermath. Criminal accusations and indictments in Pennsylvania spiked in the 1780s, jumping 64 percent, as did the number of executions, from four in 1750 to five in both 1762 and 1764, and six in 1768. In 1774, the colony executed ten convicts, a 150 percent increase in twenty-four years.[16] To better understand this, it should be noted that there were only forty-four executions before 1776, but from then until 1790, there were sixty-two.[17] Moreover, in the 1750s, there were 30 accusations of homicides, leading to 29 indictments. By the 1770s, those numbers had jumped to 98 accusations and 67 indictments, climbing to 154 and 82, respectively, in the 1780s.[18]

The rising crime rates and the movement toward incarceration resulted in the construction of Philadelphia's Walnut Street Jail, which became the first American penitentiary in 1790. The Walnut Street Jail was designed by Robert Smith and built behind Independence Hall between 1773 and 1780. Construction of the prison was halted for eighteen months during the British occupation, possibly due to lack of funds or to Smith's death.[19] The jail was eventually completed in 1780 and was officially overseen by Philadelphia's sheriff, but in practice he often delegated the responsibility to an undersheriff, who functioned as a jail keeper.[20]

On September 15, 1786, Pennsylvania's legislature passed a bill, known as the "Wheelbarrow Law," mandating that the Walnut Street Jail's inmates labor "in streets of cities and towns, and upon the highways of the open country and other public

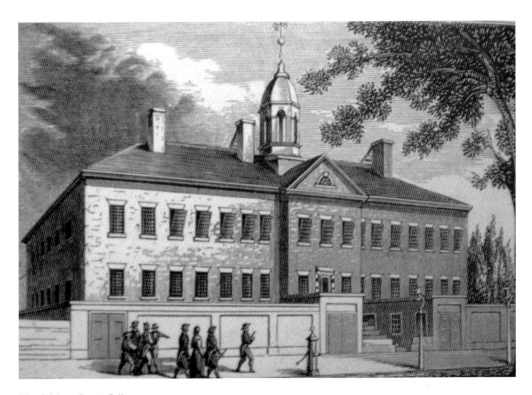

The Walnut Street Jail.

works."[21] The law's goal was twofold: first, reform those convicted of crimes, and second, deter others from breaking the law. Prisoners were required to wear garish clothes to distinguish them from citizens, and were chained to cannonballs to prevent escape.[22] However, this caused a number of problems: Prisoners verbally and physically abused passersby, occasionally lobbing the cannonballs at people. Additionally, working outside the prison's walls made it easier for inmates to escape or receive contraband like weapons or liquor. According to Richard Vaux's history of Eastern State, prisoners consumed twenty gallons of liquor *in one day*, often selling their clothes to afford the half-dollar-per-quart payment.[23] The first day the law was in effect, fifteen prisoners escaped. According to Caleb Lownes, later the Walnut Street Jail's warden:

> *The severity of the law, and disgraceful manner of executing it, led to a proportionate degree of depravity and insensibility and every spark of morality appeared destroyed… The old and hardened offender* [was] *daily in the practice of begging and insulting the inhabitants—collecting crowds of idle boys, and holding them with the most indecent and improper conversation. Thus disgracefully treated, and heated with liquor, they meditated, and executed, plans of escape—and when at liberty, their distress, disgrace, and fears, prompted them to violent acts to satisfy the immediate demands of nature.*[24]

In the two years following the law's passage, an astonishing 27 percent of the male inmates escaped.

In May 1787, a group of prominent Philadelphians gathered to discuss both the unintended side effects of the Wheelbarrow Law and the deplorable conditions at the Walnut Street Jail generally. Included at this gathering were Benjamin Franklin; William White, Philadelphia's Anglican bishop; and Dr. Benjamin Rush. Rush had argued against public punishments for inmates for at least two months, concluding that "all public punishments tend to make bad men worse, and to increase crimes by their influence on society."[25] This meeting formed the nucleus of the Society for Alleviating the Miseries of Public Prisons, an organization with two purposes: identifying wrongly confined inmates so they could be released and ensuring that prisoners were treated humanely while incarcerated. According to the preamble of the society's constitution:

> *When we consider the obligations of benevolence, which are founded on the precepts and example of the author of Christianity, are not cancelled by the follies or crime of our fellow creatures, and when we reflect upon the miseries which penury, hunger, cold, unnecessary severity, unwholesome apartments, and guilt (the usual attendants of prisons) involve with them; it becomes us to extend our compassion to that part of mankind, who are the subjects of these miseries.*[26]

Most of the society's early members were merchants, ministers and physicians, and their prominence gave them the political influence to achieve their goals.[27] Moreover, their interest in penal reform grew out of their involvement in other reform movements.

The most famous member of the society, behind Benjamin Franklin, was Dr. Benjamin Rush. Born outside Philadelphia in 1745, Rush studied at both the College

"The Worst Argument in the World"

Reverend William White, president of the Society for Alleviating the Miseries of Public Prisons (1787–1836).

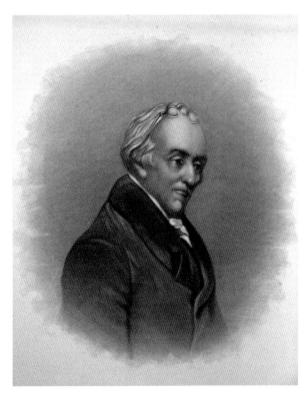

Dr. Benjamin Rush.

of New Jersey (later renamed Princeton University) and the University of Edinburgh, where he learned how to be a doctor. Returning to the colonies in 1769, Rush was named professor of chemistry at the College of Philadelphia (now the University of Pennsylvania). He also became a prominent member of both Philadelphia's and America's civic life, signing the Declaration of Independence and attending the Continental Congress. In particular, Rush was an ardent abolitionist, committed to ending slavery immediately, and a vigorous opponent of the death penalty, arguing that society should try to reform criminals.

Another prominent member was the Reverend William White, who served as president of the society for forty-nine years, from 1787 to his death in 1836. Born in Philadelphia in 1748, White earned a BA, an MA and later a doctorate of divinity from the College of Philadelphia. He was ordained an Anglican priest in England and, once he returned to Philadelphia, became rector of Christ Church. Eventually, he served as the presiding bishop of the Episcopal Church of the United States, the first bishop of the Diocese of Pennsylvania and the second chaplain of the United States Senate. In addition to his religious activities, White was extremely active in Philadelphia's civic and philanthropic world, but, according to Teeters, White "gave more of himself to this venerable institution [the Society for Alleviating the Miseries of Public Prisons] than any other one interest."[28]

People often assume that because the society was formed in the "Quaker City" and many of its most prominent members were Friends, that the organization was inspired

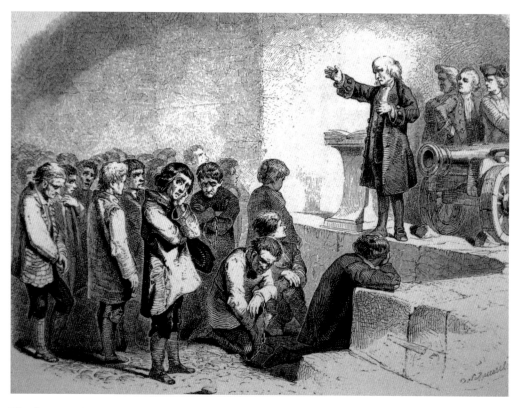

The first recorded prayer service at the Walnut Street Jail, 1787.

by Quaker ideals. This is a gross oversimplification. Many countries had moved from corporal punishments to imprisonment in the eighteenth and early nineteenth centuries. Moreover, while there were numerous prominent Quakers in the society, there were also a number of non-Quakers, and out of 340 members between 1787 and 1830, only 136 (40 percent) were Friends.[29] It seems better to conclude that the society's philosophy grew out of Enlightenment ideas about humane treatment and republican notions about the government's responsibilities toward its citizens.

However, religion was a cornerstone of the society's program of reform, and its first recorded action was introducing religious services at the Walnut Street Jail in 1789. In 1788, the society sent a memorial to the state legislature complaining about conditions in the Walnut Street Jail. They cited the fact that males and females were housed in the same spaces, even at night, that prisoners slept on the floors unless they bought better bedding with their own funds and that parents were allowed to keep children with them in the jail.[30] These complaints were similar to those of John Howard regarding European jails, and this created an instant bond between the famous English reformer and the society. John Howard was aware of the society's efforts because White forwarded the society's constitution to him, expressing the society's obligation to Howard "for having rendered

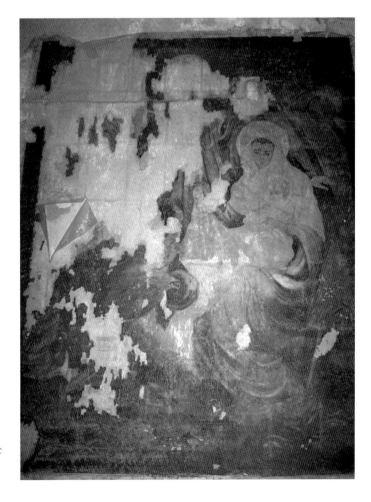

A religious painting by an inmate, located in the Catholic chaplain's office. *Photo courtesy of Dr. Jennifer Murphy.*

A sketch of Eastern State's cell layout included in Gustave de Beaumont and Alexis de Tocqueville's *On the Penitentiary System and Its Application in France*, 1833.

the miserable tenants of prisons the objects of more general attention and compassion, and for having pointed out some of the means of not only alleviating their miseries, but of preventing those crimes and misfortunes which are the causes of them."[31]

The society pushed the Pennsylvania legislature to reform the Walnut Street Jail. This pressure led to the Acts of 1789, 1790 and 1794, which collectively formed the basis of what came to be called the Pennsylvania System of penitential discipline. The most important of these was the Act of 1790, which mandated that inmates be separated from one another and labor while in prison. According to the society:

> *It may be assumed as a principle that the prospect of a long, solitary confinement, hard labour, and a very plain diet, would, to many minds, prove more terrible than even an execution; where this is the case, the operation of example would have its full effect, so far as it tended to deter others from the commission of crime.*[32]

The 1790 act also required the separation of men from women and those convicted of felonies from those convicted of misdemeanors. The law also required that newly admitted prisoners be bathed, cleaned and quarantined for a period to prevent disease, making prisons less dangerous to their inmates.[33] At first glance, these reforms appeared extremely successful. Between 1789 and 1793, convictions in Philadelphia dropped by more than 65 percent. Moreover, while over one hundred inmates had escaped from the High Street Jail during those four years, none managed to break out of the Walnut Street Jail.

"The Worst Argument in the World"

Roberts Vaux.

By the 1820s, many of the society's founders had passed away, and a new generation of leaders emerged to fill their place. The most important and influential was Roberts Vaux, a Philadelphia philanthropist who was elected the society's secretary in 1810, a position he held until 1832.[34] When he died, Vaux listed forty-nine associations or institutions of which he was a member, including the Apprentices' Library of Philadelphia, the Athenaeum of Philadelphia and the Library Company of Philadelphia. He also served as president of Philadelphia's school board.[35]

As early as 1800, the Walnut Street Jail was overcrowded and, consequently, conditions deteriorated. The number of inmates began climbing in the mid-1790s, going from 63 in 1792 to 145 in 1796 and 151 in 1801. Thereafter, the Walnut Street Jail's population jumped, reaching 206 by 1809 and 304 in 1811.[36] With this many inmates, it was no longer possible to maintain separate confinement, a key component of the penitentiary's discipline system. Moreover, in July 1800, twelve prisoners escaped through the sewer and the event was widely reported in the city.[37] In December 1801, the society issued a memorial directed at the Pennsylvania legislature, asking "that you will devise such means as may appear to you most adequate to separate the Convicts from one all other

Eastern State Penitentiary

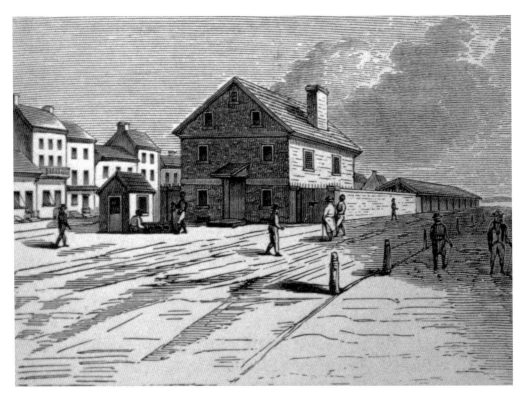

The High Street Jail.

descriptions of prisoners, in order that a full opportunity of trying the effects of solitude and labor may be afforded."[38] When the legislature failed to respond, the society issued a petition for the creation of a workhouse, to relieve the Walnut Street Jail's overcrowding. On April 2, 1803, the legislature complied and authorized the construction of a prison for debtors. However, the Arch Street Jail, as this institution was called, took fourteen years to build and did not accept its first prisoner until 1817.

In the meantime, the overcrowded conditions at the Walnut Street Jail created a tinderbox that ignited frequently during the 1810s. Riots broke out in 1817, 1819 and 1820, and the last one resulted in citizens firing into the yard to restore order and prevent the prisoners from escaping.[39] In addition, by the 1820s, the jail's administrators were accused by Philadelphia's press of misappropriating prisoners' wages from their labor, which contributed to the public's sense that the jail was poorly managed.[40] Worse, just at the moment that America's jails seemed inadequate for the inmates they had, the United States was perceived to be in the grip of a massive crime wave.

Jacksonian America (1824–48) was a violent period in American history due to a number of factors; most important was urban growth. Following the War of 1812 (1812–15), cities got bigger, spurred by immigration and industrialization. Philadelphia was America's second largest city after 1825, dwarfing everything except New York. In an era when most cities had between 10,000 and 20,000 inhabitants, Philadelphia's population in 1820 was an astounding 100,000.[41] The population of Philadelphia and its

surrounding areas jumped an astonishing 58 percent in the 1840s and nearly 40 percent in the following decade, mostly due to immigration.[42] This created friction between native and foreign-born Philadelphians that occasionally erupted into violent confrontations.

Historian Micheal Feldberg noted that "violence was central to the city's artisan culture."[43] These violent outbursts served a number of functions in antebellum cities; for instance, as historian Roger Lane noted, violence served a "recreational function" that was "a social or economic asset."[44] In other cases, the working classes used violence as a "bargaining tool" to protest price increases or wage cuts.[45] In addition, the city's fire departments were in reality glorified gangs who were as likely to quarrel with each other as put out fires. According to historian David R. Johnson, "the conflicts between these rival associations became the major source of organized violence before the Civil War."[46] There were at least *fifty* different gangs between 1845 and 1875, with descriptive names like the Bleeders, the Deathfetchers, the Thieves, the Garroters, the Killers, the Rebels, the Smashers and the Tormentors.[47] These gangs occasionally put out fires, but they were more likely to burgle, rob and harass Philadelphia's population, occasionally killing residents. They were a major source of disorder in a culture already reeling from the changes brought about by economic growth.

One form of illegal behavior that was common during this period was rioting, which became so pervasive that historians consider riots to be one form of political expression during that time. Between 1825 and 1860, riots broke out in a number of major American cities, including Boston (1825, 1829 and 1835), New York (1832, 1834, 1835, 1837, 1849 and 1857), Baltimore (1835, 1856, 1857, 1858, and 1859) and Washington, D.C. (1841 and 1857). Philadelphia was not immune to group violence. There were two riots in 1844 that resulted in a few deaths and a Catholic church being burned. Though people rarely died during these outbursts (and even then it was usually "only" one or two), riots could be extremely destructive of property, as evidenced by Philadelphia's experience.

The predilection to violence strained cities' resources, but these outbursts were exacerbated by the fact that alcohol consumption was much higher in this period than it is today. According to Feldberg, workers were often partially paid in alcohol, and "nearly every workshop and factory employed young boys to run out frequently for buckets of beer. Drinking to excess was a universal problem that crosses ethnic and class boundaries."[48] Jacksonian Americans, on average, consumed seven gallons of alcohol a year, *three and a half times* the amount Americans consume today. Historian Daniel Walker Howe noted that, "although socially tolerated, drunkenness frequently generated violence, especially domestic violence, and other illegal behavior."[49]

Because of the outrages at the Walnut Street Jail and the general atmosphere of violence following the War of 1812, Pennsylvania's legislature appropriated money for the construction of a penitentiary in Pittsburgh and authorized (but did not appropriate money for) a second penitentiary in Philadelphia. The Walnut Street Jail's board of inspectors appointed Philadelphia architect William Strickland to design and oversee the construction of Pittsburgh's penitentiary, which came to be known as Western State Penitentiary. His design called for an eight-sided prison wall, with individual cells arrayed around the wall and a great courtyard in the center.

William Strickland was born in Navesink, New Jersey, in November 1788. Historian Nicholas B. Wainwright called him one of the three great architects of his time.[50] In general, Strickland's style was Greek Revival, though his designs often incorporated elements of Egyptian and Italian design as well. During his seventy-year life, he designed and built an impressive list of buildings: the Second Bank of the United States (1824), the U.S. Naval Asylum (1829), the Unitarian Church (1828), College Hall (1830) and the Medical Hall at the University of Pennsylvania (1829), the Mint (1833), the Almshouse (1834), the Merchant's Exchange (1834) and the Philadelphia Bank (1837). According to Wainwright, "Strickland's beautiful buildings did much to enhance the appearance of the city."[51]

Western State Penitentiary opened with much fanfare in July 1826, but it quickly became apparent that Strickland's design was defective. The most important deficiency was the fact that "it is very easy to hear in one cell what is going on in another; so that each prisoner found in the communication with his neighbor a daily recreation, i.e. an opportunity of inevitable corruption," which defeated the Pennsylvania System's purpose.[52] The cells' placement around the wall created a "double frontage" that made surveillance impossible.[53] This also made labor impossible, and prisoners were left in their cells with nothing to occupy them, a situation that one visitor called "too horrible and unjust to be thought of."[54]

While Western State was under construction in January 1819, the Walnut Street Jail's inspectors solicited plans for a five-hundred-cell penitentiary for Philadelphia. However, momentum slowed until March 20, 1821, when the legislature acted to establish a penitentiary in Philadelphia to serve the eastern part of the commonwealth. By December, the governor had appointed eleven commissioners charged with purchasing a site and overseeing construction.[55] They offered a $300 prize for the best design, with $100 going to the runner-up.[56] Among the many entries were Strickland's and English-born architect John Haviland's prospective designs for the penitentiary.

John Haviland was born on December 12, 1792, in Gundenham Manor, Somerset, England, and apprenticed at eleven to London architect John Elmes. In 1815, at the age of twenty-three, Haviland left his apprenticeship for Russia, where he hoped to win a place with the Russian Imperial Corps of Engineers. It was here that he met diplomat and future president of the United States John Qunicy Adams, who encouraged the young architect to go to America. Haviland followed Adams's advice, arriving in Philadelphia in September 1816. Two years later, he published *The Builder's Assistant, Containing the Five Orders of Architecture*, which raised his profile among city architects. In short order, he began receiving commissions: the First Presbyterian Church (1820), Saint Andrew's Episcopal Church (1822), the Pennsylvania Institute for the Deaf and Dumb (1825), the Franklin Institute (1825) and, of course, Eastern State Penitentiary (1821). Success clouded Haviland's judgment, however, and by the mid-1820s, he began investing in his own projects, such as amusement parks and arcades. When these failed, Haviland started embezzling money from a commission, Virginia's Naval Hospital, but even this infusion of cash proved insufficient, and Haviland declared bankruptcy. During the proceedings, his embezzlement was discovered, tarnishing his reputation and preventing him from ever receiving another federal commission.[57]

Haviland was extremely familiar with John Howard's suggestions—like segregating inmates—regarding prison reform through Haviland's association with Howard's friend

"The Worst Argument in the World"

John Haviland. *From the* Journal of Prison Discipline and Philanthropy.

Count Morduinoff. This acquaintance with Howard's work was reflected in Haviland's designs.[58] Moreover, Haviland designed a monument to Howard in Russia, though it is uncertain whether this was ever constructed.[59] While Strickland merely recycled his plan for Western State, Haviland's plan was a modified radial plan of four cellblocks linked to a central observatory that "was similar to the many county jails the architect must have been familiar with in his native country."[60] Haviland argued that his four goals in designing the prison were convenience, ease of surveillance, economy and good ventilation.[61] In an odd move, the board chose Haviland's design, but appointed the more experienced Strickland to actually build the penitentiary, for which he would receive $2,000 per year.[62] According to the leading historian of Eastern State Penitentiary, the board "pointed out that Haviland's principle of radiating cell ranges had been considered so much more practicable than Strickland's circular blocks so far as initial cost, cost of supervision, and the location of facilities such as keepers' quarters, kitchen, and other housekeeping services were concerned."[63] It seems that the committee was impressed by Haviland's radial plan because it was cheaper to build and operate, but it was concerned about the architect's lack of experience.[64]

Under Haviland's design, the penitentiary would be heated by "cockle" furnaces underneath the cellblocks, which required exhaust chimneys at the cellblocks' ends. The inmates' drinking water was stored in the second story of the penitentiary's central

Eastern State Penitentiary

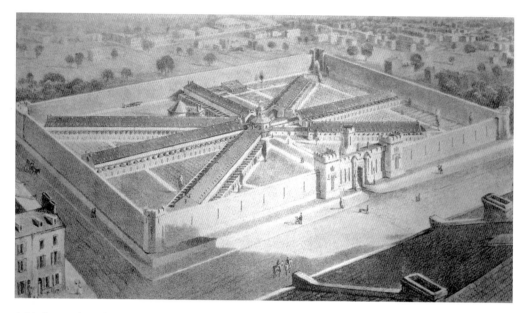

A bird's-eye view of Eastern State Penitentiary, 1830s.

rotunda, know as Center, while the water for flushing the cells' toilets (which were necessary if the prisoners were in their cells most of the day) was stored in a reservoir below Center.[65] Haviland's plan was not novel—radial-plan prisons had previously existed in Great Britain—and his contributions were usually improvements on others' designs rather than innovations.[66] What made Eastern State significant was the marriage of these improvements to the needs of the Pennsylvania System, or the creation of specifically designed buildings to suit a penal philosophy. In addition, Eastern State's castle-like exterior reflected the Gothic Revival sweeping America at the time. According to historian Faye Ringel, Gothic designs appeared in houses and cathedrals across the United States. She noted that "the architects of the First Gothic Revival believed that the nobility of their favored style would somehow ennoble the citizens who lived within the walls of these cottages and villas—and prisons."[67]

Controversy over Eastern State's construction ensued for six months because Strickland refused to be held responsible for the work, as it was not his design. This led to his dismissal by the board, who replaced him with Haviland in September 1822.[68] There was a great deal of controversy between Haviland's hiring and Eastern State's opening in 1829 that generated several significant reports. The most important report was the 1826 investigation of Western State Penitentiary.[69] The committee that conducted that investigation was influenced by the Boston Prison Discipline Society's president Louis Dwight, and their report argued that both Western and Eastern State should be modified to be administered like New York's Auburn System: separation at night, but group labor during the day.[70] Two years later, the building commissioners issued a report, at the legislature's request, which came to the same conclusion. These reports alarmed the Society for Alleviating the Miseries of Public Prisons, which was committed to the Pennsylvania System.[71]

"The Worst Argument in the World"

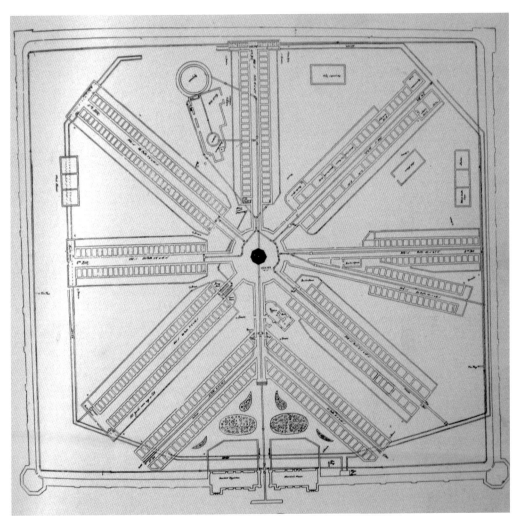

Even at the end of the beginning of the twentieth century, Haviland's distinctive design was still visible. *Michael J. Cassidy,* On Prisons and Convicts, *1897.*

Eastern State's first three cellblocks were almost complete by the time the commissioner's report was issued in January 1828, and retrofitting them to suit the New York system would have cost a minor fortune and delayed construction. For these reasons, Pennsylvania's legislature closed debate about these issues by passing an act in April 1829 decreeing that both penitentiaries were to be run on the Pennsylvania System.[72] This act also stipulated that inmates at both penitentiaries were to labor while confined. This was a problem for Western State, which Strickland had designed for incarceration *without* labor. At Western, "the arrangement and size of the cells were not adaptable for labor"; because the original law had not called for incarceration at labor, the prison had not been designed for it.[73] Inmates thus labored congregate style, which prevented the Pennsylvania System from being fully implemented.[74] By 1829, active lobbying by the society resulted in a law mandating incarceration at labor, and it quickly became apparent that Strickland's

design for Western State was not suitable because the cells were too small.[75] Even without this new law, Western State's cells lacked sanitary facilities and had improper ventilation and heating, making continuous confinement unbearable.[76] As a result, in 1836 Western State was torn down and rebuilt with a design similar to Eastern State's.

In addition to housing inmates, Eastern State was designed to house its administrative staff. The administrative building contained living quarters, as well as workspaces for the warden and his overseers. On the east side of the gatehouse were the warden's quarters, while the west side initially housed Eastern State's kitchen and bake house, the infirmary, a conference room and the overseers' quarters. Directly behind the gatehouse were yards to the right and left of the path leading to Center where the families of the warden and overseers could plant vegetables and their children could play.[77]

Because of the penitentiary's expense and size, construction took place in a fishbowl of public scrutiny and controversy. Against this backdrop, a bizarre episode occurred that sociologist Negley K. Teeters called the only case of possible fraud in the penitentiary's construction.[78] Commissioner Peter Miercken received a bank draft from the state for $20,000 to cover some of the penitentiary's building expenses. On December 3, 1821, he cashed the draft and received twenty $1,000 bills, and on his way home, he stopped at Philadelphia's Farmers and Mechanics Bank to exchange one of the notes for two $500 bills. The following day, he wrapped the money in paper and walked to the board meeting, but when he arrived, the packet of money was no longer in his pocket. He retraced his steps, but failed to find the money, so he let the board know what had happened. The other board members also searched, but were unable to recover the packet. The committee's lawyer, Horace Binney, suggested that they go to Harrisburg and explain to the governor how Miercken had lost $20,000 in state money. Miercken was undoubtedly worried that he might end up in the very penitentiary he was building.

Then something miraculous happened: at the board's meeting the following evening, Miercken appeared with a packet of money that, when counted, amounted to $15,000. According to Miercken, one of his servants had observed a strange man in Miercken's warehouse who left the packet of money. A week later, on December 12, Mierceken's brother found a note in the same warehouse signed by "Tom Find," which led them to search the warehouse. At the bottom of the cistern, Miercken found an additional $4,000 and another note from Tom Find, stating that he kept the two $500 bills. This was the story recounted to the governor, who (not surprisingly) referred the matter to Pennsylvania's attorney general. More or less, the matter was closed six months later, when, on July 7, Peter Miercken died. After his death, it was revealed that Miercken was in dire financial straits, which may have been merely a coincidence or may have been a motive to defraud the state. In either case, the commission continued to report the loss until 1827, when it adjusted the books. Negley K. Teeters noted that it was significant that, in each report to the state, the commission always chose to refer to the matter as Peter Miercken's "alleged" loss of $1,000.[79]

While this was only a premonition of the many scandals to rock Eastern State during the next century and a half, the penitentiary's promoters honestly believed that the Pennsylvania System was a huge leap forward in the humane punishment of crime. Building on Penn's legacy of humanitarianism, Eastern State's founders created an institution that struggled valiantly, but often futilely, to live up to its grandiose philosophy and achieve its lofty goals.

CHAPTER 2

EARLY YEARS

1829–1865

On February 9, 1839, Joseph Laird was escorted into the State Penitentiary for the Eastern District of Pennsylvania, or Eastern State Penitentiary. Convicted of larceny, Laird was sentenced by the Court of Quarter Sessions to four years in the penitentiary known locally as "Cherry Hill." Built on a cherry orchard, the building looked like a castle, with rising towers and arrow-slit windows cut into its imposing façade. This was the largest and most expensive structure in North America,[80] a building so immense that it occupied an entire city block and its perimeter stretched for almost a mile. While his reaction to the penitentiary can only be guessed, Laird likely wanted to be almost anywhere else. While the penitentiary's system of separate confinement was intended to be the humane alternative to the physical punishments used before the Revolution, it was extremely controversial, and some critics even claimed that it drove men insane.

Laird was escorted to a small building in the warden's yard, where he undressed, bathed and received his uniform.[81] After dressing, Laird was hooded so that he could neither see or be seen as he was escorted to the central rotunda to meet Warden Samuel Wood, who asked Laird questions about his personal history and habits, trying to discover what had compelled Laird to steal.[82] After the interview, Laird was again hooded and escorted to his whitewashed, eleven-foot, nine-inch by seven-foot, six-inch cell, which contained a tin cup and pan and utensils for meals, an iron bed frame with a cornhusk mattress that was designed to fold against the wall, a clothes rack and stool, a coarse brush for scrubbing the floors, a comb and a wash basin with towel.[83] The cell door closed behind him, and Laird began his new life as "number 1056."

Life at Eastern State was rigorous. Prisoners woke between 4:30 and 5:00 a.m. and were allowed one hour a day in their exercise yards every day except Sunday (weather permitting). Meals were served at 7:00 a.m., noon and 6:00 p.m., and bedtime was between 9:00 and 10:00 p.m. Prisoners ate reasonably well for the times: coffee for breakfast, between half and three-quarters of a pound of meat (beef or pork), potatoes and a pint of soup for lunch and "Indian Mush" for dinner, in addition to the pound of bread prisoners received daily.[84] Two cells in cellblock seven served as Eastern State's kitchen during the late 1830s, providing meals for all the prisoners incarcerated at that time.[85] The

Eastern State Penitentiary

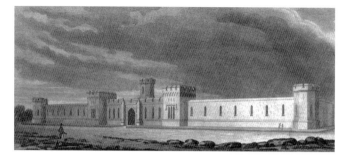

Eastern State Penitentiary.

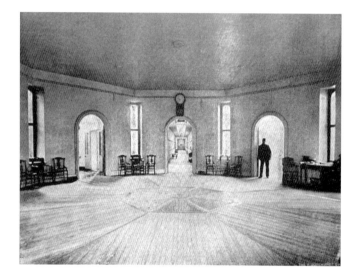

The penitentiary's famous central rotunda (Center) from which all cellblocks could be viewed merely by turning one's body. *Michael J. Cassidy,* On Prisons and Convicts, *1897.*

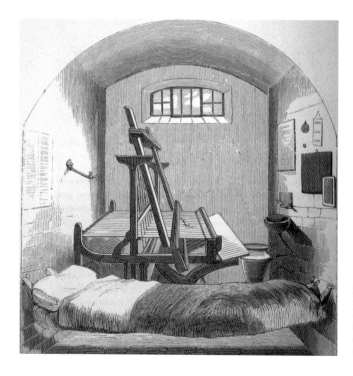

A typical solitary cell in a Pennsylvania System penitentiary. Eastern State's cells differed somewhat from this model. *From the* Journal of Prison Discipline and Philanthropy.

penitentiary had eight basic rules that were posted in each cell: first, prisoners were expected to keep their cells and utensils clean; second, they were to obey all directions given by the warden and overseers; third, prisoners were expected to be silent and refrain from communicating with other inmates at all times. The fourth rule mandated that prisoners return all uneaten food to the overseer, while the fifth instructed prisoners to "apply yourself industriously at whatever employment is assigned you; and when your task is finished, it is recommended that your time be devoted to the proper improvement of your mind, either in reading books for the purpose, or in the case that you cannot read, in learning to do so." According to rule six, if prisoners had any complaints about overseers, they should speak to the warden; complaints about the warden should be made to an inspector. Respect toward all penitentiary officials was required by rule seven, while rule eight (reflecting the penitentiary's religious underpinnings) reminded inmates to "observe the Sabbath; though you are separated from the world, the day is not less holy."[86]

At first, Laird could not have books or work, though both were eventually provided as "favors," always contingent on good behavior.[87] It is unclear what sort of labor Laird performed while incarcerated. The most popular included shoemaking, carpentry, sewing, washing, turning, brush making, tin working or shuttle making.[88] Laird's solitude was broken by visits from the warden, the physician and the visitors from the Society for Alleviating the Miseries of Public Prisons charged with ensuring that the penitentiary's administration lived up to its humane ideals. According to the society:

> *It may be assumed as a principle that the prospect of a long, solitary confinement, hard labour, and a very plain diet, would, to many minds, prove more terrible than even an execution; where this is the case, the operation of example would have its full effect, so far as it tended to deter others from the commission of crime.*[89]

Richard Vaux, writing four decades after the penitentiary opened, argued that its goals were threefold: first, prevention of crime by demonstrating what penalty lawbreakers could expect; second, protection of the community by incarcerating inmates; and third, reforming inmates through "the agencies of the system."[90]

According to historian Harry Elmer Barnes, between 1790 and 1841, the society emphasized that the Pennsylvania System was "solitary confinement," but that, in response to critics who argued that depriving men of human contact drove them insane, after 1841, penitentiary officials argued that prisoners were subjected to *separate*, not *solitary*, confinement.[91] Part of this transition was likely due to Dickens's scathing description of the Pennsylvania System published in *American Notes* (1842), which described prisoners as men "buried alive; to be dug out in the slow round of years; and in the meantime dead to everything but torturing anxieties and horrible despair."[92]

The administration defended separate confinement, noting that "although prisoners are separated from one another they are not deprived of intercourse with their fellow men," both the warden and the moral instructor visited the prisoners frequently.[93] Penal reformer Dorothea L. Dix, who visited Eastern State in the 1840s, emphasized the distinction between separate and solitary confinement, arguing that inmates saw the

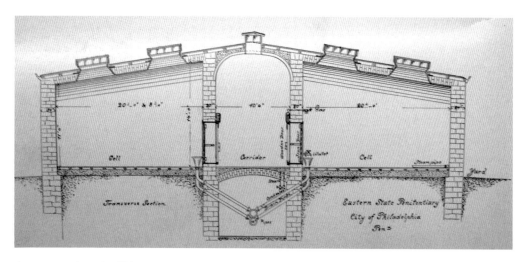

A cut-away view of cellblock one included in Gustave de Beaumont and Alexis de Tocqueville's *On the Penitentiary System and Its Application in France*, 1833.

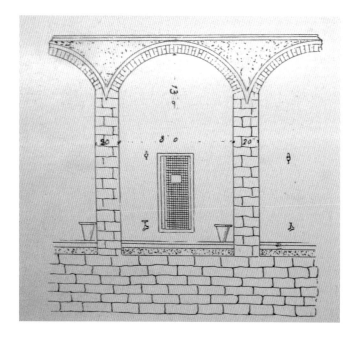

A cut-away of a cell included in Gustave de Beaumont and Alexis de Tocqueville's *On the Penitentiary System and Its Application in France*, 1833.

officers who distributed meals and work materials daily. Moreover, inmates had "the means of communicating at any moment with the officer of corridor…he may see the minister or priest of his choice when he desires; the committee from the Prison Society, weekly; the inspectors twice a week."[94]

Like most of Eastern State's inmates, Laird was male and, at twenty-three, was about the same age as most of the other inmates, 43.8 percent of whom were between twenty and twenty-nine in 1830. While most of the penitentiary's inmates were first-time offenders, this was Laird's second conviction for larceny.[95] Though it is unclear what, if any, religious

affiliation Laird claimed, Eastern State's prisoners generally came from a small number of religious denominations. According to the 1856 annual report, Methodists made up 26.45 percent of Eastern's population, followed by Roman Catholics (21.64 percent), German Lutherans (15.63 percent), Presbyterians (12.02 percent) and Episcopalians (5.05 percent). There were only six Quakers at Eastern State, making up 1.44 percent of the population, and only one Jew (.24 percent). As many as 25 percent of inmates could neither read nor write, which was an astounding 1,250 percent higher than the average in Philadelphia County in 1840.[96] According to Thomas Larcombe, Eastern State's moral instructor, "we accordingly find among [prisoners] a more intelligent and better class in the New England States, and at Auburn, than at Sing Sing and Philadelphia; they are much more easily taught trades, are more healthy, and are abler to do work."[97]

There was always a very small number of women in Eastern State, usually between 2 and 4 percent, which was about the national average. One report estimated that, in the 1830s, approximately four in one hundred American penitentiary inmates were female. The first female inmates, Amy Rogers and Henrietta Johnson, entered the penitentiary in April 1831. They were followed eight months later by two more women. These women were housed in a separate cellblock from the men and worked around the penitentiary as cooks and laundresses. Within seven years of the penitentiary's opening, there were so many women that the administration hired Mrs. Harriet B. Hall to serve as matron.[98]

While in 1850 only 3.6 percent of American penitentiary inmates were women, an astonishing 43 percent of those were black.[99] This was due to the fact that blacks made up a disproportionately high percentage of Eastern State's population relative to their numbers in Pennsylvania. According to the 1840 census, 43.1 percent of the penitentiary's inmates were black, while blacks composed only 28 percent of the state's citizenry.[100] Blacks were more likely to end up in Eastern State because the house of refuge, a type of juvenile hall, only accepted whites.[101] However, while blacks made up a large minority within the penitentiary, Eastern State did not segregate during this period, as it would in later decades, because the penitentiary's unique architecture made segregation redundant.

According to Alexis de Tocqueville, the Pennsylvania System, as practiced at Eastern State, was a combination of Western State's system of isolation with Auburn's labor system, which made the penitentiary (in Tocqueville's opinion) the best of the three for effecting inmates' reformation.[102] Initially, the Pennsylvania System was quite popular in America. Outside Pennsylvania, it was implemented, in various forms, at New York's Newgate Prison (1796) and Auburn State Penitentiary (1821–23), at New Jersey's Trenton State Penitentiary (1833–58) and Penitentiary at Lamberton (1820–28), in Maine at the Thomaston Penitentiary (1824–27), in Virginia's Richmond Penitentiary (1824–50), in Rhode Island at the Providence Penitentiary and in Maryland at the Baltimore Penitentiary (1809–38). However, for a variety of reasons, including cost, the Pennsylvania System was eventually replaced by the New York System.[103] The triumph of the harsh Auburn System signaled the substitution of retribution and punishment for compassion and rehabilitation.[104]

Eastern State's main administrators were the warden, the physician and (after 1838) the moral instructor, all of whom were appointed by five inspectors, who were, in turn,

Eastern State Penitentiary

appointed from Philadelphia's taxable citizens by Pennsylvania's Supreme Court and served two-year terms. Though unpaid, being an inspector excused the officeholder from military service and jury duty. The inspectors set the administrators' salaries and supplied raw materials for Eastern State's labor program. In addition, inspectors visited the prison at least twice a week, during which time they spoke with inmates and ensured that the Society for Alleviating the Miseries of Public Prisons' high ideals were put into practice. According to a pamphlet printed by the society for inspectors, "Rules for the Visiting Committees of the Eastern State Penitentiary and Philadelphia County Prison," members were expected to visit the prison at least once every two weeks. During those visits, inspectors should "encourage obedience to the Rules of the Prison," but should be careful not to force visits on prisoners if the inmates were unwilling. Inspectors were urged to avoid discussing pardons with inmates, lest they give prisoners false hope. In sum, the rules demonstrate that inspectors were humane, if paternalistic, in their treatment of the prisoners they visited.[105] Negley K. Teeters argued that the appointment of inspectors "gave the Pennsylvania System its strength," and that "having lay visitors enter the cells of the prisoners as friendly counselors gave the system its uniqueness."[106] According to historian Finn Horum, "The Eastern State inspectors took their oversight responsibilities very seriously and appear to have had considerable influence on policy."[107]

The warden's responsibilities could be arduous: he was required to talk with every prisoner every day (a difficult task in a prison with 385 prisoners in 1837), interview incoming convicts and appoint the penitentiary's guards, called overseers. In addition, he had to maintain a daily journal that recorded discharges, deaths, illnesses, punishments and all unusual activities. Eastern State's first warden was a Quaker businessman and

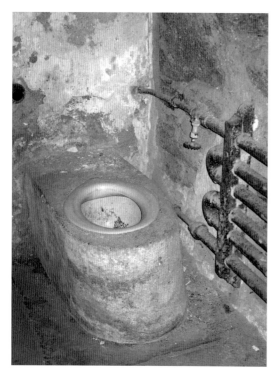

Photo courtesy of Dr. Jennifer Murphy.

society member named Samuel R. Wood. According to E.S. Abdy, who visited the penitentiary during a trip to North America in the early 1830s, the prisoners spoke "in the highest terms" about the warden, who often sent meat "from his own table" to Eastern's sick inmates. While Abdy was visiting the penitentiary, a former inmate came back to return money that Wood had lent him, and Wood confided to Abdy that he had lent another inmate ten dollars "and the warden had no doubt he would discharge the obligation, as soon as he could."[108] This contrasts sharply with the image of Wood in *Buds and Flowers: Of Leisure Hours*, a collection of poems written by George Ryno under the pseudonym Harry Hawser while he was a prisoner at Eastern State. According to Ryno, "the murderer Wood" was a "fiend in human shape" whose "hands unbrued in a daughter's blood."[109]

From 1829 through 1846, Eastern State received 2,176 prisoners, more than half of which (51 percent) were convicted of larceny. The other top four crimes were burglary (11 percent), horse theft (6.8 percent), forgery (4 percent) and passing counterfeit money (3.6 percent). In all, these five crimes accounted for 76.4 percent of all sentences.[110] These crimes reflected the growing distance between the "haves" and the "have-nots" as American cities industrialized in the 1830s and 1840s. According to historian Elizabeth M. Geffen, "Poverty had become a fixed and terrible feature in Philadelphia's life in 1840. Unskilled factory operatives received an average of 63 cents a day in 1841, 78 cents in 1854."[111] This amounted to roughly $215 annually in 1841 and $265 annually in 1854. By way of comparison, consider that Eastern State's warden made $1,500 in 1829.[112] There was a considerable class difference between many of the inmates and Eastern's administrators.

Dix noted that Eastern State's labor was "not burthensome, the prisoner being left to choose his time: so his work accomplished, he has liberty to rest, to read, or write, to listen to the counsels of the chaplain, or the teachings of the schoolmaster, and to cultivate in its season the small plat of ground, which the industrious have much pleasure in keeping in order, and in which an hour daily may be spent."[113] At least one inmate agreed, to a point, writing that "if a man is a good workman and can do his task easily he may bear it tolerably well. That is the main point, but if he cannot, then it is quite the reverse."[114] The penitentiary's labor program operated on the "public account system," a system in which inmates manufactured goods and the penitentiary sold them to the public. William Parker Foulke argued, "If we are to reconcile to steady occupation, men most of whom owe their incarceration to a dislike of it, we must accustom them to find in labor a comfort which they have not known; to obtain voluntarily from it, by habitual application, protection from evil thoughts and from the natural results of idleness, for the first time clearly manifested in them."[115] Labor was designed to not only teach inmates a skill, but also to overcome their purported laziness by showing them the material and moral benefits of honest work. Foulke and others thought that prisoners were lazy because of the types of crimes they committed, which were largely nonviolent thefts. Unlike Eastern's great rivals, New York's Auburn and Sing Sing, "there was much better control and less exploitation of the prisoners."[116]

The New York, or congregate, system was introduced at the Auburn Prison in 1816. Under this system, inmates were only separated at night; during the day, they labored

A prisoner at work in Eastern's print shop, 1890s. *Michael J. Cassidy, On Prisons and Convicts, 1897.*

together in factories, albeit in complete silence. Though introduced at Auburn, the New York System is most closely associated with the infamous penitentiary Sing Sing, which opened in 1828. The New York legislature authorized Sing Sing's construction on March 7, 1825, and ordered the penitentiary to be constructed using inmate labor. Whereas Eastern State was designed along a radial plan, Sing Sing's cellblocks were long and narrow, and because inmates only slept in their cells, the cells were much smaller than those in its southern rival. Obviously, due to the size and technical complexity of Eastern State's cells, New York System prisons were much easier, and therefore cheaper, to build and operate.[117]

Elam Lynds, Sing Sing's first warden, won the job because of his reputation as a rigid (some would say inhumane) disciplinarian. His years in the army conditioned Lynds to view inmates as "the enemy," and he therefore treated them cruelly.[118] Lynds was so concerned that Sing Sing be profitable that he ordered all inmates who refused to work to be whipped. By 1839, the public was outraged when it became known that a sick inmate was dragged from his bed, beaten and forced to work; the controversy resulted in Lynds's resignation.[119] According to Edward Livingston, who knew Lynds, the warden "did not expect reformation" because he considered it "hopeless." This meant that Lynds, and the New York System he championed, were the diametric opposite of the Pennsylvania System, causing a rivalry between the two that lasted at least until the Civil War. William Crawford, who visited Auburn, as well as Eastern State, noted multiple breakdowns in the New York penitentiary's disciplinary system. These breakdowns included notes passed between prisoners, "talking, laughing, singing, whistling, altercating and quarrelling with each other and the officers."[120] This led him to conclude that the Pennsylvania System better achieved rehabilitation, an opinion shared by many others.

Crawford and Dix were not alone in visiting the penitentiary. From the day it opened in 1829, Eastern State was a tourist destination, attracting serious scholars, government officials and curiosity seekers. During the 1840s, the prison often hosted 100 visitors a

Early Years

An inmate at Sing Sing, 1840s. *From the* Journal of Prison Discipline and Philanthropy.

day.[121] Even forty years later, when Eastern was no longer on the cutting edge of penal philosophy, it continued to draw visitors. Vaux calculated that, in the decade between 1862 and 1872, an astonishing 114,440 people had visited the penitentiary.[122] According to one visitor, during the 1850s, "though styled the separate system, the discipline admits of the freest intercourse with respectable visitors. The best people in Philadelphia call upon, and hold converse with, the convicts, who doubtless receive no small benefit through such agencies."[123] Eastern's revolutionary system of penal discipline was world famous, a condition that generated curiosity about its effectiveness. For instance, in 1861, France's Prince Napoleon visited the penitentiary and "exhibited much discernment and knowledge of the system of public correction, inquiring what percentage of convicts returned for a second time."[124] One visitor in the 1830s wrote that she "was convinced that the system of separate confinement at Philadelphia is the best that has yet been adopted."[125] Two French officials, in a report to their government on American penitentiaries, wrote about Eastern State:

> *Can there be a combination more powerful for reformation than that of a prison which hands over the prisoner to all the trials of solitude, leads him through reflection to remorse, through religion to hope; makes him industrious by the burden of idleness, and which, while*

it inflicts the torment of solitude, makes him find a charm in the converse of pious men, whom otherwise he would have seen with indifference, and heard without pleasure."[126]

However, when Charles Dickens visited the penitentiary in 1842, he concluded that "nothing wholesome or good has ever had its growth in such unnatural solitude…there is surely more than sufficient reason for abandoning a mode of punishment attended by so little hope or promise, and fraught, beyond dispute, with such a host of evils."[127]

In addition to being a tourist attraction, Eastern State was a lightning rod for political controversy. During its 142-year life, Eastern State was the subject of numerous investigations by the Pennsylvania legislature. The first of these occurred in 1834, when the legislature investigated Warden Wood and a few of his overseers over accusations that they had allowed "immoral" contact between overseers, employees and inmates and of embezzled public property. In addition, the penitentiary's administrators were accused of cruel and unusual punishments inflicted on inmates, of practices inconsistent with penal discipline and of laxity in implementing the Pennsylvania System.[128] Many of the charges were the result of lurid rumors about an overseers' wife, Mrs. Blundin. Witnesses alleged that she hosted lavish parties, stole food from the penitentiary store and had sex with guards and inmates, causing an outbreak of venereal disease. Warden Wood was accused of misappropriating inmate labor for his own profit and punishing inmates so severely that one died.[129]

These were serious charges and, consequently, the legislature held a special session in Philadelphia from December 16, 1834, to January 22, 1835, to investigate the charges. A total of sixty-five witnesses were questioned during this thirty-seven-day period. Leonard Phleger, who worked in the penitentiary's smith shop, testified that in April 1833, Wood ordered that the iron gag be placed on Matthias Maccumsey, a prisoner living in cellblock three. Another former employee claimed that Wood struck prisoners, citing one in particular—number 48—who Wood also threatened to hit with a stick. The prisoner was apparently later pardoned and sent to Philadelphia's almshouse.[130] According to Warden Wood, the charges resulted from religious differences between himself and some of the overseers and inmates, who Wood argued were deists.[131]

Because of Wood's counter charges, witnesses were examined as to their religious beliefs, and any with "unorthodox" views were barred from testifying.[132] Not surprisingly, the committee found that, by and large, the charges were unfounded. It concluded that Eastern State's clerk, John Holloway, had *heard* but not *used* "improper language," and may have had "a greater degree of familiarity" with Mrs. Blundin than "a delicate sense of propriety would justify," but this did not countervail the general evidence of Holloway's good character.[133] By the time of the committee's investigation, Mrs. Blundin had already left the prison, so no attempt was made to prosecute her. Finally, the committee concluded that "Mr. Wood could not be properly charged with any wrong doing" regarding his use of convict labor, though it did recommend that future wardens be prohibited from holding other jobs while employed at the penitentiary.[134]

Clearly, the penitentiary and its unique system of discipline were controversial; some vocally supported the Pennsylvania System, while others vehemently opposed it. It should come as no surprise, therefore, that prisoners reacted in a variety of ways to the

Early Years

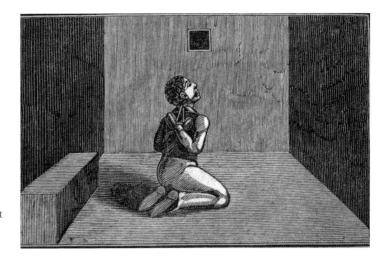

The infamous "Iron Gag," a supposedly humane punishment that claimed at least one inmate's life.

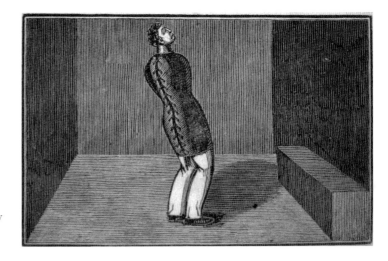

Despite, or maybe because, Eastern State was supposed to practice "humane" punishment, the penitentiary's administrators occasionally used straitjackets to calm unruly inmates.

Pennsylvania System. Some felt reformed, while others were driven to despair. In a letter to Warden George Thompson, an inmate noted, "You said once in this cell that you sometimes visited a block and found all the men perfectly happy; it may be so, but how you are to know whether a man is happy or not, by just opening the door and looking at him and saying nothing to him is hard to say."[135] Dickens's interviews with prisoners are an invaluable insight into inmates' experiences with the Pennsylvania System. One man, who had served six years of a nine-year sentence, stared off into space during the interview "as if he had forgotten something. A moment afterwards he sighed heavily, put on his spectacles, and went about his work again."[136] Another inmate Dickens encountered had been a sailor before his eleven-year sentence at Eastern State, which was due to expire a few months after the interview. According to Dickens, the man was so broken by solitary confinement that he said nothing, refused to meet Dickens's eyes and merely picked at the skin on his fingers. Dickens wrote that this prisoner had lost everything and, consequently, "it is his humour to be a helpless, crushed, and broken man."[137]

39

Originally, the penitentiary had no doors into the cells from the cellblocks; just small feeding tubes covered by doors such as these. In practice, these prevented overseers from getting into the cells, and they were discontinued after cellblock three was built. *Photo courtesy of Dr. Jennifer Murphy.*

Dickens's most enduring interview, however, was with a man who came to be known as "the old German." Dickens claimed that he "never saw or heard of any kind of misery that impressed me more than the wretchedness of this man."[138] For obvious reasons, the Society for Alleviating the Miseries of Public Prisons vigorously rebutted Dickens's claims about the horrors of the Pennsylvania System, and numerous articles appeared in the society's *Journal of Prison Discipline and Philanthropy* regarding this prisoner in particular. According to the society, Dickens's portrait of the old German, whose name was Charles Langheimer, was incorrect. According to an 1872 interview with a reporter from the *New York Times*, Langheimer claimed that he was "very happy and comfortable, and much prefers his present residence to any other prison in which he has been confined."[139] In addition, Langheimer was not so "miserable" while at Eastern State that he was reformed, for he spent most of his adult life going in and out of the penitentiary for various crimes. When asked about this by a reporter for the *Philadelphia Inquirer*, Langheimer replied, "Well, I like to come back and see my friends, you know, and when I am here nothing outside can bother me."[140]

Langheimer's story does not end there. He was released from Eastern State and moved to Michigan to live on his son-in-law's farm. This seemed to be the last the penitentiary would see of the infamous "German prisoner." However, in September 1878, Eastern's inspectors received a letter asking if they would allow Langheimer to return to the penitentiary to live out his days. Figuring that it was a whim, they did not respond. On October 13, Philadelphia's mayor opened his door to discover Langheimer, who demanded work he had been promised so persistently that the police came and took the seventy-five-year-old man away. The article noted that Langheimer called Eastern State "home," and that the old man threatened to steal something as soon as he was released by the police so that he would be returned to his cell.[141]

Dickens was not the only visitor who interviewed Eastern State's prisoners during this period, though others came away with a much sunnier view of the institution than the one presented in *American Notes*. According to E.S. Abdy, who visited the penitentiary in the early 1830s, the inmates "spoke in highest terms of Mr. Wood, the

Early Years

A door leading into a cell from the exercise yard. Overseers and inmates could only access cells from the outside, a cumbersome arrangement in emergencies. *Photo courtesy of Dr. Jennifer Murphy.*

Warden, whose mild and kind manner had removed from their minds those angry feelings which had been engendered by residence in other prisons."[142] One prisoner thanked Warden Thompson for his "great kindness to me upon an occasion when I stood in great need of assistance."[143] Frederika Bremer, who visited Eastern State in 1850, described the penitentiary's third warden, Thomas Scattergood (1845–50) as a "kind, elderly gentleman, with a remarkably sensible and somewhat humorous exterior."[144]

Prison administration was surprisingly willing to indulge prisoners, given Eastern's fearsome reputation. For instance, a visitor during the 1850s noted that prisoners were allowed to enter their exercise yards at will. Prisoners were allowed to plant flowers in their yards and, "in several instances, on entering the cells, I found the inmates in their courtyards reading in the sunshine, which stole over the high bounding-walls." In at least one case, a prisoner was allowed to keep two pigeons as pets, which the prisoner described as companions whose coos "cheer me when I am alone."[145]

Prisoners often decorated their cells, making Dickens's claims of brutal treatment somewhat suspect. Dickens himself noted that Langheimer had painted every inch of his cell with a beautiful mural, and that another prisoner had decorated his cell with "a few poor figures on the wall."[146] Langheimer's work was so amazing that, as late as 1878, it was "still shown to visitors as one of the curiosities of the place."[147] A reporter who visited the penitentiary in 1868 noted that one female prisoner had decorated her cell, covering the walls in "tissue paper and fancy work."[148] Even those who chose not to decorate their cells still had access to creature comforts. According to the *New York Times*,

"many prisoners have their cells comfortably furnished by their friends, the privilege being granted to all who behave."[149]

An unusual but interesting case occurred in 1843, when Robert Harding entered Eastern State. Though Harding had committed no crime, he swore out an affidavit in the presence of the mayor that he would unless he was incarcerated at the penitentiary. According to a witness, Harding made this odd request because he thought the Pennsylvania System would "settle his mind."[150] He wrote, "My residence here will, I think, be a lesson to me as long as I live; I don't wonder this place is a terror to evil doers."[151] While at Eastern State, Harding worked as a weaver, though he admitted that he was not very good at the trade. Aside from Harding's letters at the American Philosophical Society in Philadelphia, there is little information about the man. One apocryphal story claims that, while gardening one day, Harding dropped his tools and asked to be let out the front gate, never to return again. At the very least, we have Harding's words, which testify to the impression Eastern State made upon him. He wrote, "I shall dread the very name of this place."[152]

Other prisoners were not so impressed with separate confinement, and they occasionally rebelled in a variety of different ways. For instance, G. Brewster was denied dinner for refusing to work on November 12, 1835.[153] This was a mild form of resistance, and occasionally prisoners opted for something a little more dramatic. On April 20, 1856, inmate number 3333 committed suicide by slitting his own throat with a shoemaker's knife.[154] In August 1857, number 3387 tried unsuccessfully to hang himself in his cell, and two months later he opened a vein in his arm with scissors. The following year, number 3572 tried a similar trick, losing half a gallon of blood before the penitentiary staff was able to stop the bleeding.[155] John Baird committed suicide by using a handkerchief to hang himself a few months after being sentenced for two years for receiving stolen goods.[156] Sometimes inmates directed their aggression outward, like in May 1860, when number 4261 flooded his cell during a periodic fit of "mental alienation."[157] Another prisoner was reprimanded by the warden for drawing obscene pictures in the penitentiary's books, while prisoners 3300 and 3323 were disciplined for talking to other prisoners.[158] The ultimate misbehavior was escape, and though Eastern State was designed to be an escape-proof prison, inmates still found a way out. Usually, this involved using the tools provided for laboring in their cells.

According to the report issued following the 1834 investigation of Eastern State, Samuel Brewster managed to escape in large part because of his trade. Assigned to carpentry, Brewster was in the habit of leaving his cell to sharpen his tools, which defeated the purpose of solitary confinement by allowing him to learn the penitentiary's layout. Using some small planks, he fixed the locks on his cell so that neither the wooden nor the metal doors' flanges would catch, which allowed him to leave his cell once the guards had retired for the night. Climbing over the wall of his exercise yard, he scaled the main wall using a ladder he had surreptitiously built in his shop. Built in pieces, he stored the ladder under the shop's refuse, and it was never noticed. Using screws (so that the sound from a hammer did not arouse attention), he scaled the wall. Unfortunately for Brewster, while the grade is level *inside* the prison, outside, the walls on the south end are ten feet higher than the walls on the north to compensate for the fact that Eastern State was built on a

Early Years

hill. Brewster swung his ladder over the wall and lowered it, but when he realized that it was ten feet too short, he dropped it. He was now stuck on the wall. Realizing he would be punished if caught escaping, he decided to take his chances and jumped, injuring his leg in the process. He managed to shuffle all the way to Kensington (a distance of over five miles), but was recaptured hiding in a pile of wood in a relative's cellar.[159]

Another good example was William E. Crissey's 1852 escape—he walked right out the front door! Crissey had been ordered to press some clothes for an inmate whose time had expired and who was being paroled. Instead, Crissey donned the outfit and managed to open the door leading out of his exercise yard. He then walked to front gate, told the guard on duty that he was visiting with some friends but felt tired and requested to be let out.[160] Crissey was eventually recaptured in Montgomery County, living under the name Charles Jenkins. Nine years later, an inmate named George Race, who had (amazingly) been employed as a locksmith while in the penitentiary, used Eastern State's tools to fashion duplicate keys and, while the guards were distracted, opened the massive front gate and walked out. While he was eventually recaptured, his escape demonstrates how prison labor was both a positive and a negative force within the penitentiary. More often, prisoners merely waited for convenient opportunities to escape. For instance, in 1847, prisoner 2120 asked his overseer, David Scattergood, to come into the cell and read. Once the guard was inside, 2120 jumped out the open door and slammed it behind

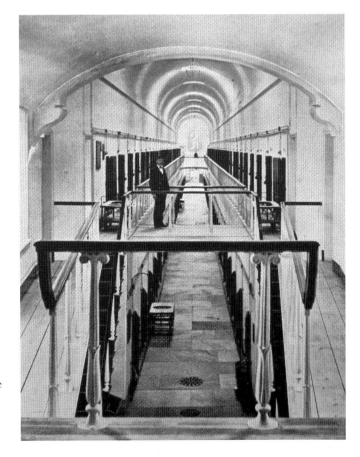

The gallery of cellblock seven. Overcrowding while the penitentiary was under construction forced Haviland to revise his design. He lengthened the last four cellblocks and made them two stories. *Gustave de Beaumont and Alexis de Tocqueville,* On the Penitentiary System and Its Application in France, *1833*.

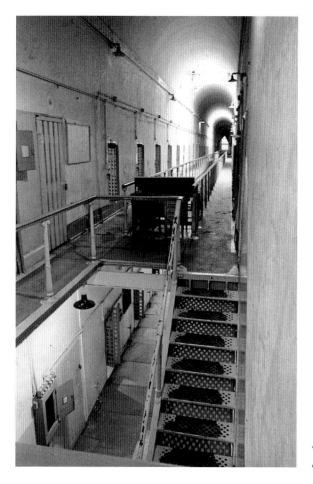

The gallery of cellblock seven today. *Photo courtesy of Dr. Jennifer Murphy.*

him, locking Scattergood in the cell. Inmate 2120 managed to liberate another prisoner, who "evinced a disposition to help the overseers," and 2120 was eventually subdued and placed in a dark cell as punishment.[161]

When prisoners misbehaved, Eastern State's administrators tried a variety of corrective methods to discipline them. The first disciplinary tactic was to take away inmates' access to work, books and writing materials, all of which were given as a "favor." If the inmate still acted out, the warden would often place him or her in a darkened cell in cellblock two; this was the punishment for both inmates 3300 and 3323 when they refused to keep silent. In extreme examples, prisoners might be subjected to the straitjacket, tranquilizing chair, iron gag or shower bath, all cruel punishments designed to ensure conformity with Eastern State's rules. These could be brutally applied. On a December morning in the 1830s, Seneca Plumly (prisoner number 75) was stripped naked and hoisted up his exercise yard wall. One of the overseers climbed a ladder and dumped a dozen buckets of water on Plumly's head. It was so cold that the water froze to Plumly's body and formed icicles in his hair.[162] These punishments belied Eastern State's claims to humanitarianism and, in at least once case, led to a prisoner's death.

Early Years

An important issue during Eastern State's early years was prisoners' mental stability before and during their incarceration. Because psychiatry was in its infancy, Eastern State often received mentally imbalanced convicts who today would be placed in a psychiatric care facility. Once placed in separated confinement, these prisoners often exhibited aggressive or self-destructive behaviors. For instance, in January 1840, a prisoner named Isaac Thomas tried to castrate himself using his shoemaking knife.[163] Another man cut his own throat in the courtroom after being sentenced to two years at Eastern State.[164] These incidents, and others like it, were widely publicized in the sensationalist newspapers of the day, fueling critics' argument that the Pennsylvania System was too harsh, driving men out of their minds.

Naturally, the Pennsylvania System was extremely difficult to administer, and it was often violated in practice. Prisoners often worked outside their cells. For instance, in the 1830s, five prisoners worked as blacksmiths, one as a cook and another as an apothecary, positions that they could not have practiced in their cells.[165] According to the state's report issued following the 1834 investigation, "It does appear that convicts had been frequently employed in cooking, in working, in breaking coal, in making fires, occasionally as waiters, and in work connected with the building and construction of cells, out of their cells."[166]

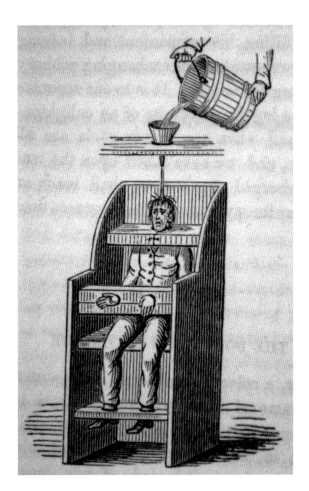

The "Shower Bath," another "humane" disciplining technique. *From the* Journal of Prison Discipline and Philanthropy.

The report concluded that, while this violated the letter of the Pennsylvania System, the warden maintained the spirit because "care seems to have been taken to keep [inmates] entirely separate from one another."[167]

Inmates laboring outside their cells continued throughout Eastern State's early years, despite the heightened danger of escape and the fact that such a situation defeated the purposes of separate confinement. By the 1860s, one of the prisoners worked as Eastern State's librarian, and 13 percent of inmates were employed around the prison in various positions.[168] William Hamilton, prisoner number 94, served as the warden's waiter, a position that gave him the opportunity to escape when, in 1832, he tied the warden's bedsheets together to make a rope and climbed out the window. Hamilton added insult to injury by taking with him some of the warden's clothes, razors and silver spoons. Fortunately, he was rearrested for larceny in Norristown, convicted and returned to the penitentiary a short time after his escape.

One of the cornerstones of the Pennsylvania System was anonymity, or the belief that prisoners would never meet one another, making it possible for inmates to start their lives over once they left the prison. William Crawford, who visited the penitentiary in 1834, quoted a prisoner, who told his story:

> *An instance of this kind was related to me of a convict who had manifested great contrition for his past life, and conducted himself so well as to obtain his pardon from the Walnut-street prison. Having been recommitted, he was asked why he had returned: he replied "I intended to behave well, and I went for the purpose to the State of Ohio where I hoped my former character would be unknown and I might set out anew in life. I got employment and was doing well, when unfortunately I one day met a man who had been a convict here the same time as myself. I passed him, feigning not to know him: he followed me and said 'I know and will expose you, so you need not expect to shun me. It is folly to set out to be honest. Come with me and drink, and we will talk over old affairs.' I could not escape from him: my spirits were in despair, and I went with him. The result you know."*[169]

Crawford noted the fact that, when he visited the prison, the Pennsylvania System was so successful that inmates were unaware of the outbreak of cholera in the city a few months previous.[170] Harriet Martineau alleged that, during her visit to Eastern State, she met two brothers who were convicted and sentenced within a short time of each other and were allegedly unaware of the other's presence in the penitentiary.[171] This was obviously the ideal situation, but in reality, inmates' identities were often known to the public and sometimes to each other, making the transition back into outside life very difficult because, in order for inmates to survive, they had to be able to get jobs after release. However, the stigma of imprisonment made it extremely difficult for some prisoners to find work. The 1838 annual report complained of the "unwillingness manifested by most employers to take persons released from prison into their workshops," which made it difficult "for convicts to obtain good situation in any period of time, but during the winter especially."[172] Martineau noted that public knowledge of inmates' crimes was "a great drawback upon reformation and upon repose of mind."[173]

Early Years

To prove her point, Martineau wrote about an inmate whose conviction for forgery was known in the city. The publicity surrounding his conviction cost his wife the job she had taken to support her family during her husband's sentence. Martineau wrote, "These virtuous ladies [who employed the inmate's wife] could not think of countenancing anybody connected with forgers and coiners."[174] This was the reason that, in official documents, inmates were supposed to be referred to by their number, rather than by their names; in practice, this was only done inconsistently. By the 1850s, local newspapers often referred to inmates by name, such as the *Philadelphia Inquirer*'s July 1868 report that Wendt, "the Germantown molester and school-master," had not in fact been released from Eastern State, despite rumors to that effect. Such articles made anonymity almost impossible to maintain.[175]

Historian Finn Hornum has erroneously argued that the Pennsylvania System "was successful in preventing the development of a prisoner subculture." While this probably *would* have been true if Eastern's administrators had actually been able to fully implement separate confinement, this did not happen.[176] In reality, the lapses in separation throughout Eastern's existence provided plenty of opportunities for prisoners to talk, interact, resist authority and (in at least one case) carry on a love affair. Among the boxes of Eastern State material at the American Philosophical Society are a series of love letters written between E.V. Elwell and Albert Jackson, both inmates at Eastern State during the early 1860s. These letters document a love affair between the two that, on at least one occasion, involved them meeting at night and, on another, conversing in the yard, both of which were violations of the Separate System.[177] The only logical conclusion is that, at least in some instances, the Separate System was not as rigidly practiced as some historians have maintained.

As this chapter demonstrates, Eastern State Penitentiary's early years were fraught with controversy and discord. The Pennsylvania System was too complex to be effectively administered, and breakdowns appeared almost immediately. Moreover, despite the best of intentions, the penitentiary's rehabilitative program sometimes resulted in despair, violence and even death. These negative side effects of the Separate System became more pronounced after the Civil War, when overcrowding and changing penal philosophy strained Eastern State's resources, and eventually destroyed the Pennsylvania System.

CHAPTER 3

"INFLEXIBLE DISCIPLES"

The Separate System in Retreat, 1866–1913

While the Pennsylvania System never functioned the way Eastern State Penitentiary's founders and supporters intended, changes in American society following the American Civil War doomed the Separate System. While the penitentiary's administration could credibly claim in the 1830s, '40s and '50s that most of Eastern State's inmates were separated most of the time, by the late 1860s this was no longer the case. The Separate System was now a "popular fiction," to use the words of one contemporary observer, albeit one to which the penitentiary's supporters clung tenaciously and fought vigorously to maintain. Rocked by scandal and rendered obsolete by changing tastes in penal discipline, Eastern's administrators struggled vainly to maintain the system that, less than half a century before, had been the most progressive in the world.

According to Teeters, "By 1860 the system had broken down to the point where a disinterested observer would have admitted that concept championed by the Society was no longer tenable."[178] This occurred for two reasons: first, following the American Civil War (1861–65), the amount of crime went up; and second, this led to more convictions and more inmates at Eastern State. By 1866, there were more inmates than there were cells, meaning that Eastern State could no longer separate, and this created a number of problems. The *Philadelphia Inquirer* noted in 1872 that the Pennsylvania System could not be carried out because there were 596 prisoners but only 550 cells.[179] A decade later, Philadelphia's Judge Allison attacked the penitentiary's administration because "the prisoners are not in solitary confinement, unless you can call two and three persons in one cell solitary."[180] The administrators responded two days later with the dubious explanation that, because the prison contained so many "imbeciles," "tramps and bummers" and prisoners convicted of a single offense, most of whom were not sentenced to separate confinement, the penitentiary could put multiple inmates in cells.[181]

Eastern State's supporters and administration tacitly recognized that separation was no longer possible. Starting in the 1870s, they dropped the term "Separate System" in favor of "individual treatment."[182] In fact, by 1881, fewer than half (40.4 percent) of inmates were held in solitary confinement, which, as the last chapter demonstrated, hardly lived up to the name.[183] Testifying before a legislative committee in 1897, Eastern

"Inflexible Disciples"

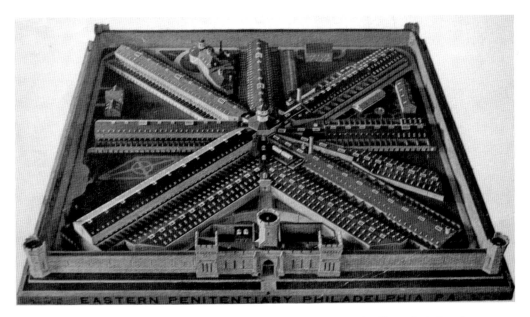

A model of the penitentiary built in the early twentieth century showing significant deviations from Haviland's original design.

State's warden, Michael Cassidy, was asked, "Are there cases here of what is commonly known as solitary confinement, where a prisoner is kept entirely by himself?"

Cassidy replied, "No, sir; there never was such a thing here."

In response to a question about the number of inmates in solitary, Cassidy noted, "I suppose there are more than a hundred…Most of the cells have two occupants, some have three, some have four; the latter being larger rooms….There are rooms that are very large, which sometimes have five in them but not often. It is just as the number increases. There have been prisoners here up to fourteen hundred. Then we have to condense considerably."[184] Eastern State's overcrowded conditions were caused by an explosion in crime following the Civil War, longer sentences for those crimes and a growing population that yielded more convicts.

The growth in the penitentiary's population was reflected in prisons around the country. Contemporaries argued that the country was in the grips of a crime wave because of the explosion of convicts. In fact, the percentage of indictments for homicide that led to convictions jumped from 33 percent in the mid-1850s to 42 percent in the late 1860s and to 63 percent by the late 1890s.[185] In addition, the length of sentences increased; for instance, before the war, only 5 percent of convictions for homicide led to sentences of greater than twelve years, but between 1860 and 1880, this number increased to 8 percent. During the next twenty-year period (ending in 1901), it doubled to 16 percent.[186] The professionalization of the police force and judiciary led to more prisoners sentenced for longer periods.

However, the upward trend in prison populations dovetailed with a seemingly contradictory reality: during the Civil War, the number of men incarcerated dropped precipitously. This happened because those most likely to commit crimes (poor young

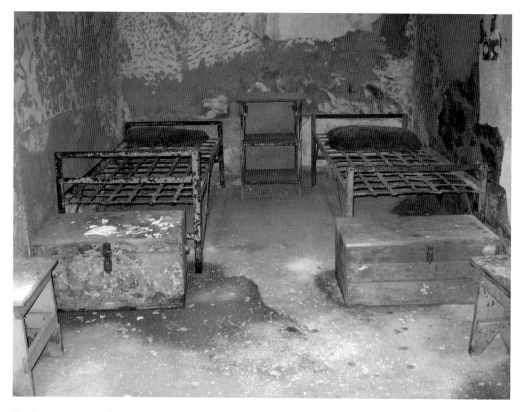

By the late nineteenth century, most cells had at least two, and sometimes three, prisoners, a tight fit in a space originally designed for one. *Photo courtesy of Dr. Jennifer Murphy.*

men) were funneled into the military. Some people at the time argued that those caught committing crimes were given a choice between military service or prison as a way of ensuring that each county had enough "volunteers" to escape the draft. According to economist and social worker Edith Abbott, "During the Civil War, apparently, sentences were given with reluctance; and when they were, they were probably of short duration."[187] If they survived the war, these men often returned to their homes with no more prospects than when they left; oftentimes they resorted to crime. This tendency was exacerbated by a general depression that started in 1873, when Jay Cooke and Company, a banking firm in Philadelphia, went bankrupt. This set off a chain reaction that included the ten-day closure of the New York Stock Exchange. Businesses collapsed, putting thousands out of work. By 1876, unemployment reached almost 15 percent.[188] With no jobs and the country mired in a depression, men often committed crimes to survive. This led to a great number of convictions, which swelled prison populations across the country, Eastern State included. Writing in 1893, James McKenn argued that "we are confronted with the appalling fact that crime for several years past has seemed to be steadily increasing."[189]

The same year McKenn wrote that assessment, the United States went through its worst economic slowdown up to that point: the Panic of 1893, which was caused by a run on the banks. At that time, American dollars were redeemable, up to a point, for

"Inflexible Disciples"

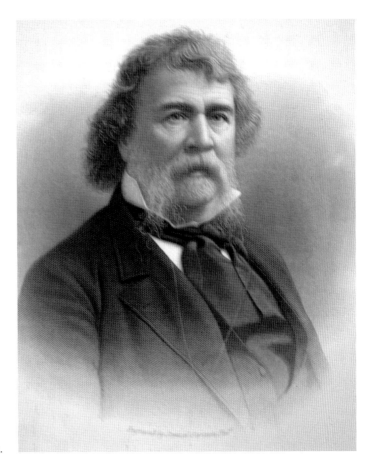

Richard Vaux.

gold dollars. The number of people demanding gold quickly drained the federal gold reserves and the government stopped redeeming notes. This caused a panic, which bled into the stock market, sending it spiraling downward. Banks and railroads collapsed, and the price of silver plummeted, causing inflation that eroded workers' wages. Workers responded by striking, the most famous of which was the Pullman Strike, which crippled the country's system of transportation. Unemployment, which had been somewhere between 3 and 4 percent in 1892, jumped to between 8 and 13 percent the following year, topping out at somewhere between 12 and 18 percent in 1894. Unemployment remained unusually high until the crisis passed in 1896.[190]

Overcrowding forced the administration to add more cells, which created a problem: how would they fit those cells into a prison where the architecture was part of the security system? The administrators modified the prison as best they could. For instance, they reopened cellblocks one, two and three, all of which had been practically abandoned due to the fact that they did not have doorways into the cell from the corridor. These cells had been used as punishment cells—the penitentiary administrators had covered the skylights in order to create completely dark cells. In 1875, inspector Richard Vaux ordered cell doors constructed so that these cells could be conveniently used to house Eastern's overflowing population.[191]

Eastern State Penitentiary

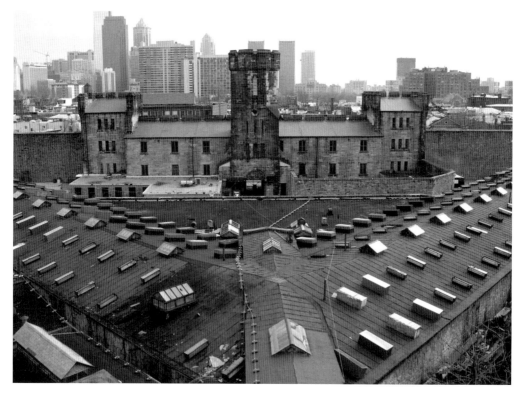

Cellblocks eight and nine, the first added to the penitentiary, built in the 1870s. *Photo courtesy of Dr. Jennifer Murphy.*

In March 1877, the *Philadelphia Inquirer* noted that an appropriations bill to expand the prison had passed both houses of the Pennsylvania legislature, allowing the penitentiary to build two hundred new cells, but that Eastern State's administrators had not yet decided on their location.[192] There was also some relief when the federal government decided, in 1902, to remove all of its prisoners housed at Eastern State, a practice that had started in 1843. The government cited cost because Eastern's administration spent about $0.30 a day boarding each prisoner, or roughly $109.50 annually, a pittance compared to the warden's $4,500.00 annual salary.[193]

The penitentiary also built a second series of new buildings following the turn of the century, for the purposes of "modernization" and dealing with health issues that had arisen, though these did not contain any cells.[194] In 1901, a new hospital and boiler room opened between cellblocks three and four, followed by a storehouse in 1905 (located between cellblocks four and five), an industrial building in either 1906 or 1907, a shop building near the boiler room in 1907 and an emergency hospital between cellblocks two and three the year after that.[195] These buildings testified to that fact that daily life at Eastern was changing; prisoners left their cells to work in the shop building or the storeroom and were treated in groups at the penitentiary's hospital. Moreover, the new buildings' placement in between existing cellblocks distorted the beauty of Haviland's original design, creating, in the words of Negley Teeters and John D. Shearer, "an architectural nightmare, giving one the impression of a hodgepodge."[196]

"Inflexible Disciples"

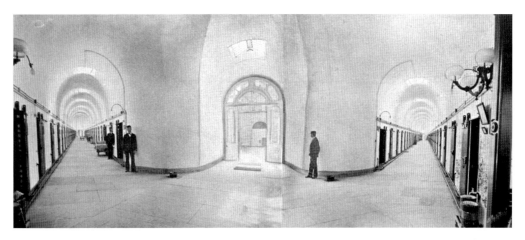

Cellblocks eight and nine, added in the 1870s to alleviate overcrowding. *Michael J. Cassidy,* On Prisons and Convicts, *1897.*

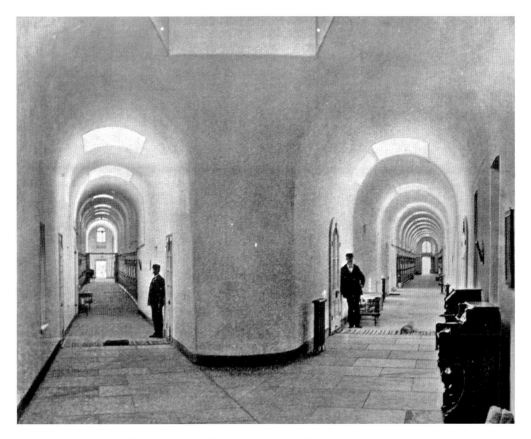

Cellblocks two and ten. Later, a third cellblock, eleven, would be added in a vain attempt to overcome overcrowding. *Michael J. Cassidy,* On Prisons and Convicts, *1897.*

Eastern State's kitchen. *Michael J. Cassidy,* On Prisons and Convicts, *1897.*

Eastern's sister institution, Western State Penitentiary, was also afflicted by overcrowding during this period. Twice, in 1861 and 1864, the legislature passed acts authorizing the penitentiary's expansion. However, by 1867 Western held 486 inmates, but it only had 418 cells.[197] The newly appointed warden, Captain Edward S. Smith, pushed for a series of transitions that effectively dismantled the Pennsylvania System at Western. In 1869, the state legislature passed a law allowing prisoners to congregate while they worked; three years later, Western opened a congregate-style factory and "developed a diversified industrial program [for] the production of shoes, cocoa mats, hosiery, and brooms."[198] In addition, the legislature passed the commutation, or "good time," law, which "provided for the automatic deduction of a certain number of days from each month served as a reward for good conduct. The sentence thus became an indefinite one, with a judge fixing the maximum and the prisoner determining the minimum by his behavior in prison."[199]

However, these advances did little to stem Western's swelling population, so in 1878 the legislature approved the construction of a new facility. Designed by E.M. Butz, the new Western State Penitentiary took fourteen years to complete and was, in the words of historian John C. McWilliams, "the most modern and expensive prison in the world."[200]

"Inflexible Disciples"

This time, the building was modeled on New York's Auburn prison, a clear sign that the congregate system had triumphed, at least in America. The new building was a marvel, with an expected maximum capacity of 750 inmates, though it would eventually house many more than this. Unfortunately, Western's proximity to the Ohio River meant that it occasionally flooded; between 1884 and 1936, the prison was deluged with water four times, one time reaching forty-six feet![201]

Despite the fact that Western abandoned the Pennsylvania System, Eastern State's administrators and inspectors remained stubbornly committed to the system that had once been at the cutting edge of prison reform. However, their good intentions alone could not counter the negative effects of overcrowding and inadequate facilities, one of which was that prisoners were better able to plan escapes that before had necessarily been solitary endeavors. The *Philadelphia Inquirer* noted in 1871 that Eastern State Penitentiary "presents such a secure appearance that it would seem impossible for anyone to attempt an escape," but there are numerous examples from this period of prisoners doing just that. For instance, in 1871, three inmates managed to escape through the sewer system that ironically had been designed to allow the penitentiary to keep prisoners *in* their cells.[202]

According to a newspaper account, John and William Thomas and Thomas Dare, who were all trusted inmates and therefore allowed unusual privileges, pulled up a sluice grate located in one of the cellblocks and lowered themselves down into tunnels that run underneath the penitentiary. They were missed, but, as no one had seen them go over the wall or through the gate, Eastern's administrators were not entirely sure that the men had escaped. At about eight o'clock that evening, the three men climbed up from a sewer grate on Corinthian Avenue (the street bordering the penitentiary to the east) in full view of a large crowd. No one in the crowd stopped them, and the prisoners (still wearing their prison issue uniforms) shuffled away.[203] Being a trusted inmate, or a "trusty," made escape that much easier, although the administration seemed to learn its lesson. Three years after this event, two other inmates tried a similar escape but were stopped by the trap connecting the penitentiary's sewer to the municipal line running under the street.[204]

Whether these men were ever recaptured remains a mystery. There is no mention of a recapture in the *Philadelphia Inquirer*, which normally reported such occurrences, and the year following the escape, inspector Vaux noted that, "since the opening of the Penitentiary, in 1829, there have been nine escapes. Of these, six were retaken."[205] It is possible that the three inmates not retaken were the ones who escaped in 1871. The actual number of inmates who successfully escaped from Eastern State (i.e., were not later returned) is difficult to ascertain. A 1908 article in the *New York Sun* incorrectly asserted that there had been no escape attempts for forty years and that "no one has ever successfully gotten away from the Cherry Hill penitentiary."[206] This assertion conflicted with Vaux's statement that three had managed to get away, although it is possible that these men were recaptured after his book was published. To further complicate matters, in 1897, Warden Cassidy testified, "There have been five successful escapes in the history of the institution"; presumably he did not simply mean inmates who had gotten out and been recaptured as there had been more than five such cases by 1897.[207] The only logical

55

conclusion from this statement is that five inmates had managed to escape and had not, at least up until the spring of 1897, been recaptured. Thus, with all the contradictory evidence, it is very difficult to know for sure how many inmates managed to permanently escape from Eastern State. In any event, the overcrowding of the penitentiary, coupled with the use of inmates to labor around the grounds, proved the ideal environment for elaborate escape attempts.

On August 26, 1908, John Edwards and John Berger climbed over the penitentiary's southern wall using ladders and a rope they fashioned in the prison by splicing together two hundred pieces of smaller rope. Apparently, Berger was a "trusty," which gave him the ability to wear a special blue uniform (rather than the demeaning prison stripes) and greater freedom of movement around the grounds. Being a trusty gave Berger access to the ropes and ladders the men used for their escape. Berger made it down to the ground with no problems, but while Edwards was climbing down, the rope snapped and he fell, breaking his leg. Edwards screamed for Berger to run, and then sat on the ground for a while. He was soon approached by a police officer named McClanahan, who asked what he was doing. Edwards had a hammer and beat on the wall, telling the officer he was repairing a crack in the wall. Eventually, McClanahan got Edwards to admit that

An inmate baking bread under the overseer's watchful eye. *Michael J. Cassidy,* On Prisons and Convicts, *1897.*

"Inflexible Disciples"

Photo courtesy of Dr. Jennifer Murphy.

he had escaped, and the officer dragged the inmate back into the penitentiary. The recaptured inmate was philosophical about the escape, noting that "there are other days coming."[208]

Edwards and Berger were not the only inmates who tried going "over the walls." In 1913, a pair of inmates named Homer Wiggins and Charles Taylor made a similar escape. In late August of that year, the two men filed off the lock on their cell door and replaced it with a dummy one made of wood. They snuck out of their cell and down to the penitentiary carpentry shop, where they were employed as workers. Apparently, they had used their tools to construct a crude collapsible ladder which they hid in the shop until it was complete. They then made their way to the yard, sneaking past five guards and six bulldogs, which roamed the open areas of the penitentiary at night. Wiggins and Taylor climbed to the top of the wall, slid down forty-eight feet of vine growing up the outer side of the penitentiary and snuck off into the night.[209]

More elaborate and numerous escapes were only one of the negative effects of overcrowding; another was violence, which increased markedly during this period. In 1873, a counterfeiter named Gregar smashed his cellmate's head into the wall, resulting in near-fatal injuries.[210] In June 1900, Cornelius Bush killed his cellmate, James Pratt. According to the *Evening World*, an overseer stopped by Bush and Pratt's cell to give the men their breakfast. After opening the wooden door, the overseer asked Bush where his

cellmate was. Bush reportedly responded, "He won't bother you anymore," whereupon the overseer noticed a bundle on the floor. Summoning another overseer, the two guards entered the cell to find that the bundle was, in fact, Pratt's body, minus the dead man's head. The guards found Pratt's head wrapped in a shirt on a table in the cell. Apparently, the two inmates had quarreled over religion, and Bush ended the argument by bludgeoning Pratt with a stool and cutting off his head.[211]

Sometimes, prisoners directed their violence at themselves. On March 27, 1881, inmate Charles Decker hanged himself with a noose made from a linen shirt. Apparently, the prison issue clothing irritated his skin, so he was allowed to have a few shirts from home. During the night, he tied the shirt to a bracket in the ceiling and leaned forward, slowly choking to death. The article noted that his death was slow and painful, and that it was "the climax of a life of self-willed independence and idleness." Eight years later, John Pfeiffer strangled his cellmate, John McBride, and then committed suicide.[212] A year after that, Rheinhard Buch slashed his own throat with a razor, dying almost immediately.[213]

Inmates were not the only victims of violence; overseers were also occasionally targeted. For instance, one overseer was slashed in the throat by an inmate in April 1873, while transferring him from one cell to another.[214] According to the *New York Times*, an inmate escaped from his cell by picking the lock and was apprehended trying to free another prisoner. The article noted that this inmate had attempted to escape before and had attacked a keeper while doing so.[215] That same year, an overseer heard strange noises coming from a cell. He walked to the cell's door, but was met by the inmate, who demanded to know what right the overseer had to enter the cell. The inmate then seized a spiked club (apparently used in whatever form of labor he performed) and swung it at the overseer. Had it hit the guard's head, rather than the wall, it is almost certain the overseer would have died. Fortunately, another overseer, alerted to the altercation, appeared at the cell door and used his revolver to subdue the inmate.[216] In 1881, the *Philadelphia Inquirer* noted the death of a notorious inmate named "Barney," who had threatened the lives of the warden and various overseers.[217]

When prisoners misbehaved, they were no longer placed in the iron gag or a straitjacket. Eastern State had an underground cell where inmates like Harry Macesse were placed when they misbehaved.[218] In 1897, Warden Cassidy denied the existence of such cells, arguing, "We have no mechanical appliances for punishment of any sort…we have no dark cells."[219] According to an 1881 article in the *Philadelphia Inquirer*, prisoners were punished with a bread and water diet. This was the punishment meted out to James Gentry in 1903 after it was discovered that he planned to incite a riot and take over the penitentiary.[220] More often, Eastern State's administrators employed a "carrot and stick" approach; rewards for good behavior and penalties for bad. During an investigation into the penitentiary's disciplinary system, the warden was asked about this approach.

> *Q: Can a prisoner have any instruments for his amusement?*
> *A: He may have any musical instrument from a jew's harp to a piano.*
> *Q: Can he have pets of any sort?*
> *A: That depends upon the individual. The system here is one of individual treatment. He may have it as an allowance, not as a right, just as he may have musical instruments.*

"Inflexible Disciples"

The penitentiary greenhouse, likely built in the first third of the twentieth century. *Photo courtesy of the Urban Archives, Temple University.*

However, if the prisoner abused his privileges, such as by making noise after the nine o'clock "lights out" bell, Eastern's administrators had a way of disciplining him: "To shut them up we forget to give them their breakfast in the morning."[221]

Some of the misbehavior was undoubtedly due to the fact that, as in the earlier period, Eastern State continued to house some of Pennsylvania's mentally ill. According to an 1881 article in the *Philadelphia Inquirer*, there were ten or eleven insane inmates at the penitentiary, not counting those who were mentally handicapped.[222] Eastern State's inspectors noted in 1874 that they had

> *called the attention of the Legislature to the deplorable condition of the insane committed to the custody of that institution, and have suggested legislation which would relieve us from the pressure of a duty which we could not fulfill in providing for them proper care and medical treatment, and which would provide for these defenseless and, for the most part, irresponsible persons, a more rightful and suitable abode than prison.*[223]

Edward Townsend, Eastern's warden at the time, strongly seconded the inspector's opinion and wrote that he felt a hospital separate from the penitentiary, and under different management, should be constructed.[224]

The stress of dealing with insane convicts often proved more than Eastern's guards could handle, resulting in violence against inmates. Insane convicts (or those feigning insanity) were usually chronic rule breakers, and the guards sometimes resorted to clubbing them as punishment. Whether this is what happened to prisoner Archibald

Eastern State Penitentiary

White, or whether he was injured by a fall during a shower, is unclear. What we know for certain is that his injuries were the catalyst for a major investigation of Eastern State's facilities and administration in the spring of 1897. Philadelphia judge James Gay Gordon testified in 1897 that he was visited in November 1896 by a woman, whose nephew, Archibald White, was imprisoned at Eastern State. She told the judge that her nephew was sick and dying and that his nose had been broken by a guard because White was not able to work. She begged the judge to have her nephew moved to an asylum, where he could get the treatment he needed.[225]

Gordon decided to investigate and visited the penitentiary, where he claimed to find an emaciated White, naked and chained to the floor of his cell. Gordon immediately summoned Warden Cassidy, who told the judge that White was not insane; he was "malingering," or acting insane so that he would not have to work. Cassidy also assured the judge that White's sentence was due to expire in February, so he would not be at the penitentiary much longer. Gordon immediately requested that White be moved to a mental hospital. To Gordon's outage, he had to wait five days for Cassidy's response,

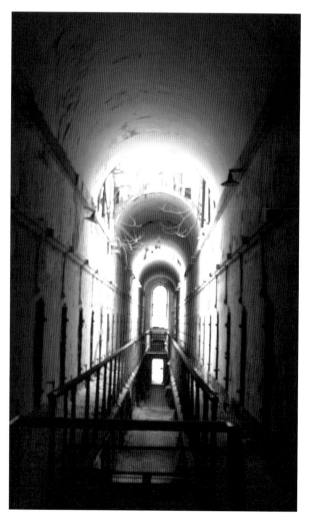

Cellblock seven. *Photo courtesy of Dr. Jennifer Murphy.*

which was negative. According to both the warden and Eastern's resident physician, White was only acting insane.[226] Gordon responded by returning to the penitentiary with a commission of local philanthropists and doctors, who ruled that White was, in fact, insane. Based on their judgment, Gordon had the legal authority to order White removed to an asylum, which he did immediately. However, this was not the end of the controversy because Gordon decided to investigate how many other "malingerers" were housed at Eastern.[227]

In December, the *Philadelphia Inquirer* published (under the provocative title "Prison Walls Echo Maniacs' Shrieks") some of the proceedings of Gordon's grand jury investigation into Eastern State Penitentiary. Gordon argued that Eastern's cells were filthy, the food was inedible and that overseers routinely abused inmates.[228] Gordon's most explosive charge was that an inmate died of injuries sustained at Eastern after being transferred to Norristown State Hospital. The penitentiary's inspectors vigorously denied Gordon's assertions and argued that his grand jury was a kangaroo court designed to reinforce his preconceived notions, not to discover the truth. According to inspector James C. Biddle, "It was an inquisition as bad as anything I ever heard of in the time of King James II, of England. I did not think that such a thing could happen to a body of citizens composed of gentlemen like General Wistar, Mr. Day, Mr. Maloney and Mr. Zeigler. But we were tried there in secret…The way he put his questions was insulting. It was as if we were beneath them, as if we were of the worst class of people imaginable."[229] Biddle also noted that, within two weeks after the prisoners were transferred to Norristown State Hospital, "one of them escaped, another was murdered—and I am told that three of the others (that will make five) are not insane and that the asylum is not a fit place for them."[230]

Gordon later testified that he visited the penitentiary in late March or early April 1897 and requested a list of insane convicts, which Warden Cassidy refused to provide until he had met with the board of inspectors and gotten their permission. Gordon was appalled:

> *I confess I found myself at bay by the interdict of your subordinate. For the first time in the history of this commonwealth a judge visiting a prison within his jurisdiction, in his official capacity, and inquiring as to the mental condition of the prisoners committed from his court, was obliged to walk out of the institution with all information refused him and hear the closing gates shut him off from the self-complacent and triumphant warden and his unseen and undescribed prisoners.*[231]

To add insult to injury, the following week the board sent Judge Gordon a letter that offered to give Gordon the information "as a courtesy," the board being unaware of any legal obligation to do so. Gordon argued that he had the authority under an 1883 law to investigate prisoners' mental conditions as he saw fit, which, by implication, legally required Eastern's administrators to provide him with whatever information he requested. Gordon issued a veiled threat, noting that the physician had testified in December that there were only eight insane prisoners, but the list he got in April had eleven different names, all of whom were inmates at the time. This was a subtle implication that the administrators had perjured themselves. Gordon also resolved to question every employee

of the institution regarding prisoners' mental conditions, a not-so-subtle threat to the board that he would not tolerate any more questionable information.[232]

Eight days later, the board of inspectors responded in an open letter to Governor Daniel H. Hastings, also published in the *Philadelphia Inquirer*, which decried the fact that "our administration of the trust confided to us has been assailed by an ex-parte investigation which we believe is as unjust as it is sensational."[233] The letter asked the governor to request that Pennsylvania's legislature pass "such a resolution [that] in their wisdom will seem best calculated to throw the fullest possible light upon every detail of the management of the trust committed to us and the treatment of every prisoner at any time in our charge."[234] Pennsylvania's legislature appointed a committee to investigate the charges made about the penitentiary's operation.

Officials from Norristown State Hospital admitted that the prisoner whose case had started it all had been received in good condition and that his death was a result of mistreatment by attendants at the hospital, not the penitentiary. The attendant in question was later tried, but was acquitted for the murder. The committee refused Gordon's request that inmates and employees who testified against the warden and the inspectors be given immunity and refused to allow the judge to interrogate his own witnesses. Public opinion was clearly on Gordon's side. An article in the *Philadelphia Inquirer* dated May 1, 1897, argued that "the stories that are told by convicts on the stand are heartrending in the extreme. Such brutality reminds one of the Middle Ages."[235] The disclosure of these events during the 1897 investigation added support to calls for a state hospital to deal with the mentally deranged. In 1905, partially as a result of the outrages disclosed during the investigation, Pennsylvania's legislature passed an act to establish such an institution. It opened in 1912 in Wayne County.[236]

The shift away from incarcerating the mentally ill to treating them in hospitals represented a wider change in penological thought that rendered Eastern State anachronistic. After the Civil War, the penitentiary no longer represented the cutting edge of penology because the Pennsylvania System had been superseded by both the Elmira System and the Irish System. The 1897 investigation reflected the changing nature of penal science in nineteenth-century America. According to Zebulon Brockway, Elmira's superintendent, "The old principle of punishment must give place to the idea of social protection…the criminal must be studied instead of studying the criminal act."[237] In 1870, experts on American prisons met in Cincinnati, Ohio, and adopted a *Declaration of Principles* that outlined the next wave of penal development and reflected this new thinking. According to Barnes, writing in the 1920s:

> *Pennsylvania ha*[d] *long since ceased to be a pioneer, an innovator, and a leader in penological progress and ha*[d] *become content to follow, more or less tardily, progressive departures initiated elsewhere.*[238]

After the Civil War, penological experts began talking of a "crime class," or a genetically distinct group of people (usually Central European or African) who were considered less developed than "normal" Americans. The focus shifted from the criminal act to the criminal himself, and the goal was to find a "cure" for this condition.[239] There is some

"Inflexible Disciples"

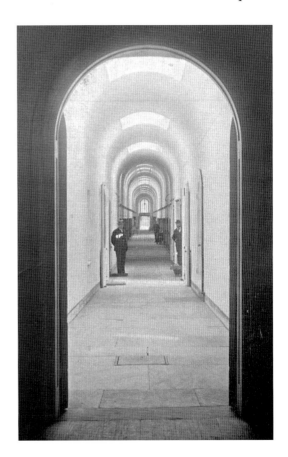

A cellblock as it looked in the 1890s. *Michael J. Cassidy,* On Prisons and Convicts, *1897.*

controversy about how this affected Eastern State, which was an extremely conservative institution wedded (at least in theory) to the Pennsylvania System. Finn Hornum argued that "the management of this institution was indifferent or opposed to the introduction of the reformatory principles that swept the country between 1870 and 1920,"[240] but Teeters notes that "by 1900 practically all state penal institutions had embraced some of the features of the Elmira Reformatory system, a happy compromise which, historically considered, 'saved the faces' of the belligerent advocates of the congregate system and the inflexible disciples of the separate system."[241] Pennsylvania passed a commutation law in 1869 that "offered some encouragement for good behavior while in prison by reducing [a prisoner's] sentence." This was followed by another such law in 1901 and a law in 1909, called the Indeterminate Law, which created a minimum and maximum sentence for crimes, giving parole boards discretion about the actual time an inmate served.[242] These laws clearly reflected the new penological thinking, making Hornum's statement that Eastern State was unaffected suspect. Still, it is undoubtedly true that Eastern's administrators clung to the Pennsylvania System long after other states (and even Pittsburgh's Western State Penitentiary) abandoned it.

One of the impulses behind the new penal science was the growing professionalization of medicine and law enforcement during the Progressive Era (1890–1920). According to historian John C. McWilliams, "Progressives relied on behavioral science, maintaining that

the root causes of deviant behavior were socially and psychologically rooted. Progressives advocated using social workers, psychologists, psychiatrists, and other specialists to conduct surveys, write reports, and compile statistics for scientific decision making."[243] It should come as no surprise that Warden Cassidy, who disdained academic education, argued that the penitentiary was an acceptable site for the treatment of the mentally ill, or that he would view mentally disturbed patients as "malingerers" who simply needed to be coerced into working. As Teeters noted, "The investigation brought out the difference in the approach toward the disposition of the criminally insane," with progressives like Gordon calling for hospitalization and treatment and people like Cassidy arguing for incarceration and coercion.[244]

This is not to argue that Eastern State's administration totally rejected professionalism; on the contrary, the administration was very eager to develop a professionally trained workforce. To that end, in 1879, Warden Edward Townsend instituted an evening "school" to train guards. The warden himself, supplemented by guards who had been with the penitentiary a while, worked with new hires to ensure that they understood and implemented Eastern's unique disciplinary system. This tended to reinforce Eastern's conservatism because, as Harry Elmer Barnes noted, "before there was any opportunity presented for a promising young officer to introduce any original ideas or innovations he was initiated into the methodology of the old separate system and soon became an advocate of its retention."[245] Apparently undertaken at the suggestion of inspector Richard Vaux, the school met five nights a week after work, during which time the warden "instructed them in the true philosophy of prison-keeping and the requirements of their position."[246] This was also true of Eastern State's administrators; according to Teeters, Edward Townsend, who served as warden between 1870 and 1881, "may be regarded as the last non-professional warden," who bridged "two epochs, characterized by moral and humanitarian Quakers on the one hand and 'career' administrative officials on the other."[247]

Townsend was a Quaker, born in Philadelphia in 1807. Like most middle- and upper-class Friends, Townsend was philanthropically inclined, opening a free school for blacks in the 1820s, serving as a manager for the Pennsylvania Institute for the Instruction of the Blind and joining the Society for Alleviating the Miseries of Public Prisons in 1846. He would eventually serve as the society's secretary, vice-president and president. All of this was in addition to Townsend's day job—dentistry—which he quit in 1870 to become Eastern State's warden. Though he evinced a decades-long interest in the penitentiary, he had, like the men who had preceded him, no formal training for the position. His departure in 1881 marked the end of the era when wardens were chosen from among the "gentlemen dabblers" who formed the society's membership. After Townsend, a new epoch dawned in which professional qualification was more important than a philanthropic interest in penal reform.

No one better represents the new epoch than Townsend's successor, warden Michael Cassidy. Cassidy was born in Philadelphia in 1829, the same year Eastern State opened. His parents had emigrated from Ireland, and the family lived in what was then a heavily Irish Catholic neighborhood in the Fourth Ward, before moving to the Fifth and Second Wards. A man of little formal education, Cassidy was hired by the penitentiary's administrators as a carpenter in 1861 at age thirty-two. The following year, he became an overseer in the third block. This was entirely consistent

"Inflexible Disciples"

Warden Michael J. Cassidy, Eastern State's last true believer in the Pennsylvania System. *Michael J. Cassidy, On Prisons and Convicts, 1897.*

with Eastern's practice of hiring guards for their work skills. These guards were then expected to teach, as well as guard, the inmates. Cassidy described his career at the penitentiary in 1897: "From carpenter to warden, doing all that was to be done in different directions."[248]

Cassidy served as the cellblock three overseer until 1870, when he became the penitentiary's deputy warden. President of the Inspectors Andrew Maloney described Cassidy as a great reader, though an uneducated man. According to Maloney, Cassidy was "a man of very great mental power and strength of character. His personality would impress anybody, in my judgment."[249] Another inspector, Conrad B. Day, described Cassidy as "too lenient" for not punishing small infractions of the rules.[250] James Biddle, a third inspector, noted that Cassidy only allowed the overseers to use force when it was absolutely necessary and that, even when a prisoner killed an overseer, the inmate was not abused.[251] Perhaps the best description of Cassidy's temperament came from Isaac Wistar, one of Eastern's inspectors. According to Wistar:

> *I think he is the most extraordinary man whom I ever knew...When I came here I was prejudiced against the Warden. I had heard that he was unsympathetic and harsh; that he had rude manners to people (which latter report had some truth in it), and I made it my*

business to get the measure and the character of the man. I was not long in finding out that I had never made a greater mistake in my life. He is a man who gives away a very large part of his salary, though he does not know that I found out the fact. For instance, a prisoner who wants to send five dollars to his mother gets it and the Warden says nothing about it. I saw him slipping a quarter to a man surreptitiously for postage; and he did not think I saw him do it. He cares nothing about money personally. I believe he gives a good portion to the men. When they are going away from the jail, after having been secluded from the world, they are depressed and apprehensive of what they are to encounter. The Warden talks to a man, under those circumstances, in a gentle and encouraging way and generally ends by adding a little of his own money to the state's donation.

Following Cassidy's death in 1900, the *New York Daily Tribune* interviewed a number of current and former inmates at Eastern State who knew Cassidy personally. The article, titled "Warden Cassidy: Former Convicts Have a Pleasant Word to Say About Him," demonstrates that even some of the prisoners were fond of the warden.[252]

Some assumed that Cassidy's death might also be the end of the Pennsylvania System, but Cassidy's successor was chosen from among the penitentiary's own: Eastern State's chief clerk, Daniel W. Bussinger.[253] Born in 1843 and educated at Philadelphia's Girard College, Bussinger fought in the Civil War, serving for almost the entire duration of the war. During the war, Bussinger was captured by the Confederates and spent time as a prisoner of war at both Libby Prison in Virginia and Georgia's infamous Andersonville prison.[254] He was appointed the penitentiary's chief clerk in 1877, a position he held until his promotion in May 1900.[255] Bussinger was much more optimistic about reformation than Cassidy, who by the end of his tenure assumed that most freed inmates would return to the penitentiary. According to Bussinger, "I believe in treating the convicts here like men. I believe in treating them as though we had forgotten their crimes…let us treat them here as though we were confident that they intended to live good lives hereafter."[256] Bussinger's tenure as warden was cut short due to shocking revelations that prisoners were colluding with guards to counterfeit coins *inside the penitentiary*!

The story about counterfeiting in the penitentiary broke during an investigation into fraudulent bookkeeping in the penitentiary's cigar-making department. Apparently, sixty thousand inmate-produced cigars disappeared, while the ones that remained were not stamped "convict made," as the law required, and were missing the internal revenue stamps, which meant that no taxes had been paid on them. While it was later discovered that these cigars were stolen by revenue officers of the state government, the charges were scandalous enough that Warden Bussinger and the overseer of the cigar department were temporarily suspended, pending the outcome of the investigation. On September 14, 1903, a number of local and national newspapers reported that, while investigating the cigar department, investigators became aware that prisoners had been coining dimes, quarters and half dollars. A former penitentiary employee noted that inmates had access to all the materials they needed within the penitentiary's walls in the course of their normal work. The inmates apparently used solder from the tin shop, which they mixed with tin from the refrigerator shop to make it solid and glass to make it "ring" when dropped. Then, using the same plaster of Paris used to plug holes in cell walls, the inmates created molds

"Inflexible Disciples"

Warden Daniel J. Bussinger. *Michael J. Cassidy*, On Prisons and Convicts, *1897.*

into which they poured their solder-tin-glass concoction, creating remarkably accurate reproductions.[257] According to the *Philadelphia Inquirer*, "Government detectives regarded the workmanship as marvelous, so perfect did they appear in every way."[258]

Some of these coins even got out into the city, which alerted the Secret Service and ultimately led to the clandestine mint's discovery. Warden Bussinger knew about the counterfeiting operation for almost two months, but he kept it quiet so that government officials could investigate the matter.[259] Eventually, eleven inmates were implicated in the counterfeiting ring. Even more shocking was the revelation that a guard named Alvin Struse aided the prisoners in assembling the materials and passing the coins, for which he was eventually arrested and convicted. The scale of this operation, coming amid a series of revelations about lax oversight at the penitentiary, including the "loss" of 300,000 pairs of stockings from Eastern's stocking factory and the discovery of a whiskey still in a cellblock, created an impression that the inmates were running the asylum—an impression cemented by revelations of a planned riot in October that year.

According to the *San Francisco Call*, the attempted riot was masterminded by an inmate named James Gentry, an actor sentenced to Eastern State for the murder of an actress named Madge Yorke. Apparently, Gentry encouraged 348 of the penitentiary's nearly 1,100 inmates to get "outside" employment, or jobs around the penitentiary outside their cells. With this accomplished, the plan was to overpower the thirty-six guards and take control of the penitentiary. Somehow, the administration became aware of the plot and immediately returned all the prisoners to their cells, which were then thoroughly searched. The recovered items included files, saws, hatchets, wire, chisels, hooks, various types of knives, iron bars, sandbags, metal knuckles, whiskey, money and counterfeit

coins. In addition, the administration discovered that many of the locks on cell doors had been disabled and that the telephone system had been rigged so that it could be disabled "with a twist of the wrist."[260] These revelations, coming weeks after the counterfeiting and cigar shop scandals, convinced the board of inspectors that Bussinger had lost control of the penitentiary, and he was removed later that month.

That was not the end of the matter because, on October 30 of that year, a Philadelphia grand jury impaneled to investigate the numerous scandals at the penitentiary issued a scathing report that laid all of the blame at Bussinger's feet. According to the report, the jury heard testimony that the "irregularities" that plagued the penitentiary's various industrial departments were long-standing, some having gone on for years. The jury charged that the penitentiary's administration listed prisoners as idle who were in fact working, "earning part of or in excess of their keep." Perhaps most damning was the jury's conclusion that Eastern State "was a veritable breeding place for consumption," which had caused 60 percent of all inmate deaths during the preceding thirty years. In particular, the report highlighted the penitentiary's plumbing system, which the jury argued should be condemned and replaced with a modern system.[261]

In addition to aging infrastructure, another problem that emerged after the Civil War was aging inmates. Theoretically, this should have been an oxymoron because the Pennsylvania System was designed to ensure that convicts did not commit crimes once they were released. Like so much of Eastern State's program, theory and reality diverged. In 1878, the penitentiary transferred an inmate described by the *Philadelphia Inquirer* as "one of the first prisoners confined in the Eastern Penitentiary."[262] Bob Ridley was apparently transferred from Walnut Street and had been in and out of various penal institutions for more than four decades.

In July 1907, "the most dangerous counterfeiter in the country," eighty-one-year-old Sam Tate, was sentenced to eight years at Eastern State. Two years later, eighty-one-year-old Jeremiah J. McLane was arrested in Newark, New Jersey, in connection with a "swindling game." He had been out of Eastern State less than a month when arrested. Perhaps the most absurd case came in 1922, when ninety-three-year-old James Bundy was returned to his cell after being sentenced to five years for stealing chickens. Bundy had been in and out of the penitentiary for fifty-three years and was hailed upon his return as the "dean of convicts."[263]

These men represented the type of career criminals that Eastern State was designed to deter or reform, and their advanced age not only challenged the penitentiary's philosophy, but also presented it with a series of pressing problems. The issue of old and infirm inmates became so pressing that, in 1889, the penitentiary introduced a new industry, described as "the hand weaving of woolen jackets and hoods, etc." so that "old and infirm inmates are enabled to earn enough to defray the expense of their support." According to the *Philadelphia Inquirer*, this solved the problem "that numbers of the inmates could earn either nothing at all or next to nothing, because there were no suitable employments for them."[264]

However, life at Eastern State was not all violence and death; there were numerous happy events that brightened inmates' lives. Eastern State was the sight of at least one wedding, which took place in 1909. According to the *Washington Times*, on April 22, 1909,

"Inflexible Disciples"

Photo courtesy of Dr. Jennifer Murphy.

Katherine Moran (described as a "comely young woman") wed George Clayton, who was then serving a six-year sentence for burglary. The ceremony was performed in the warden's office and the groom was then immediately returned to his cell to serve the remainder of his sentence.[265] In March 1901, Lizzie Stanley declared her intention to marry Walter C. Thompson, who was awaiting trial for forgery and burglary. Apparently, Thompson, who had previously served three years at the penitentiary, forged the warden's signature on a check and then convinced one of the penitentiary's overseers to cash it, swindling the guard out of twenty-five dollars. Whether Thompson and Stanley were ever wed is unknown, though she did declare her intention "to marry him no matter what is done with him" and promptly made her way to the licenses office to seek a marriage license.[266]

Numerous religious and secular groups visited the penitentiary, including the American Society for Visiting Catholic Prisoners, which paid 515 visits to Eastern State in 1902 alone.[267] By the twentieth century, family members were welcome to visit the penitentiary once every three months, though the administration made it clear that "a family pass is given with the expectation that the members of the family will visit said institution together."[268] One group of people that was *not* welcome at Eastern State was Philadelphia's lawyers, who were banned by the inspectors in July 1881. Apparently, lawyers would convince inmates that they were eligible for pardons and offer to file the paperwork for a fee of between $100 and $200 (a huge amount in an era when workers often made between five and twenty cents an hour). Inmates, sure they were going to be pardoned and released any day, became extremely difficult to manage; many refused to work and verbally abused guards.[269]

Eastern State Penitentiary

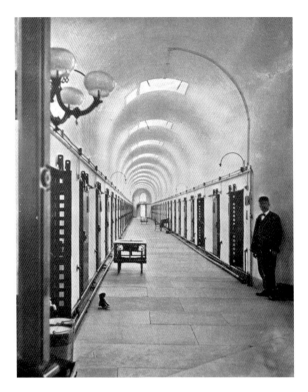

A cellblock as it looked in the 1890s. *Michael J. Cassidy,* On Prisons and Convicts, *1897.*

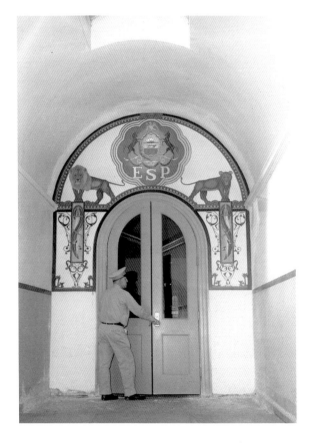

A doorway to Center as it looked in the 1960s. *Photo Courtesy of the Urban Archives, Temple University.*

"Inflexible Disciples"

There was also some concern that inmates preferred Eastern State because conditions were better than the county jail at Moyamensing. According to the *Philadelphia Inquirer*, "experienced convicts, who know they will be better off, prefer being sent thither to being sent to Moyamensing [because] they know the fare is better."[270] While this may have been the case in the 1880s, twenty years later, Eastern State sounded downright horrible. According to a grand jury investigation in December 1903:

> *The cells in several of the corridors are damp and dark, and in them are looms being worked by the convicts. This in the course of time affects they eyesight and the health of the occupants. It is due to these conditions of cells that consumption in this institution is increasing. And as respects the treatment at the hands of the resident physician, from the information received from the male and female convicts, it is not such as can be commended. The bake house was found in a dirty condition. The bread was sampled by the grand jury and was sour. The cook house was in a dirty condition. We regret that our time for inspection of this institution was limited, as more time for such a purpose would afford a better opportunity for a more thorough inspection.*[271]

Perhaps this is why penal reformer Florence Maybrick, who had spent fourteen years incarcerated in England for her husband's murder and consequently dedicated her life to the reform of prisons around the world, called Eastern State the worst prison in all of America.[272]

When not plotting escapes or committing random acts of violence, inmates at Eastern State spent their time very much like free people. Responding to a question about his leisure time, inmate Charles Yerkes responded in 1872 that he spent his time "doing anything to keep my mind off my troubles…I have half an hour of exercise every morning in the small yard adjoining my apartment…the afternoon I generally devote to reading or any other occupation by which I can pass the hours away."[273]

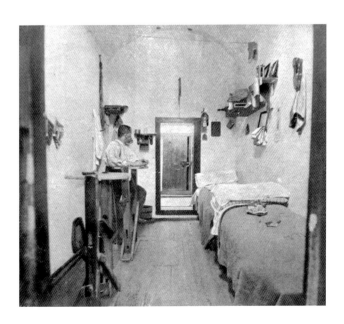

A cell showing prisoner's decorations. Inmates were allowed, and even encouraged, to decorate their cells. *Michael J. Cassidy,* On Prisons and Convicts, *1897.*

Eastern State Penitentiary

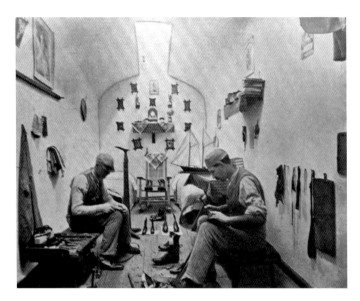

Two inmates working in their cell, demonstrating that the Pennsylvania System was a fiction by the 1890s. *Michael J. Cassidy,* On Prisons and Convicts, *1897.*

In addition, Eastern State's inmates continued to labor, and some became well-known for their products. For instance, the penitentiary's cabinetmakers lived and worked in cellblock three. One, a twenty-two-year-old, made such beautiful boxes that the *New York Tribune* waxed, "In each there must be two or three hundred pieces of inlaid wood of white holly, ebony, mahogany, walnut and birch, and each is polished until there are reflections in its surface such as water has. Yet each was made with a dull knife, an old saw, and a pot of glue."[274] Some of the inmates painted, and the article described one cell decorated with an amazing mural of the sea, while in another hung paintings of dancers and landscapes, their frames made of gilded newspaper pulp. Other inmates carved wood, and the article described cells filled with miniature ships or trains that inmates created in their spare time.[275]

The growing power of organized labor eroded Eastern's ability to employ its swollen inmate population. The number of idle prisoners jumped from 291 in 1890 to 795 in 1893, peaking at 1,156 the following year.[276] As visitors in the early nineteenth century noted, solitary confinement without labor was akin to torture for inmates, and Eastern State had been specifically designed to provide that labor. Idle inmates were more likely to plot escapes and, as conditions became more crowded and therefore less pleasant, violence between inmates increased. From the day the penitentiary opened, labor unions attacked the Pennsylvania System for producing goods at artificially low prices and creating the impression that manual labor was punishment, implicitly promoting the idea that manual laborers were somehow analogous to criminals. After the Civil War, labor unions became more powerful and were able to convince legislatures across the country to abolish inmate labor. According to historian Dorothy Gondos Beards, "[Philadelphphia's] mainly skilled and semi-skilled workingmen remained dedicated to the preservation of the privileges of their trades and as many as possible of the remnants of independent artisanship. The skilled trade unions of Philadelphia took advantage of wartime and immediate postwar prosperity to rebuild and strengthen their local organizations and to stimulate a movement for national organization of their trades."[277] The labor market in Philadelphia, which was

"Inflexible Disciples"

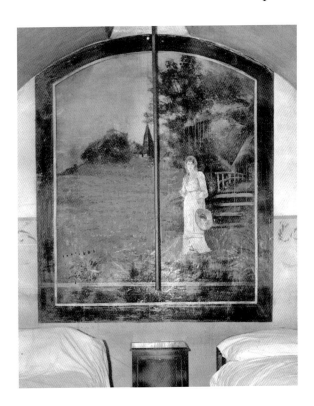

Inmate artwork. *Photo courtesy of the Urban Archives, Temple University.*

largely skilled and focused on small workshops, felt particularly threatened by inmate labor, which it correctly viewed as a threat.

The first blow to the Separate System came in June 1883, when Pennsylvania's legislature abolished contract convict labor throughout the state. While this did not directly affect Eastern State (which operated on a slightly different system), it demonstrates Pennsylvania's growing hostility to inmate labor. This hostility is further evidenced by a second act, passed in June 1883, requiring all goods produced in state penitentiaries to be stamped "convict made." The worst blow to Eastern's industrial system was the Muehlbronner Act, passed in 1897, which prohibited state prisons from using power machinery in manufacturing and capped the number of inmates who could manufacture brooms, brushes and hollowware at 5 percent of the penitentiaries' populations. Furthermore, the Muehlbronner Act decreed that only 10 percent of the population could manufacture anything else (except for mats, where the cap was 20 percent).[278] As the last chapter made clear, labor was viewed by the Society for Alleviating the Miseries of Public Prisons (which changed its name in 1887 to the Pennsylvania Prison Society) as a crucial component of reformation, so it reacted sharply, calling the act "monstrous" and "a disgrace to the intelligence of the nineteenth century."[279]

Teeters argued that the Pennsylvania System did not so much die as fade away, noting that when the legislature officially abolished separate confinement at Eastern State in 1913, the penitentiary's annual report did not mention it. He concluded that this was because the law finally matched reality at the penitentiary.[280] He is right, to a point, but Teeters fails to appreciate that, following Warden Cassidy's death in 1900, discipline and

Eastern State Penitentiary

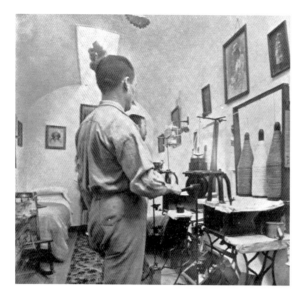

Michael J. Cassidy, On Prisons and Convicts, *1897.*

Michael J. Cassidy, On Prisons and Convicts, *1897.*

living conditions at Eastern State deteriorated. While 1913 is a convenient stopping point because of the official abolition of the Pennsylvania System, in reality the outlines of Eastern's life as a congregate penitentiary—lawlessness, overcrowding, escapes and gang activity—were already clearly visible by the turn of the twentieth century. What was new was the degree to which Eastern State's reputation was affected by these developments, which became widely known outside the institution.

CHAPTER 4

FROM CHAOS TO CLASSIFICATION

1913–1953

The Pennsylvania System's slow death eroded administrative control over the institution until, by the 1920s, the inmates were quite literally running the asylum. During the forty years covered by this chapter, Eastern State abandoned all of the characteristics that had made the penitentiary unique a century before: separation, surveillance and rehabilitation. By the twentieth century, Eastern State's wardens were declaring rehabilitation a joke; there were numerous cellblocks that could not be observed from Center and separation was used to punish inmates, not reform them. Thus, Eastern State had mutated from a penitentiary—an institution designed to inspire regret and rehabilitation—to a mere holding pen for some of Pennsylvania's worst offenders. As a custodial institution, Eastern State was not very good; the institution was rocked by a series of riots, escapes and even a plot to blow the penitentiary up.

Robert J. McKenty is one of Eastern State's most controversial wardens, presiding as he did over a period of massive transformation at the penitentiary. McKenty was named warden of Eastern State in 1909. Before that time, he was the superintendent of a house of correction, as well as director of the Department of Public Safety and a police officer.[281] McKenty's daughter remembered her father as "very understanding, very patient. And any [inmate] that has been there, if you ask them they'd tell you the same thing."[282] McKenty believed that inmates could be rehabilitated and prided himself on his professional administration of the penitentiary. He noted, "I have dealt with some criminals in my time and I have sent some to the gallows, but even those who went to the gallows went there without an ill feeling in their hearts for me. I have always done my duty, but I have never found it necessary to do it viciously."[283]

Norman Johnston called McKenty's administration "idealistic," noting that the warden embraced new innovations, like inmate self-government. Called the "Honor and Friendship Club," it was designed to help inmates and newly discharged prisoners, as well as arrange for entertainment and give prisoners a voice in the penitentiary's administration. This was not as unusual as it sounds. Sing Sing's progressive warden, Thomas Mott Osborne (1914–17), relied on a similar organization, the Golden Rule Brotherhood, for advice in shaping administrative policy at Eastern's onetime rival.[284] The spirit of McKenty's rule was probably best summarized by inmate B8266's

poem "McKentyville," the last lines of which are "To strive, with tireless hands and an iron will/To Fashion a future good from a by-gone ill—/Is not this the spirit of 'McKentyville?'"[285]

However, not all inmates agreed with this rosy assessment, and McKenty's tenure was wracked by protests and riots against conditions at Eastern State. For instance, in 1919, there was a "virtual riot" in Eastern's courtyard during a visit by the grand jury to the penitentiary, which was an attempt to get better food and medical attention. According to the inmates, the warden had been notified beforehand that the jury would visit and had therefore prepared "an extra fine meal," but in general the food was poor and insufficient. According to a reporter accompanying the grand jury, one inmate even shoved a two-and-a-half-inch matchstick up his nose to demonstrate the lack of medical attention. When the reporter called him "empty-headed," the inmate replied, "It's the lack of medical treatment that makes me so." All the while, McKenty smiled as inmates poured forth their complaints to the jury men, and then denied the inmates' charges as the grand jury left the penitentiary. For its part, the grand jury omitted any reference to the inmates' complaints in its report to Judge Joseph P. McCullen.[286]

McKenty got his revenge two hours after the grand jury's visit, when he deposed every officer and member of the Honor and Friendship Club.[287] The inmates retaliated by demanding that the warden do something about the random acts of brutality committed by the guards against the inmates and about the generally poor quality of the food at Eastern or they would send a petition to the governor demanding another investigation. McKenty seems to have acquiesced to these conditions rather than risk another investigation, although it does not appear that conditions improved significantly.[288]

McKenty also ran afoul of one of Eastern State's inspectors, William A. Dunlap, and the penitentiary's moral instructor, Joseph Welch. Apparently, the inmates complained to both and found sympathetic ears. Dunlap attacked the grand jury's report as a "whitewash," saying that conditions at the penitentiary were worse than the jury acknowledged, and demanded that everyone on the penitentiary staff, from the warden down, be removed. According to Dunlap, twelve hundred of the penitentiary's nearly sixteen hundred prisoners were willing to testify against the warden, though the other four inspectors disagreed with Dunlap and said so publicly. In addition, McKenty asserted that Dunlap made a speech to the inmates, during which he said, "I am not a speechmaker. I am an undertaker. I bury stiffs, and there are a couple of stiffs around here that I would like to bury."[289]

Unfortunately for Dunlap, it was *he* who was investigated when Pennsylvania's governor, William C. Sproul, dispatched the assistant state attorney general, Robert S. Gawthrop, to investigate the matter. The Board of Public Charities, which now oversaw the penitentiary, dismissed the two men and discontinued the Honor and Friendship Club. In addition, while the board's investigation found the inmates' charges to be unfounded, it did recommend that the warden establish "firmer control" over the institution.[290]

While McKenty was eventually exonerated, the reality is that conditions at Eastern State *had* deteriorated, and the administration could not truly claim to be in control of the institution. One manifestation of the administration's loss of control was the rising amount of narcotics entering the penitentiary, which became a huge scandal in the

From Chaos to Classification

1920s. Though illicit substances were surely smuggled into Eastern State during the nineteenth century, the Pennsylvania System's breakdown, coupled with the nooks and crannies created by the addition of cellblocks and other buildings, created a landscape with plenty of opportunities for inmates to indulge their addictions. Drug use at Eastern State became front-page news when Dr. E.E. Dudding, president of the Prisoners' Relief Society of Washington, charged in 1922 that Eastern State was rife with drugs, which guards were supplying to inmates.[291] The following year, Dudding outrageously asserted that 50 percent of the penitentiary's nearly seventeen hundred inmates were either drug addicts or sellers. This was such a preposterous charge that a state official noted, "This and most of his other complaints must be taken with quite a grain of salt."[292] Warden McKenty was less diplomatic, calling Dudding a "confounded liar."

Unfortunately, Dudding's charges turned out to be partially true, though his assertion that one in two inmates was addicted to drugs was certainly an overstatement. During the spring of 1923, partially in response to Dudding's charges, a grand jury was impaneled to investigate the penitentiary. The investigation revealed numerous breakdowns in security and confirmed that drugs were widely available at Eastern State. According to newspaper reports, the grand jury discovered a still in one of the cells, and a member of the grand jury even bought some heroin from an inmate in that inmate's cell. Eventually, six former guards and seven inmates were indicted on charges of smuggling and dealing drugs, though McKenty steadfastly claimed that both the still and the drugs were planted by his political opponents "to discredit his record as warden."

Photo courtesy of Dr. Jennifer Murphy.

Eastern State Penitentiary

Photo courtesy of Dr. Jennifer Murphy.

These revelations brought to light a penitentiary-wide drug-smuggling ring led by a gang of inmates known as "the Four Horsemen." The Four Horsemen functioned "as the self-appointed administrators of the big prison," according to one newspaper account. Historian Richard Fulmer described them as a "bastardized inmate self-government committee" that "abused the system that was created."[293] They even printed passes, labeled "peacemaker," which allowed inmates bearing the cards unfettered access to any of the cellblocks at any time (even guards were obliged to respect the peacemaker card). Running afoul of the Horsemen could be dangerous because, as one newspaper article noted, the gang was a "strong-arm squad," or the "men who beat up prison guards and prisoners who refused to box to the rules of the committee."[294]

The situation came to a head that spring, when rioting broke out at Eastern State that lasted, off and on, *for five weeks*. Historian Harry G. Toland attributed the violence to "poor food, corrupt and low paid guards, lack of sufficient work, overcrowding and dirt."[295] According to John C. Groome, who succeeded McKenty as warden, "Prisoners conducted guerilla warfare not only against the unarmed guards, but against one another." Basically, a small portion of the population had broken into rival gangs: the Four Horsemen, who had some sort of official status, and their rivals, the Prisoners Mutual Welfare Association. Groome claimed that these two groups accounted for roughly 20 percent of the penitentiary's population; the other 80 percent "frantically petitioned the

board of inspectors for permission to be locked in their cells day and night" in order to escape the violence.[296] The riots were eventually quelled, but a search following the riots yielded more than four hundred knives (a ratio of one knife for every four prisoners), several hundred "other types of weapons" and "large quantities of narcotics."[297] Because of these problems, McKenty was forced to tender his resignation on April 22, 1923, to become effective three weeks later.

The same day that McKenty tendered his resignation, the *New York Times* printed an exposé on the Horsemen, titled "Prison was Run by Convict Clique." The article created the impression, fostered by the Pennsylvania Prison Society, that the Horsemen were a relatively short-lived organization formed merely to protest conditions within the penitentiary. McKenty denied giving the Horsemen any authority, though the article noted that the truth of that claim "has not been made clear."[298] J. Washington Logue, spokesman for the Prison Society, blamed the Horsemen completely for the violence that broke out, arguing that the four "desperate" inmates controlled 90 percent of the population and that, because the gang gave penitentiary employees the impression that it had the backing of the board of trustees, "the result was that the guards and overseers became demoralized because their authority was being overridden."[299] The result was that thirty-three inmates, including the Four Horsemen, were transferred to Western State Penitentiary in the hope that, with the troublemakers gone, the penitentiary's administration could restore order.

In June 1923, the *Philadelphia Bulletin* published portions of a letter allegedly written by one of the Horsemen, and its allegations were explosive: favoritism, guards neglecting their duties and rampant drug use. According to the letter, printed under the headline "Says 800 Addicts Are in Eastern Pen," more than one-third of the penitentiary's inmates were addicted to drugs, supplied by twenty dealers, who in turn employed thirty-five inmate runners. The letter even asserted that one dealer made as much as $1,500 *per month* selling drugs inside the penitentiary. All of this was possible because, according to the letter, there were only two guards on each cellblock during the day and only one during the weekends. In addition, the letter's author asserted, it was "a common occurrence to see them sound asleep every afternoon."[300]

However, even the breakup of the Four Horsemen did not staunch the problem of drugs at Eastern State. By 1924, there were enough addicts that they were segregated and held in the gallery of cellblock five, which became known as "Dopers' Row."[301] Warden Groome even tried putting guards undercover in the cells to discover how the drugs were getting into the penitentiary, but with only minor success. This undercover operation did discover that Eastern State's chef, Henry M. Rudolph, was supplementing his income by selling inmates drugs at a 200 to 300 percent markup.[302]

The inmates quickly adapted to the new conditions and found ways to keep the flow of drugs. For instance, in December 1923, it was discovered that inmates used radios to coordinate their smuggling operation. Apparently, a visitor to the penitentiary overheard the radio broadcast, indicating that a rubber ball filled with drugs would be thrown over the penitentiary wall the following morning. This visitor alerted the president of the penitentiary's board of trustees, Alfred W. Fleisher, who alerted the guards to be on the lookout for rubber balls. At the 10:00 a.m. the next day, a rubber ball flew over the wall

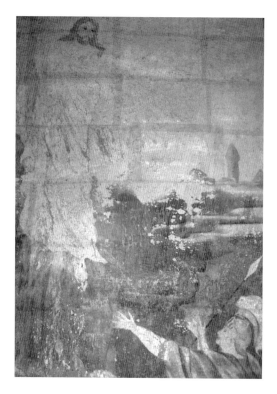

Inmate-painted religious artwork in the Catholic chaplain's office. *Photo courtesy of the Urban Archives, Temple University.*

and landed a few feet from an inmate work group. Inside, guards discovered six "decks" of heroin, a reasonably large shipment. All of the inmates' radios were immediately seized, and while some were sent to family members or friends, most were destroyed. Even this failed to stop the flow of drugs, in part because inmates were able to build miniature radios out of materials available throughout the penitentiary. One inmate was even discovered with a crystal radio hidden in the pages of his Bible.[303]

But again, this failed to keep drugs outside the walls. In August 1927, Eastern State's administrators discovered a $5,000 "slush fund" assembled by the inmates to buy drugs. The most disturbing element was that one of the penitentiary's guards, Sergeant Pike A. Harper, was supposed to smuggle the inmates' drugs into Eastern State.[304] Apparently, the thirty-three-year-old guard, who had served in the army for eight years and was recognized for bravery, bought the drugs for fifty dollars an ounce and then sold them to a number of inmates, who in turn acted as distributors. Once this was discovered, the resulting search turned up "a large amount" of both morphine and cocaine, demonstrating that, for all their best efforts, Eastern State's administrators found it almost impossible to keep drugs outside the penitentiary.

Following McKenty's resignation, Groome tried to reassert control over the penitentiary. Groome had an extensive career in public service and law enforcement. After founding and organizing Pennsylvania's State Troopers in 1905 and serving as the first commander, Groome joined the United States Army and served as acting provost marshal general in charge of the military police during World War I. After the war ended, Groome, aged sixty-one, was twice offered the position of warden at Eastern State, and he twice refused.

Once the riots broke out in 1923, however, he was again offered the position, and this time he accepted. Unlike McKenty, who believed that inmates could be rehabilitated and ought, therefore, to be treated like citizens, Groome argued that self-government was silly and that inmates should be treated harshly. He wrote in 1930,"I regard [the convict] as an undisciplined human being who needs to be taught that deliberately violating the rights of other people is likely to prove an uncomfortable career…I admit further a belief in the whipping post for those convicted of their second felony, fewer of whom would be convicted of their third."[305] This was a direct repudiation of Eastern State's philosophy, which had (at least in theory) emphasized rehabilitation and penitence over retribution and punishment. Groome's tenure as warden thus marked a new epoch in the penitentiary's history.

The new warden launched an investigation into reports that inmates were bribing guards, discovering that at least one, Hugh Drum, smuggled letters into the penitentiary for at least one inmate.[306] Groome also fired fourteen guards, some for their age and others for neglect of their duties following an escape, and he transferred twenty-six others to Western State Penitentiary. This was apparently an attempt to cleanse the administration of McKenty supporters. The *Philadelphia Bulletin* noted that the fourteen guards who were fired "belonged to the regime of former Warden Robert J. McKenty," while the twenty-six transfers were allegedly sent to Western State following "recent transfers from the penitentiary to outside jails," an odd reason given Eastern State's chronic overcrowding.[307] In addition, Groome armed the penitentiary guards, a practice his predecessor had discontinued, and slammed the previous administration for allowing the inmates to "carry on self-government."[308] Thus, in just a few short months, Colonel Groome made it clear that he intended to run a very different penitentiary than McKenty had.

Groome did this by tightening regulations and cracking down on prisoners, which naturally created a great deal of resentment against him. Whereas the penitentiary had a reputation for laxity during McKenty's regime—one newspaper article at the time was headlined "Jail Life Too Easy Grand Jury Finds"—Groome's efforts to change that were extremely unpopular with inmates and therefore quite controversial. According to Johnston, Groome ordered the construction of enclosed guard boxes on each of the penitentiary's corner turrets, where the guards would be armed with Krag repeating rifles and Thompson submachine guns (the so-called "Tommy Gun" of gangster lore). In addition, Groome moved the warden's offices from the corridor between cellblocks eight and nine (where it had been for decades) back into the gatehouse at the front of the penitentiary. Finally, Groome discontinued the practice of allowing inmates to meet with visitors in specially designated cells on each cellblock, creating instead a special area in the east side of the gatehouse, where inmates and visitors were separated by a barrier to prevent smuggling.[309]

Naturally, these new regulations were not very popular. Eighteen inmates jammed mattresses against their cell doors and ignited them in protest. Groome quickly crushed this minor rebellion and punished the inmates involved.[310] For prisoners who stepped out of line, the likely punishment was a trip to "Klondike," or a series of darkened cells on the gallery of cellblock four. Here inmates were placed, naked, in a bare cell and given only food and water to survive. While this is similar to punishments employed by

previous administrations, media scrutiny had increased to the point that information about institutions like Klondike would not long remain behind penitentiary walls.[311]

Isolation, which had once been interned to rehabilitate inmates, was now being savagely used to punish the worst offenders, a shocking reversal of the penitentiary's founding philosophy. In June 1924, the *Philadelphia Record* published a letter from inmate B-8266, under the headline "Pen Inmate Calls Conditions Savage," in which he argued that inmates were scared to talk about conditions to the various grand juries for fear of retribution.[312] The warden was eventually cleared of these and a variety of other charges leveled by inmates in a grand jury report issued the following month that noted, "We do not consider criticisms made of Colonel Groome justified by the facts."[313]

Unfortunately, Groome's tenure was marred by a number of escapes and escape attempts that demonstrated how challenging administering Eastern State had become. This point was driven home by the discovery, in May 1923, of a plot to blow up the penitentiary. According to the *Bulletin*, penitentiary administrators found "a large quantity of high powered explosives" in a cell facing Eastern State's back wall. Apparently, the plan was to blow a hole in the wall so that all of the inmates could escape.[314] While this was one of the more fantastic episodes, it certainly demonstrates the lengths to which inmates were willing to go for freedom.

As if that point needed reinforcement, on July 15, 1923, six inmates—Thomas J. Gillen, Louis A. Edwards, James Brown, James L. Malone, George Brown and James Williams—escaped by climbing over the penitentiary's eastern wall and hijacking a truck. According to the *New York Times*, the six inmates were detailed to clean up Eastern's southeastern yard. From here, they rushed two guards, bound them and locked them in the sentry box. Next, the six inmates climbed the wall using an ingeniously constructed ladder that broke down into a number of parts that were designed to look like pieces of penitentiary-issued furniture. Using a hook and rope, the six escapees lowered themselves to the ground, all while a group of local residents watched. The fugitives hijacked a passing truck using revolvers, which had obviously been smuggled into the penitentiary, and sped away. Six blocks from the penitentiary, they ditched the truck for a maroon sedan driven by Thomas McAllister, who noted, "I saw [we] were not going to a Sunday school picnic!"[315] The convicts eventually drove to Elkton, Maryland, where McAllister escaped. Warden Groome offered a reward of $250 for each inmate, and people reported seeing the escapees in both Pocomoke City, Maryland (July 17), and Atlantic City, New Jersey (July 20).[316] It was later alleged by one of the escapees that the inmates had paid the guards $30,000 to "look the other way," a stinging blow to Groome's administration, which was based on rooting out corruption.[317]

In November of that year, three more inmates escaped, killing a guard in the process. According to the *Bulletin*, Groome had ordered the warden's living quarters converted into administrative space, mostly to distance his administration from McKenty's. A number of inmates were detailed to do this and to paint the deputy warden's quarters. While working on these renovations, four inmates came down the stairs and into the guardhouse, where one of them "blackjacked" one of the guards on duty. The other inmates shot at the second guard and fled through the penitentiary's front door. They unsuccessfully held up a taxicab driver and then fled east down Fairmount Avenue. One

of the inmates, George Dubeck, was recaptured after a short chase by police, while another, Emil Brody was recaptured in Los Angeles in 1926. The most interesting was Francis Joseph Flynn, who was retaken after he "ingenuously" had himself committed to the Berks County Jail for vagrancy. He assumed that authorities would never look for him in jail, and it was only dumb luck that the Berks County warden recognized Flynn from his picture in the newspaper.

Flynn kept trying, and in 1926, the administration narrowly averted another escape, this time through a forty-foot tunnel. It was only the serendipitous discovery of the tunnel that kept the inmates locked up.[318] Groome had not been so lucky the previous year, when an inmate named John Campbell escaped by hiding underneath a load of hot ashes that were trucked out the penitentiary's front gates. According to the *Bulletin*, "screaming with pain, he emerged from the ashes a few minutes later" and, using a gun he had somehow gotten while in prison, hijacked the penitentiary's sedan, which was following the truck. The truck's driver expressed some sympathy for the inmate, saying, "He must have been nearly roasted to death. [The ashes] were so hot that I could see steam rising when the snow fell on them."[319]

One of the worst escapes during Groome's tenure occurred in 1927, when two inmates threw a guard off the wall as they climbed over. At about 11:00 p.m. on Sunday, September 4, William Lynch and William Peter Bishie walked across the penitentiary toward the northwest tower with a lead pipe wrapped in a towel and a rope made of twine used for making boats in Eastern State's model shops. Because the two men were working inside the penitentiary as electricians, they were taken out of their cells to fix a broken telephone line, and they climbed, via ladder, into the guard box, where the lone guard, Floyd Reynolds, was waiting for them. One of the inmates hit the guard with the pipe, and in the ensuing struggle, the guard fired his rifle once or twice, alerting the guards in the other three towers. However, when they pulled the cord to signal the alarm, nothing happened. The two inmates had cut the wires, and no alarm was raised. Lynch and Bishie pushed Reynolds over the wall, and the guard fell thirty-five feet to the ground. The inmates tied their makeshift rope to an iron rail and slid down, dropping the last five feet because the rope was too short, and then shuffled off into the darkness.

Warden Groome retired after five years and was replaced by his deputy warden, Herbert E. "Hardboiled" Smith. Johnston argued that many of Groome's initiatives continued under Smith, which is natural because, as the deputy warden, Smith was responsible for formulating and implementing those policies. Smith, like Groome, was dubious about rehabilitating Eastern's inmates, calling the idea of rehabilitation a "joke."[320] According to one newspaper account, inmates felt that Smith was very standoffish and walked around "with a chip on his shoulder."[321] Both Willie Sutton and Joe Corvi's memoirs, which agree about very little, assert that Smith was a heavy drinker, if not an alcoholic. Corvi called Smith "a boozer with the telltale florid face," while Sutton recounted a story about Smith charging through the cellblock in the early hours of the morning, drunk, firing his pistol and screaming about some imagined indignity.[322] In addition, Smith had a reputation for blunt aggressiveness. Sutton alleged that, upon his reception at the penitentiary, Smith threatened that if the famed jail breaker tried to escape, the guards had been ordered to "blow your fuckin' head off."[323] Oddly, for

Eastern State Penitentiary

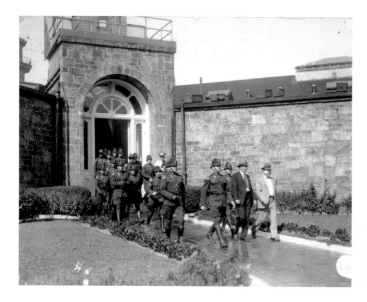

Warden Herbert "Hardboiled" Smith reasserts control following a riot. *Photo courtesy of the Urban Archives, Temple University.*

Damage to the laundry facility caused by inmates during the riot. *Photo courtesy of the Urban Archives, Temple University.*

all of these negative qualities, both Corvi and Sutton ultimately used the same word to describe Warden Smith: fair.[324]

It was during Smith's tenure that Eastern State welcomed its most infamous "guest": Al Capone, known during his sentence by his inmate number, C-5527. According to *Time*, Capone had gone to Atlantic City, New Jersey, in May 1929 to arrange a peace pact between Chicago's rival liquor gangs. On his return trip to Chicago, Capone had a layover in Philadelphia, where he was arrested for carrying a revolver. Capone pleaded guilty and received the maximum sentence: one year. It was rumored at the time that he was trying to escape from his rival bootleggers in Chicago, but there is no proof of this. He was transferred to Eastern State after serving two months and spent the balance of his sentence in relative luxury at the penitentiary. During his stay, Capone had his tonsils removed and played baseball. He also donated liberally to the penitentiary, with some estimates ranging as high as $25,000. To thwart any assassination attempts at his release, Capone was transferred to another prison the evening before he was let go. According to *Time*, he was whisked away by a blue Buick sedan that "streaked away into the underworld."[325]

Smith's tenure, like Groome's, was marred by a series of well-publicized riots and escapes. According to Norman Johnston, prisoners went on a hunger strike (August 1933), rushed the wall in an attempt to escape (November 1933), rioted over war rationing (March 1942), tried to blow up the penitentiary with dynamite (December 1944) and rioted over the stiff sentences given to inmates who broke out during the infamous "Willie Sutton Tunnel" escape (April 1945).[326] In July 1934, five inmates escaped through the sewer system, crawling half a mile underground before emerging from a manhole. Apparently, during yard out, the men had arranged for a group of inmates to stand in front of a cesspool opening along the outer wall adjoining Fairmount Avenue. The escapees somehow lifted the cesspool cover (it was locked down and the lock was found intact) and climbed down into the penitentiary's sewer system. Here, the men stripped and made their way through Philadelphia's sewer system, emerging *nude* onto a city street. The *New York Times* called this the second most "daring" escape in the history of the penitentiary, "exceeded only by" the 1924 escape during which William Lynch and William Peter Bishie had thrown guard Floyd Reynolds over the wall.[327]

While some men chose to go over the wall, others tried to go under it. There were numerous attempts to tunnel under Eastern State's massive walls, which extend ten feet below the ground. On February 13, 1940, Warden Smith discovered a tunnel leading from cell fifty on cellblock nine toward Fairmount Avenue. Apparently, Smith had been alerted by an informant about the tunnel, which was six feet deep and twenty-five feet long. The six inmates involved were immediately placed in administrative segregation, and one, James Wilson, committed suicide over the prospect of time being added to his sentence. The following day, *another* tunnel was discovered, this one in cellblock ten, cell twenty-nine. In both cases, the inmates had cut holes near their toilets, which they covered with precast slabs designed to fit seamlessly back into the holes.[328] As these stories indicate, tunnel building was something of a pastime for Eastern State's inmates; most were serving long sentences and figured they had nothing to lose and everything to gain.

Around this time, Eastern State's best-known escape occurred, through the so-called "Willie Sutton Tunnel." Over the years, multiple versions of the escape have surfaced, making it difficult to separate fact from fiction. Contradictory descriptions of the escape appear in Sutton's two memoirs—*I, Sutton* and *Where the Money Was*—as well as in Joseph Corvi's memoir (co-written with Steve J. Conway), *Breaching the Walls*. The main difference is Sutton's degree of involvement. Sutton's memoirs present him as the tunnel mastermind, while Corvi argued that Sutton was a relatively late addition to the escape and was only reluctantly accepted by the other plotters. Sutton's own police interrogation, during which he said, "they didn't let me know until the night before," seems to confirm Corvi's assertion, though Sutton may have lied in the hope of leniency from the warden.[329] Unfortunately, the egos involved have probably ensured that we will never know the whole truth about the escape, and what follows is a composite account of the escape based on various sources.

The main actor in this drama was an inmate named Clarence Klinedinst, a mason by trade, who was sent to Eastern State for burglary and forgery. Corvi remembered Klinedinst as "a very ordinary man…ploddingly persistent, thorough, patient, introverted, and physically unremarkable—180 pounds, 5′10″, and balding…Klinedinst could walk down the middle of a block cluttered with inmates and neither see nor speak to a single person."[330] Sutton largely confirmed this description, but he got Klinedinst's name wrong, called him "recklessly desperate" and argued that the bashful mason was his

The courtyard of cellblock seven. Klinedinst's tunnel ran under the wall on the left. *Photo courtesy of Dr. Jennifer Murphy.*

(Sutton's) "first recruit."³³¹ This description of "reckless desperation" contradicts Corvi's recollections. According to Corvi, Klinedinst "didn't seem to be in any great hurry" and therefore "didn't work every day."³³² One of the guards at the time noted that Klinedinst was a hard worker and a good mechanic, but "quite anti-institutional"; in other words, the perfect man to build an elaborate escape tunnel.³³³

In any event, Klinedinst managed to get himself transferred to cellblock seven in late March 1944, and immediately began work on his tunnel.³³⁴ For the first three days he was in his new cell, Klinedinst was either allowed or ordered to keep a wet blanket over the cell door, blocking the guards' view of the cell. Ostensibly to keep the plaster dust inside the cell while Kliendinst worked, in reality the blanket was there to keep the guards from seeing Klinedinst break through the cell's wall. Klinedinst covered the tunnel entrance with a board painted to match the cell, which he attached to the wall using a hook secured to the inside of the tunnel. Around the seams, Klinedinst used a mixture of Vaseline and dirt to create the impression that the board was firmly mounted to the wall. To top it off, he hung a metal wastebasket over the panel. A few days later, during an inspection, the deputy warden congratulated Klinedinst on the job he had done, saying "Nice touch, Klinedinst."³³⁵

Klinedinst's tunnel was pretty sophisticated, given the conditions. According to the diagram published in the *Philadelphia Inquirer*, Klinedinst had made a seven-foot ladder that led from his cell to the tunnel, wooden boards to shore up the tunnel's walls and a string of electric lights throughout (which Kliney plugged into the outlet in his cell).³³⁶ There's even reason to believe that Klinedinst installed a fan so that he did not overheat while he was digging. The tunnel varied in width from three feet to just over one foot, and Pennsylvania's secretary of welfare estimated that it would have taken 850 trips to move that quantity of dirt with a ten-quart pail.³³⁷ No one is exactly sure how the inmates got rid of that much dirt, but the most likely explanation is some combination of flushing it down the toilet, packing it in their pockets and dropping it in the penitentiary's yard and dumping it into the underground creek and sewer pipes the inmates discovered while digging the tunnel.

However, in acquiring these items, it is likely that Klinedinst was forced to tell other inmates about his tunnel, or, like Sutton, they simply guessed what he was up to. According to Corvi, two other inmates, James Van Sant and Frederick Tenuto, knew about the tunnel from the beginning and were involved with the digging. Corvi claimed that Klinedinst needed these two because they were assigned to the penitentiary's trash detail, which Klinedinst used to get rid of the large rocks that made up his cell's wall.³³⁸ Along the way, Klinedinst also realized that, due to overcrowding, he was going to be assigned a cellmate sooner or later. This would be fatal because, unless the cellmate was in on the escape, he might turn Klinedinst in to the administration. According to Corvi, Klinedinst approached his "partners," Tenuto and Van Sant, and suggested that they head off this potential problem by requesting that an inmate named William Russell be transferred into Kliney's cell. They agreed, and Kliney made the request, which was granted.³³⁹ An inmate named Bob McKnight, who worked in Eastern State's dental office, stole some plaster so that Klinedinst could make a bust to leave in his bed at night while he worked in the tunnel.³⁴⁰ How many other inmates were involved in building the

tunnel, as opposed to those who merely saw an opportunity to escape and took it, is hard to say. Obviously, Klinedinst rang up debts to people while building his tunnel.

In addition to the danger of discovery that would have accompanied the ever-expanding group of inmates involved, there were numerous setbacks along the way. Sometime in the summer of 1944, a portion of the tunnel collapsed, which required a month and a half of repair work. Then, according to Corvi, a guard was killed at the penitentiary in August 1944. The tunnel rats heard about the murder over the penitentiary's radio system and immediately closed the tunneling operation down for three weeks while the state police investigated. That December, a passerby threw a package containing three sticks of dynamite over the penitentiary wall, which naturally precipitated a lockdown while the administration inspected the penitentiary for any other bombs. Corvi argued that, during this period, "tensions were high" because Klinedinst and company were convinced they would be discovered. Discovery would lead to solitary confinement and stiff additional sentences. However, the sense of crisis eventually abated, and work continued on the tunnel.

At 7:00 a.m. on Tuesday, April 3, 1945, twelve inmates managed to squeeze through the tunnel, crawling almost one hundred feet under Eastern's massive walls and up onto the flower beds that line the penitentiary's façade. Apparently, Klinedinst's crew had broken through the night before, but they chose to wait until the following morning to escape. This ultimately proved to be a disastrously bad decision. After breakfast, the "lucky" inmates drifted to Klinedinst's cell and scurried through the tunnel, emerging on a busy city street and shocking passersby. Tenuto, Van Sant and Klinedinst were the first three to emerge from the tunnel, and Sutton was the last. Unfortunately for Sutton, he popped out of a tunnel just as two Philadelphia police officers rounded the corner onto Fairmount Avenue. Sutton was almost immediately recaptured, and by the end of the day, five additional escapees were brought back to the penitentiary.

William Russell was apprehended a week later, when he visited an ex-girlfriend while dressed as a sailor. He had to be carried back to the penitentiary—when he walked into the woman's apartment, he was met by a squad of Philadelphia policemen, who shot him seven times.[341] Tenuto and Van Sant were apprehended in New York a few weeks later, plotting a robbery. The tunnel escape did have its light side: guards were stunned when they heard a knock at Eastern's massive door at 5:15 a.m. eight days after the robbery. Upon answering the door, they were even more surprised to find one of the escapees, James Grace, who *asked* to be let back into the penitentiary. The legend at Eastern State is that Grace, who was not a Philadelphia native, hid under a bridge in nearby Fairmount Park, but eventually returned to Eastern State because he was tired, hungry and had nowhere else to go. While it makes for a fantastic story, there is little evidence to support it. Grace did not look like he had been sleeping in the park, and police did not believe his story. Corvi quoted a *Philadelphia Inquirer* article, which noted that one of the guards originally told Grace to "go away and come back when the penitentiary was open." Eventually, the administration happily accepted the escaped prisoner back into the penitentiary, fed him and sent him to solitary with the rest of the recaptured escapees.[342]

Despite his earlier promise, Warden Smith did *not* in fact blow Sutton's "fuckin' head off." Sutton and the rest of the escapees were "merely" sent to "Klondike" as punishment for the escape. According to Sutton's memoirs, the inmates widely believed that they were going to be kept in isolation indefinitely, which they considered inhumane. (This was ironic, given that they were serving time in the penitentiary that had become world famous for isolation.) In order to avert this outcome, Van Sant suggested that the escapees go on a hunger strike until the warden agreed to release them all from solitary confinement. Thirteen eventually agreed, and they refused to eat. Most of the men lasted until the twelfth day, during which time Sutton recalled, "Our flesh just melted away. We grew gaunt and weak."[343] Finally, Warden Smith came to visit Sutton, who he identified as the ringleader, and offered a compromise: eat something and the warden would transfer the escapees to another prison, where they could start with "fresh slates." Sutton agreed, and he and many of the other tunnel conspirators were transferred to Holmesburg, from which they managed to escape two years later. While this may have seemed like a "win" for Sutton, he recalled a decade later in *I, Willie Sutton* that the legendary penitentiary had "defeated me."[344]

Despite all the escapes and the negative media attention, Eastern State's neighbors seemed genuinely appreciative of their foreboding neighbor. In multiple oral histories conducted during the 1990s, former residents of Philadelphia's Fairmount neighborhood noted that residents simply took the penitentiary for granted and rarely worried about their security.[345] Tom Owens, a Fairmount resident since the early 1940s, recalled, "The neighbors never feared or never had any qualms about the prison. They were happy because the place was always kept spic-and-span, was always neat, we never had any problems and never had any reason to have any problems."[346] Thomas Ruth, who lived near the penitentiary for nearly seven decades, believed that the neighbors liked "the security that went with a prison."[347] Even when that security system broke down and inmates escaped, residents did not usually fear for their security. As lifelong Fairmount resident Raymond Holstein pointed out, "An escapee [who] got over the walls or through the sewers wasn't going to hang around here, they were long gone so we just never thought that much about it."[348]

George Mingle, whose father was a guard and later deputy superintendent of Eastern State, remembered that, on Saturdays, he would ride the trolley by himself and spend the day with his father at work. An inmate named Danny Day would cut his hair for free.[349] William Zielinski, whose father also worked at Eastern State, had a similar experience. As a first grader, his father began taking him to the penitentiary, where an inmate cut his hair. Zielinski recalled that someone told him that the inmate barber was at Eastern State for cutting someone's throat with a razor. In retrospect, he decided it was gallows humor, but at the time, "it made an impression on me."[350] Ray Bednarek, who was a guard at Eastern State during the 1950s, remembered taking his son to the penitentiary for a haircut, which cost him twenty-five cents. These reminiscences demonstrate that, like Eastern State's neighbors, the penitentiary's guards felt comfortable enough with the inmates to take their children to work on a regular basis.

This is further reinforced by the fact that, for many of the administrators' and guards' children, Eastern State was a unique playground. Steve Bednarek remembered that,

after his haircuts, his father "would let me go off with the inmates and never had a worry. They would never hurt children and I really enjoyed it."[351] Warden McKenty's daughter, Elsie Hough, who lived in the penitentiary during most of her father's tenure, recalled, "Those prisoners were just like brothers to me because they looked after me like I was somebody."[352] It is interesting to note that, as comfortable as the guards and administrators seemed to be with the penitentiary, neither William Zielinski nor George Mingle's father talked about Eastern State much. According to Zielinski, his father "did not bring his work home too often. On an occasion I would hear him talking to someone else about it. But that's generally the way it was. He didn't bring it home."[353]

Richard Fulmer, who worked at the penitentiary, remembered the relationship between guards and inmates as a "formal one," though he noted an "expectation that guards and prisoners needed to know one another as people, and that was how all of us were going to survive together." He also noted that part of a guard's job is to "harass an inmate" to ensure that prisoners live up to the institution's expectations and "follow the rules."[354] This contrasts sharply with Joe Corvi's memories. According to Corvi, inmates and guards were on a first-name basis, and their relationships were defined by a sense of camaraderie.

However, in the same interview, Corvi also noted moments of tension between guards and inmates. He recounted one incident in which an unpopular guard came into one of Eastern's barbershops for a haircut. The barber covered the guard's face with hot towels, spit into his hands and proceeded to massage the guard's face. Of course, the inmates watching found this riotously amusing because the guard had no idea the "massage oil" was phlegm.[355]

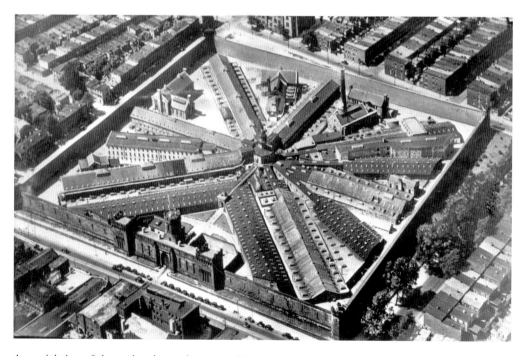

An aerial view of the penitentiary as it appeared in the twentieth century. *Photo courtesy of the Urban Archives, Temple University.*

From Chaos to Classification

Despite the fact that Eastern State's neighbors felt little anxiety about the penitentiary, it was still an incredibly violent and dangerous place. According to historian Norman Johnston, by the late 1920s, Eastern State was designated a maximum-security facility, designed for "chronic recidivists and others for whom rehabilitation was not deemed likely." These inmates were often serving life sentences and had little to lose in trying to escape or in attacking inmates or guards.[356] Cliff Redden characterized Eastern State during this period as "brutal," and a few examples demonstrate this to be true. For instance, in September 1922, Ambrusio Silva bashed his cellmate's skull, which led to the man's death two days later, after an argument over the correct pronunciation of a word.[357] This incident followed one that had occurred the previous June, in which Peter Marone killed his cellmate, Frank Saris, reportedly after a quarrel over "the price of phonograph records."[358] James Milburn used furniture in his cell to beat his cellmate to death because they were arguing "over the merits of their parents."[359] Ignazio Crino was stabbed in cellblock seven by Joseph Kelly, who refused to explain why he did it.[360] In June 1948, inmates Robert McGrogan and William Palmer stabbed inmate Richard J. Rafer with knives made of sharpened kitchen spoons.[361] Three years later, Marshall Pepperissa smuggled a baseball bat into the cellblock after a game of baseball and used it to beat William Van Arsdale to death.[362] One inmate during this period estimated that only 5 percent of inmates regularly carried weapons, but in a tinderbox environment like Eastern State, 5 percent was more than enough to make the penitentiary a dangerous and unpredictably violent place.[363]

Guards were not immune to the violence and were always sensitive to possible threats. For instance, in March 1936, an inmate began throwing his furniture around his cell and making noises. When the guard entered the cell, the inmate hit him with a bar of soap. The other inmates on the block cheered the inmate and cursed the guards, who responded by throwing gas grenades into the cellblock. After that, according to the *Evening Bulletin*, "all was quiet."[364] The fear of organized violence was one of the reasons why, shortly after he arrived in 1923, Warden Groome ordered the construction of "head gates," or barred doors that could quarantine individual cellblocks and prevent riots from spreading throughout the penitentiary.[365] This created a heightened sense of tension that could occasionally lead to embarrassing overreactions, such as in August 1947, when Philadelphia police were called after a report that someone was trying to tunnel into the penitentiary late one evening. It turned out the would-be escape artist was simply digging for worms.[366]

While this story points to the lighter side of life at Eastern State, the tension guards felt was very real and occasionally led them to abuse the inmates. In November 1923, the grand jury asked quarter sessions court Judge John Monaghan to investigate how inmate James Fraley had gotten a broken jaw and arm. According to the grand jury, when they asked Fraley how it happened, he refused to answer, but other inmates confided that Fraley had been "unmercifully beaten by the guards" for assisting four inmates in their escape earlier that year.[367] According to acting warden Herbert Smith, Fraley received his injuries in a fall, and Smith resisted a habeas corpus order for Fraley to go to court and explain his injuries himself, saying that the inmate was not well enough to travel.[368] Fraley did eventually testify, asserting that he was beaten in his cell by none other than Captain

Smith and Deputy Warden Charles Santee. Though Smith was eventually exonerated of these charges, Santee was indicted and convicted of beating Fraley.[369]

Sometimes, the tension reached a crescendo, and rather than abusing inmates, guards turned inward and struck at themselves. For instance, on May 4, 1940, guard Edward V. Bishop was found in the guard box atop the southeast tower with a bullet wound near his heart. According to the warden's journal, it was widely assumed that this was a failed suicide attempt. Bishop was taken to the hospital in cellblock three, and his wife was notified. He spent two weeks in cell six of the hospital ward recuperating and seemed to be on the road to recovery, only to take a sudden turn for the worst on May 18. He died the following day of a hemorrhage caused by complications from the bullet wound.[370]

In addition to murder and suicide, Eastern State's policy of segregating homosexuals and blacks created de facto ghettos, which heightened tensions and probably contributed to the violence. Even though Eastern State's system of separation was never perfect, the policy of keeping one inmate to a cell largely mitigated any tendency toward segregation. Under the Pennsylvania System, all inmates were already segregated, so there was no need to designate special areas of the penitentiary for specific groups. This changed in the twentieth century, particularly as the number of black inmates at Eastern State rose. According to historian Norman Johnston, the percentage of the penitentiary's African American population jumped from one-third before the war to one-half by 1945.[371] One source called Eastern State a "largely segregated prison" and noted that, following World War II, segregated cellblocks were the norm at Eastern State. This same source noted that cellblock seven was "whites only" during this period.[372]

For homosexuals, the situation was unique. Whereas blacks were segregated as a policy, gay prisoners were only disciplined if they got caught. Sexual relationships between inmates were clearly pervasive. In a single month, March 1940, at least five inmates were disciplined for committing sodomy.[373] However, Richard Fulmer noted, "If you didn't flaunt what you were doing, and it didn't get out of control, your activity, be it illegal or legal, was respected and dealt with…the only way to stop that was to lock up every single individual in the prison…so you had a tacit or a de facto kind of permissiveness."[374] Former inmate Cliff Reddern agreed with Fulmer, noting that, in his experience, guards were willing to turn a blind eye to homosexual relationships as long as the two prisoners involved did not cause any problems. According to Redden, "The guys were too slick really and probably [the guards knew it was] going along and they figured it would be easier to handle these guys if they, if we let them go. So I think they just turned their heads, a case of turning their heads."[375] However, should these relationships become a problem—neither Fulmer nor Redden defined exactly what that meant—the inmates would very quickly find themselves banished to cellblock five, a policy that, according to Fulmer, created a "ghetto."[376]

The administration's concern about homosexuality was probably exacerbated by the fact that women, who had been a small but consistent part of Eastern State's population since the penitentiary opened, were transferred out to Muncy Industrial Home for Women in 1923. In many ways, this reflected the difficulties of adjusting to congregating inmates rather than separating them. According to Harry G. Toland's biography of Warden Groome, when Groome assumed his duties there were at least two pregnant

From Chaos to Classification

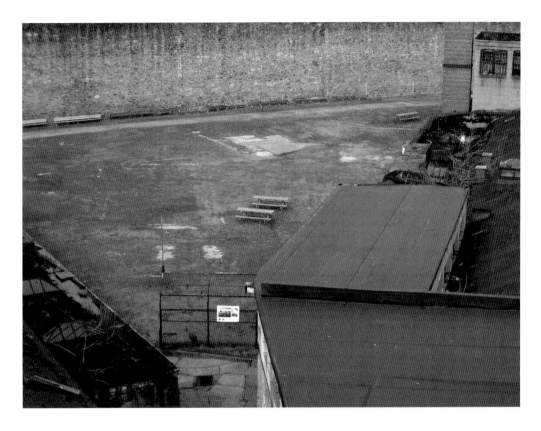

Eastern State's baseball and football field. After inmates lost their individual exercise yards, large spaces like this were used for organized sporting events. *Photo courtesy of Dr. Jennifer Murphy.*

women at Eastern, both of whom had conceived their children while incarcerated.[377] While love affairs between inmates had occurred in the past—E.V. Elwell's letters to Albert Jackson, discussed in chapter 2, demonstrate this—congregating inmates made such relationships easier. In addition, there had been a movement to create separate institutions for women for nearly fifty years.

Because Eastern State was a homosocial environment after 1923, sports played a big part in life at the penitentiary. Under Pennsylvania law, inmates were allowed two hours of outdoor exercise a day, and following the conversion of their individual exercise yards to other functions, inmates often participated in organized sports. These sports were such an integral component of life at Eastern State that the penitentiary's weekly newspaper, the *Umpire*, was dedicated to sporting events. The newspaper even admonished inmates not to make too much noise because it might give people living near the penitentiary the impression that the prisoners were having too much fun.[378]

George Mingle remembered watching inmate boxing matches, which were a regular occurrence at Eastern State. According to Mingle, "I had never seen anybody box before, and they had regular bouts, and they had a referee and all of the things that go with it, and the prisoners would come to the auditorium…and they would cheer for their favorite boxer, and that was a great thing."[379] Joe Corvi, who served time at Eastern State

on three separate occasions, remembered inmates playing a number of sports, including handball, basketball, football and baseball, most often on the narrow slivers of open space between cellblocks.[380] To pass the time, inmates sometimes bet on these games, often using cigarettes as money.

Another important aspect of life at Eastern State was food. Remember that the riots in 1924 and 1933 were caused, in part, by complaints over the quality and quantity of food. In the early days of World War II, some inmates were so incensed that, because of rationing, their donuts no longer had powdered sugar that they threw their entire meal into the corridor and then started fires in their cells with straw from their mattresses.[381] Opinions about the food at Eastern State varied; some found it excellent, while to others it was just one of the many indignities that went along with incarceration. Joe Corvi called the food merely "tolerable," except during World War II, when rationing forced changes in the menu. According to Corvi, "They had meatless days, and all that other stuff you know, and it was garbage."[382] Cliff Redden, who served time at Eastern State after the war, remembered the food as "fair," but he also noted that prisoners could supplement their diet with things they purchased at the penitentiary's commissary.[383] The quality of food available to staff was a little higher, due in part to the fact that staff meals were prepared in a separate kitchen, overseen by one of the guards. Merv Richards, who worked part time as Eastern's dentist, remembered the food being so good that he put on weight. This contrasted sharply with the food served to inmates. According to Richards, "The food really wasn't that great."[384]

One of the ways in which inmates passed their time was with pets, which, even into the twentieth century, were surprisingly plentiful. By the twentieth century, the penitentiary had a number of watch dogs that patrolled the grounds to intimidate possible escapees. But there were also numerous animals kept strictly as pets, the most famous of which was Pep, a black Labrador formerly owned by Pennsylvania's governor, Gifford Pinchot (1923–27). According to Eastern State lore, Pep was "sentenced" to life at the penitentiary for killing Mrs. Pinchot's favorite cat. Reality turns out to be a little more mundane. According to Pinchot's son, Pep was given to the Pinchots by one of the governor's nephews, but the dog was "absolutely worthless" because he repeatedly chewed up the family's sofa cushions. Not wanting to offend his nephew, the governor decided to "donate" Pep to Eastern State, which had few cushions for the dog to chew. Somewhere along the way, an overeager reporter concocted the story about Pep murdering Mrs. Pinchot's cat, and it has been repeated ever since.[385]

There were plenty of other pets at Eastern State during this period. Inmate Joe Corvi remembered keeping a gray mouse, while another inmate named Blind Jack kept a sparrow in his cell. According to Corvi, "If you have a rodent, you become attached to it. If you have a bird, which a hell of a lot of men have birds, sparrows, they have pigeons, you become very attached to them."[386] These animals usually helped the inmates get through long sentences, and the inmates grew incredibly attached to them. Corvi remembered a particularly sad story from the early 1960s involving an inmate named Harry Fricker, who found a cat that had wandered into the penitentiary. Fricker housebroke the cat for life at Eastern State to the point where the cat would leave Fricker's cell, walk down to the end of the cellblock, urinate and then return to the cell. Fricker grew so attached to

the cat that Corvi noted, "Wherever you saw the cat, you saw Harry, whenever you saw Harry, you saw the cat."

Unfortunately for Fricker and his cat, somewhere along the way, another cat got into Eastern State and was taken in by an inmate named Harry Ricobini. Ricobini's cat was not housebroken, however, and used the inmates' cell as a bathroom, which naturally caused it (and the rest of the cellblock) to smell like cat urine. Because of the smell (which was a public health concern), Eastern State's administrators decided to get rid of both cats. Fricker came back to his cell one day and found his cat gone. According to Corvi, Fricker asked the guards in Center about the cat, and they told him the bad news: the warden had ordered the cats removed from the penitentiary. Fricker became enraged and attacked one of the guards, so they punished him by putting him in isolation in cellblock one. Apparently, Fricker was so depressed by the loss of his cat that, after only a day or two in solitary, he hanged himself. Pinned to his body was a note, addressed to the warden, which simply said, "This is all your fault."[387]

Following the 1913 law officially ending the Pennsylvania System at Eastern State, the penitentiary had abandoned everything that made it unique. Inmates were no longer separated from one another, and the penitentiary's architectural plan, which was designed to allow guards to survey all of the cellblocks, had mutated in a disjointed series of buildings disconnected from one another. As the twentieth century wore on, administrators were less convinced that inmates could be rehabilitated. On the one hand, there were inmates like Henry G. Brock, who, after he was released from Eastern State in 1923, was appointed by Governor Pinchot as a trustee of the penitentiary. Brock, the scion of a wealthy Philadelphia family, was convicted of manslaughter after he killed three people with his car while driving under the influence of alcohol.[388] There were also inmates like Abe Buzzard, who, after spending a combined total of forty-two years in prison, devoted himself to becoming a minister and working with prison populations.[389]

But such declarations often proved to be merely another front to cover criminal activity. This was the case with Lew Edwards, who lived a "Jekyll-Hyde" life after he was released from Eastern State (where he was known as the "toughest guy" who ever served time at the penitentiary). According to newspaper accounts, while Edwards promised that he had gone straight, he led a gang of ex-convicts who held up a number of businesses in the Philadelphia area.[390] Understandably, guards and administrators were often cynical about the possibility of reform; more than one guard told newly paroled inmates "see you soon."

The administration's ambivalence about rehabilitation is best illustrated in a story Willie Sutton recounted in his memoir, *Where the Money Was*. While at Eastern State, Sutton worked for the penitentiary's psychiatrist, Dr. Philip Q. Roche. One day, Sutton asked Roche if it was possible for a repeat offender like Sutton to go straight. Roche responded negatively, saying, "I think that banks will always present such a challenge to you that I have serious doubts that you wouldn't try to rob one as soon as you were out on the streets."[391] This was an astonishing statement for a man charged with rehabilitating Eastern State's inmates, and it points to the fact that, by the twentieth century, the penitentiary's focus had shifted from penitence to punishment.

CHAPTER 5

THE RETURN OF REHABILITATION

1953–1971

The year 1953 was, like 1913 and 1829, another seminal moment in Eastern State's history. Whereas the forty years chronicled in chapter 4 represented the Pennsylvania System's death, certain aspects were reborn during Eastern State's final eighteen years as a penal institution. Though the penitentiary did not return to strict separation, the gradually shrinking inmate population meant that the ratio of prisoners to cells approached one to one. Eastern State's administrators tore down some of the outdated buildings on the penitentiary's campus, freeing up some space for inmate recreation. Though this did not completely alleviate the dangerous alleys and sharp corners that had earlier facilitated violence, it certainly raised the inmates' quality of life. In addition, the harsh discipline and cynicism associated with Groome's and Smith's tenures gradually abated and were replaced with a tempered belief in the possibility of rehabilitation. Around this time, the newly formed Pennsylvania Department of Corrections issued a pamphlet that claimed these changes were an attempt to recapture "the humanity and hopefulness" of the Pennsylvania System's early years.[392] While Eastern State was still a dangerous and gloomy place—the riot of 1961 and the multiple murders and suicides attest to this—it was generally regarded as one of the most humane and unique penal institutions in Pennsylvania.

According to the *Pottstown Mercury*, a riot broke out at Eastern State in May 1953 after eight inmates ignited the contents of their cells—"mattresses, blankets, and furniture"—to protest conditions in the penitentiary. According to Deputy Warden Walter Tees, inmates, who were all in "administrative segregation" (punishment cells), demanded they be placed back in the general population, a "better" parole system (the exact nature of their complaint is unclear) and better radio programming. Tees concluded that, in reality, the inmates "just wanted their own way."[393]

This was mild relative to events at Eastern State's sister institution, Western State. Four months before the incident at Eastern, one thousand inmates rioted at Western State. During the riot, guards were taken hostage, and inmates set fire to the building. Rioting also broke out at the "new" Western State Penitentiary—Rockview—in January 1954, when four hundred inmates took six guards hostage and tried to burn the prison down. After two days, nearly one hundred state troopers, armed with tear

gas and machine guns and supported by two fighter planes and a C-47, stormed the prison and restored order.

Unfortunately, Pennsylvania was not the only state whose prisons were in turmoil. Eight other states experienced prison violence in 1952. The *New York Times* dubbed the year between April 1952 and spring 1953 "the most explosive year in American prison history," and by October, the country had witnessed forty prison riots—that's more in eighteen months than in the previous quarter century.[394]

In response to the riots, the legislature passed, and Governor John S. Fine signed, a bill that created the Bureau of Corrections within the Department of Justice. The governor appointed Arthur T. Prasse, superintendent of the State Industrial School at White Hill, as its first superintendent. The bill stripped the penal institutions' boards of trustees of its power, giving Prasse wide latitude to set policy and enact reforms. Prasse believed that these institutions should have a "corrective," rather than a strictly "punitive," function, and the Department of Corrections renamed the commonwealth's penal institutions to reflect that new philosophy. Thus, Eastern State Penitentiary now officially became State Correctional Institution, Philadelphia, or SCIPHA.

The changes at Eastern State were more than just skin deep, however. The penitentiary was split into *two* institutions, one a state correctional facility and the other a diagnostic and classification center designed to ensure that new inmates were properly routed to the appropriate institutions. According to Finn Hornum, who studied Eastern State's classification system in the 1960s, "Essentially what they tried to do was study the characteristics of the inmate in terms of his social background, his psychological profile, his prior criminal record, his medical conditions, work experience, educational background and so on, and this was essentially done by different professionals in the institution."[395] In many ways, Eastern State's new classification system was a return to the spirit, if not the letter, of the Pennsylvania System. By understanding the penitentiary's inmates, administrators hoped to treat them and maybe lower recidivism.

Norman Johnston noted that Eastern State's inmate population hovered around one thousand, with about three-quarters of those inmates at the state correctional facility and the other 25 percent housed in the classification center.[396] Inmates wore different uniforms to identify where they belonged: light brown for the classification center and blue denim for SCIPHA. In addition, inmates awaiting classification were housed in cellblock fourteen, and the diagnostic center's staff offices were located in cellblock three, the hospital wing, where they provided counseling and psychological assessments for all of Eastern State's inmates. Eventually, the diagnostic center became affiliated with Temple University Hospital and, according to Richard Fulmer, "many prominent specialists in [medicine or psychiatry] either began their careers with prison experience or consulted [at Eastern State] at various times."[397]

One of the most important changes that reflected the new emphasis on correction following Eastern State's rebirth as SCIPHA was the removal of punishment cells known around the penitentiary as "Klondike." The Devers Commission report, which called Eastern State "remarkably well-kept," noted that the segregation cells should be removed, a point that was reiterated after the district attorney investigated the penitentiary in response to an inmate complaint that the cells "endangered sanity."[398] Segregation,

when practiced in the haphazard way that characterized the penitentiary after 1913, was inconsistent with the new penal philosophy symbolized by Eastern State's rechristening.

There were other changes during this period as well. For instance, in 1959, a new cellblock containing thirty-four cells opened, the last new cellblock to be built at Cherry Hill. Known informally as "Death Row," cellblock fifteen actually housed all inmates who required segregation from the general population. This included not only inmates sentenced to death, dangerous because they had nothing to lose (you couldn't kill them twice), but also inmates who had a history of violence toward guards or other inmates. Cellblock fifteen replaced the range of punishment cells known as cellblock thirteen, which were roundly (and rightly) condemned in 1953 as inhumane.

Still, Death Row could be just as intimidating. Mervin Richards, who worked part time as the penitentiary's dentist during the 1960s, recalled one particular intimidating incident that illuminates the administration's attitude toward Death Row. According to Richards, an inmate housed on cellblock fifteen needed dental work, but because the man had killed a guard, he could not be taken to Richards's office. Instead, Richards went to cellblock fifteen. Because of the danger, he had to work on the inmate's teeth *through the cell door*. Standing behind Richards was a guard, who aimed a shotgun at the inmate and threatened, "I'll blow your head against that wall." Richards later said he was most worried that the inmate would bite him.[399]

Drug and alcohol use among inmates was a continual problem. In December 1958, penitentiary officials discovered a few loose marijuana leaves during a routine cell inspection. The cell's owner, William Wickens, confessed to having the marijuana and implicated his common-law wife. As it turned out, she would visit the penitentiary and drop the drug shipment into the wastebasket. Wickens, who worked as a janitor around the penitentiary, retrieved the drugs when he cleaned the lavatories later in the day.[400] Three years later, one of Eastern State's cooks, a man named Benjamin Lichy, was discovered smuggling amphetamine tablets into the penitentiary for sale to inmates. Eventually, two others were arrested, and investigators discovered that Lichy and company had smuggled nearly twelve thousand amphetamine tabs into Eastern State.[401]

Inmates also used alcohol to escape the reality of their lives behind the walls. Roosevelt Grant, who served time at Eastern State during this period, recalled that inmates made wine by fermenting whatever was handy, including potatoes, fruit and rice, and then hid the bottles wherever they could.[402] Though bottles of wine were more difficult to conceal than drugs, alcoholism was so common among inmates that, in 1963, the penitentiary formed an Alcoholics Anonymous chapter, and once a week, rain or shine, recovering alcoholics from the outside came to Eastern State to counsel and encourage inmates to stop drinking.[403]

In March 1959, Assistant District Attorney Juanita Kidd Stone blasted the penitentiary in open court, arguing that inmates enjoyed "luxuries" that those on the outside could only dream about. The occasion was a hearing to determine whether inmate James Bozzi should be transferred back to Holmesburg from Eastern State. Bozzi's lawyer, Vincent A. Cirillo, argued that life at Eastern State was "harder" than life at Holmesburg. Stone responded by enumerating the "luxuries" available to inmates at the penitentiary— movies three times a week, television from 7:00 p.m. to 9:00 p.m. every night, musical

The Return of Rehabilitation

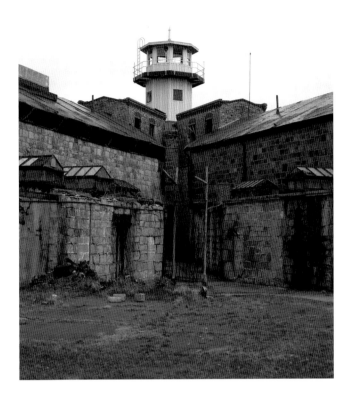

A view of the guard tower from the sports field. *Photo courtesy of Dr. Jennifer Murphy.*

performances, organized sports teams and floor shows from nightclubs—in order to demonstrate that life at Eastern State was not as difficult as Bozzi made out.[404]

In many ways, this argument reflected a debate that had been going on since Eastern State opened: where was the line between treating inmates humanely and pampering them like guests? The penitentiary had been criticized in the 1930s for supposedly keeping inmates in luxury, while at the same time the penitentiary was *also* criticized for its purportedly inhumane conditions. In truth, conditions at Eastern State were not nearly as luxurious as Stone made out. According to Roosevelt Grant, the penitentiary was cold in winter and extremely hot in summer. This is not surprising given the fact that most of the cellblocks were nearly a century and a half old. Grant also remembered that his bed was extremely uncomfortable, so he ended up sleeping on the floor most evenings.[405] Another former inmate recalled that, despite the fact that the penitentiary was extremely clean, it had a rat infestation. According to this inmate, the rats would climb across the cellblock roofs and occasionally fall through the skylights, landing on prisoners as they slept.[406]

While not a pleasant place to be, Eastern State did offer its inmates a variety of educational and recreational opportunities that could alleviate the worst effects of long prison sentences. In addition to television, some Eastern State inmates became regionally celebrated chess players! According to Richard H. Fulmer, Warden Joseph Brierly encouraged the game and even acted as the chess team's coach. In April 1965, Eastern State's chess team won the first-place trophy at the awards ceremony of the Philadelphia Chess Association, but it was unable to accept in person because, as the

Philadelphia Bulletin drolly noted, "They don't travel."[407] Two years later, the penitentiary hosted the league's banquet, which allowed the inmates to play against chess enthusiasts from other regions. Warden Brierly boasted that the chess club seemed to have a positive impact on inmates' lives. He noted that the club had been free from any "detrimental incidents" and that "several of our former inmates have secured jobs—while others have attained parole sponsors through their contacts made with visiting Chess Clubs."[408]

As in earlier periods, Eastern State's inmates continued working, though by the 1950s and 1960s, it was more about making a little money or passing the time than reformation. Ray Bednarek, a former guard, recalled that in the 1950s, inmates made a slew of interesting and unusual goods: slippers, belts and gun holsters, boats and miniature furniture for dollhouses.[409] Eastern State's products were regionally, and occasionally even nationally, known. Many Philadelphians and local businesses still have examples of penitentiary-produced products, some of which have been returned to the historic site and can be seen in its museum.

In July 1954, the *Philadelphia Bulletin* profiled an inmate known as "Penthouse Pete," a former safecracker who became a well-known leatherworker during his time at the penitentiary. According to the article, "topflight politicos, wealthy men and women, Hollywood and Broadway personalities and nationally known athletes are among Penthouse Pete's number of customers."[410] Obviously, Penthouse Pete's experience was not typical, though inmates could do surprisingly well for themselves by working at many of the trades available in the penitentiary. One of the most important sources of inmate income was carding bobby pins, which, according to Bednarek, prisoners made from morning until night because they was so lucrative. In his memoir, Joe Corvi recalled that he made forty dollars a month carding bobby pins. When he was offered a job in the vocational director's office at six dollars a month, the administration compensated him for the lost income by giving him five packs of cigarettes a week.[411]

Perhaps because the prisoners were able to make money so easily, Eastern State's inmates were incredibly civic-minded and generous. During this period, the penitentiary donated money, time and sometimes even blood to various charities. In 1954, the inmates donated $568.00 to the Salvation Army; while this was roughly $0.60 per inmate, consider that inmates only made about $0.20 per hour. In all, 65 percent of inmates contributed, and the donation (if given by an individual) would have required 2,844 days of full-time work.[412] That same year, Eastern State's inmates donated $822.96 to the March of Dimes, and the next year they donated $519.92.[413] The American Red Cross frequently ran blood drives at the penitentiary, and the inmates were eager donors. The nurses had, at least in a few cases, to turn down offers of more than a pint.[414]

In one particularly bizarre instance, the inmates even collected funds to pay for another inmate's plastic surgery. According to an article titled "Ugly Thief Needs New Face So Convicts Sponsor Surgery," Albert Lapinsky was convicted of mugging in 1952 and was sentenced to twelve and a half to twenty-five years at Eastern State Penitentiary. Lapinsky blamed his crime on the fact that he was ugly, and the judge suggested plastic surgery, even going so far as to write the penitentiary's medical director, Dr. Nathan Blumberg. Blumberg took the matter to the directors of the penitentiary's welfare fund, which was financed and overseen by the penitentiary's inmates. They were convinced that Lapinsky

The Return of Rehabilitation

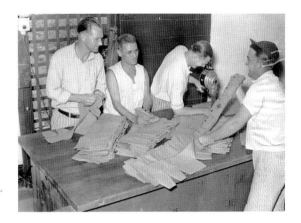

Inmates assemble uniforms for the U.S. Marines during World War II. *Photo courtesy of the Urban Archives, Temple University.*

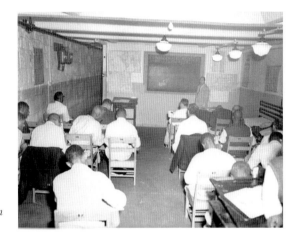

Inmates take advantage of Eastern State's educational program. *Photo courtesy of the Urban Archives, Temple University.*

During the twentieth century, inmates often performed live on local radio. This inmate is serenading the audience of KYW, now a twenty-four-hour news station. *Photo courtesy of the Urban Archives, Temple University.*

was a deserving case and agreed to fund the eight cosmetic surgeries needed to build the inmate a new face.[415]

Despite the reputedly "luxurious" conditions and the community's goodwill, inmates at Eastern State did what they had always done: they tried to escape. In December 1959, inmates Richard Payne and Eugene Hammen ducked away from the penitentiary's exercise area and somehow managed to climb atop cellblock seven. The warden called in the Philadelphia Fire Department to use pressurized water to push the men off the cellblock's roof. This worked, and the would-be escapees were placed in cellblock fifteen as punishment.[416]

Most escape attempts were not quite as dramatic, and some were downright comical. Richard Fulmer recalled one escape when an inmate hid in a barrel that was discarded as trash. The guards failed to search the barrel, and it was placed on the trash truck and taken out through the main gate. The inmate jumped out of the barrel, fell off the truck and broke his ankle, all in sight of the penitentiary. He was picked up a few minutes later by one of Eastern State's guards.[417]

Light stories like these should never mask the fact that Eastern State remained a dangerous and depressing place. Despite a declining population, suicide remained a problem at the penitentiary. In Eastern State's last year as a state penitentiary, the institution was rocked by Norman Maisenhelder's suicide. According to Richard H. Fulmer, this event was, for the people at the penitentiary, "their most memorable experience at Eastern State."[418] Maisenhelder was a lifer, sentenced in 1953 for murdering his wife, and he had spent some time in a mental institution during the late 1950s because he exhibited obsessive-compulsive and aggressive tendencies. During his time at Eastern State, the administration created a number of mental "supports" to help Maisenhelder cope with incarceration. He was assigned to the diet kitchen, where only he worked, and he was a regularly scheduled patient at the penitentiary's counseling department. He was passionately devoted to his daughter, who was placed with another family following her mother's murder and her father's incarceration. Maisenhelder kept in touch with his daughter through regular letters from the caregivers, but it was ultimately these letters that sent him spiraling toward suicide.

In August 1969, Maisenhelder received a letter from his daughter's caregivers that disturbed him. Apparently, the glowing reports they had been sending about his daughter's condition were largely false. According to this letter, Maisenhelder's daughter was, in reality, taking drugs and close to failing out of school. Maisenhelder responded by snatching two knives from the diet kitchen where he worked and climbing atop the intake and parole building between cellblocks eight and nine right around lunchtime on August 8. To get the administration's attention, Maisenhelder slit one of his wrists, and the spectacle of an inmate atop a building holding himself hostage attracted a crowd. The administration tried to set up a telephone line so that Maisenhelder could speak to his daughter. Even if this did not calm the inmate's mind, at the very least it would keep him alive until they thought of something else. Someone attached an extension wire to a phone, which was passed out a window and up onto the roof via a ladder. Unfortunately, the call was unsuccessful, and Maisenhelder responded by throwing the phone and shouting, "That's it!" In the next

The Return of Rehabilitation

moment, he plunged one of the knives into his chest. The knife was blocked by his rib cage, so the damage was only (relatively speaking) minor. Maisenhelder stabbed himself again, this time hitting his heart. This wound proved fatal, and Maisenhelder later died in the penitentiary hospital.

Violence remained a problem at the penitentiary. Richard Fulmer called the violence "considerable" and recounted a story in which he almost became a victim. Shortly after Dr. Fulmer began work at the penitentiary in the mid-1960s, an inmate visited him in his office. The inmate pulled a knife and stabbed Dr. Fulmer's desk, telling the frightened counselor that he (the inmate) had planned to stab him (Fulmer), but had decided against it because Fulmer had correctly answered a question earlier in the day.[419] This was only one of many examples that point to the fact that life at Eastern State could be incredibly, and randomly, violent. According to former guard Tom Finn, "You had maybe a couple of skirmishes a month. I mean a stabbing or, you know, fights."[420] These "skirmishes" often left a body count. For instance, in November 1953, Robert Robinson, one of Eastern State's barbers, fatally stabbed Emmanuel L. Porter with an eight-and-half-inch-long table knife.[421] Five years later, Charles A. Barr stabbed Edward Huber in the penitentiary's reception center while the two men were unguarded. Apparently, the two had gotten into a fistfight earlier in the day, but that was broken up by the guards. Barr accosted Huber later in the day, renewed the fight and stabbed Huber with a sharpened table knife similar to the one Robinson had used the previous November.[422]

In 1967, William Jennings Mundy died at the penitentiary after being found unconscious in his cell. Jennings apparently had been slashed by a razor in the arm, but no razor was discovered in the cell, suggesting that it was not a suicide.[423] In another incident, inmate Robert Lee Jackson injured three guards during a mêlée that started when Jackson refused to obey an order. It took six guards to subdue Jackson, who was later charged with multiple counts of assault.[424] In March 1967, Clarence Young stabbed another inmate, Cornell Wylie, while the two worked in the penitentiary's mess hall. No reason was given for the attack.[425]

The inmates were not the only ones prone to violence. During this period, a shadowy group of guards known as "the goon squad" enforced discipline and order through a variety of "non-official" means. Though the goon squad disappeared after William A. Banmiller became warden in 1956, it was nonetheless a major force within the penitentiary for punishment and retribution. The goon squad was overseen by Warden Walter Tees, whose antipathy toward rehabilitation and prisoners' rights made him a bit of a holdover from the militaristic style of governance described in the last chapter. Former inmate Cliff Redden remembered that some members were ex–prize fighters because "they need to be…some tough guys." According to Redden, "The goon squads were rough. Yeah, they would rough you up and get you out of the cell and drag you, if need be, down to the punishment block."[426]

One important development during this period was the rise and growth of the Nation of Islam as a force in American prisons. Eastern State was no exception, and as the penitentiary's black population rose, so did the number of inmates identifying themselves as Muslim. Founded in 1930 by Wallace Fard Muhammad, the Nation of Islam became

Eastern State Penitentiary

a presence in American prisons during World War II, when the Nation's leaders were convicted of refusing to serve in the United States Armed Services. Prisons became an important recruiting station, inmates being the ultimate "captive audience." According to former New York State prison chaplain Imam Talib Abdur Rashid, the Nation of Islam appealed to black inmates because of "slavery, segregation and the history of U.S. racism."[427]

In addition, the black Muslim movement created a sense of solidarity among Eastern State's African American inmates and provided them with security. According to former inmate Willie "No-No" Smith, who was at Eastern State during this period, "a whole lot of those Muslims…joined them for protection. And they were doing that because of fear."[428] Eastern State, with its segregated cellblocks, all-white guard force (until 1957) and goon squad became an ideal location for conversions to the Nation of Islam. Moreover, the Muslims were the only major religious group at Eastern State denied a specialized place of worship; Jews, Catholics and Christians all had dedicated sanctuaries staffed by trained ministers.

Though it is impossible to know when the Nation of Islam first appeared in Eastern State, by the late 1950s, black Muslims and the penitentiary's administration were on a collision course. In 1959, the warden requested the support of state troopers to avert a possible riot following a series of small confrontations between the Muslims and the administration.[429] These included an attack against a number of guards by Muslim inmates in the penitentiary's kitchen, which resulted in the administration banning black Muslims from practicing their faith, arguing that the religion tended to "disturb the orderly functions and administration of the penal institution…[and therefore] must be regulated by the administrators of the prison."[430]

Five years later, inmate Maurice X. Walker filed a petition with Philadelphia's district attorney's office, arguing that the penitentiary discriminated against black Muslims by refusing inmates the opportunity to practice their religion and by punishing black inmates by segregating them in "prison ghettoes." Walker demanded that the penitentiary set

Eastern State's synagogue, built in the 1920s. *Photo courtesy of Dr. Jennifer Murphy.*

The Return of Rehabilitation

Eastern State's chapel, built in 1953. *Photo courtesy of Dr. Jennifer Murphy.*

aside a designated space so that, once a week, black Muslims could worship. In addition, he requested that Muslim inmates be permitted access to a "religious representative" and that they receive religious literature.[431] These were not unreasonable requests, given the fact that both Christians and Jews had special sanctuaries in the penitentiary.[432] Nonetheless, the administration refused to allow the inmates to practice their faith or proselytize, which only heightened the Muslims' sense of grievance.

In many ways, the administration's continuing problems with the penitentiary's Muslim population reflected the functional racism that characterized the institution until it closed. Though the majority of inmates remained white, blacks were a close second, and from 1904 to 1964, the penitentiary's official policy was segregation. Former inmate Roosevelt Grant recalled that, during his sentence, blacks and whites did not mix. During sports games, teams were always blacks versus whites, which most likely increased racial tension.[433] The first black minister, Dr. Arthur D. Williams, was not hired until 1962. According to Dr. Williams, his experience with prejudice made it easier to win inmates' confidence because "they come forward more readily if they know this guy here, the chaplain, has been short-changed and 'framed.'"[434]

In addition, the majority of the officers who oversaw the prisoners were white. Eastern State did not hire its first black guard until the late 1950s. Moreover, the guard corps reflected Philadelphia's ethnic and racial tensions. First and foremost a city of neighborhoods, Philadelphians from working-class neighborhoods like Fairmount tended to be clannish and look askance at outsiders. According to Steve Bednarek, "A lot of family worked here. And friends."[435] For an almost completely white guard force, working with inmates of color during a period of heightened racial tension was extremely difficult and often led to violence.[436]

Eastern State also experienced its share of riots during this period. In addition to the aforementioned 1953 uprising, the penitentiary's inmates rebelled in 1961 following a failed escape attempt. On December 24, 1960, inmate Richard Mayberry was discovered carrying a zip gun, or a penitentiary-built weapon that uses a spring to propel "bullets."

This was the first indication that an escape was being planned, though Mayberry's capture obviously pushed back the date. Two weeks later, after cleaning the officers' dining hall, inmate John Klauzenberg asked the guard on his cellblock, Donald Carr, to open another inmate's cell so that he (Klauzenberg) could retrieve his guitar. Klauzenberg told the guard that he had loaned it to the other inmate, a man named Harry Shank. Though this was against the rules, Carr was a "newjack," or recently hired guard, and he complied, taking Klauzenberg down to Shank's cell and opening the door. Once the door was open, both Klauzenberg and Shank subdued Carr, stabbing the guard in the process. Though Carr managed to escape from the cell, the two inmates had taken his keys, which they used to release another inmate, Manny Madronal.

The three inmates, brandishing homemade knives, made their way to Center and took the four guards on duty hostage. One of those guards was Lieutenant William Richter, who, as the senior officer, was in charge of the penitentiary. The three inmates then swapped clothes with the captured guards and moved to secure cellblocks one (administrative segregation) and fifteen (Death Row or maximum security). Klauzenberg, Shank and Madronal likely assumed that the inmates on these blocks, all of whom had histories of violent crime or inability to follow the penitentiary's rules, would prove ideal assistants in what was quickly becoming a riot. Among the inmates freed from cellblocks one and fifteen were two who are generally considered to be the other two ringleaders of the riot, Dominic Codispodi, who knew Madronal from the outside, and Anthony Scoleri, who was counting down the days until his execution.

Unfortunately for the rioters, Officer Carr, who hid after being attacked, managed to contact the officers in the gatehouse, who in turned called Warden Brierly at home and informed him that some of the inmates were out of their cells in the penitentiary. Brierly, when he could not reach Lieutenant Richter in Center, assumed that Richter had been taken hostage and immediately set into motion a predetermined plan. Called "Operation Breakout," the plan was designed to coordinate the efforts of the Pennsylvania State Police, Philadelphia Police Department and the Philadelphia Fire Department in order to first contain, and then end, a riot or escape. Once the ringleaders figured out that the administration was on to them, they decided to free *all* of the penitentiary's inmates, hopeful that the chaos would provide enough cover for them to escape. A significant number of inmates were released from their cells (mostly white because the ringleaders only made it to the white cellblocks of the still-segregated penitentiary), and there are some reports of inmates exacting vengeance on one another and on guards.

The breakout started at roughly 8:00 p.m., when Officer Carr was attacked, but within an hour and a half, the warden was on the scene restoring order. Deputy Warden Brierly claimed that it took him only half an hour to return the inmates who had not taken hostages to cells and that, by 10:00 p.m., Eastern State was flooded by four dozen guards and state policemen ready to reassert control. Brierly and his troop made it as far as the garage, where the ringleaders were holed up with inmates, knives, zip guns and Molotov cocktails made from filled gas cans. One of the ringleaders even threatened to decapitate the guards and roll their heads out "like bowling balls" if the warden approached the garage. Brierly responded by having the state troopers fire tear gas into the garage, and then he stormed the garage. Eventually, Brierly's troops overcame the rioters, and all of

The Return of Rehabilitation

the men in the garage were stripped naked and made to stand in the cold so that the guards could be separated from the inmates. Once that happened, the inmates were carted back to their cells, where they were severely punished. The time was 10:20 p.m., less than three hours after John Klauzenberg finished cleaning the officers' mess and made his way back to his cellblock.[437]

Most of the inmates did not riot, and many were as confused and scared by the chaos as the administrators. Former inmate Willie "No-No" Smith lived on cellblock ten in 1961. The night the riot broke out, he was laying in bed, listening to Louis Armstrong through headphones, oblivious to the violent outburst taking place on the other side of the penitentiary. He was awakened by a harsh voice demanding that he come into the corridor. Smith saw the man's uniform and jumped to the only logical conclusion in 1961: the Communists had taken over the country and were going to liberate Eastern State. He was understandably confused when the uniformed man told him to strip and sent him back to his cell. Smith said to his cellmate across the corridor, "I see that the United States won't play with them Communists, and they done took it over. Now I guess they're satisfied." The man in other cell had to tell Smith it was state troopers, not Soviets, who had occupied the penitentiary.[438]

Though the riot was successfully contained, the violent outburst was an embarrassment to both the penitentiary and the state legislature because it "spurred renewed criticism of the antiquated structure and its residential location."[439] None of these points were new. Eastern State had been criticized for nearly half a century for being obsolete and a hazard to the city. Following the 1945 tunnel escape, then-warden Herbert Smith had complained that "the physical conditions [of Eastern State Penitentiary] are not fitted for a general criminal population."[440] After the riot in 1961, however, the public became aware of just how vulnerable the aging institution was, and demanded a solution. The legislature funded a three-year study of the Pennsylvania penal system, which recommended sweeping changes, including the relocation of Eastern State to a site outside Philadelphia. Unfortunately, few municipalities were looking to add a maximum security prison to their infrastructure, and repeated attempts to procure land were defeated by the township councils in those areas. The commonwealth offered to give Eastern State (a large, and therefore valuable, piece of land) to the City of Philadelphia if the city would help find another site, but promising sites in Philadelphia, like Fort Mifflin, fell through.[441] For the time being, Eastern State survived, though the penitentiary was clearly existing on borrowed time.

Unable to find a suitable parcel of land, the commonwealth simply decided to close the penitentiary, transfer the inmates to other institutions and sell the building to the City of Philadelphia. According to Norman Johnson, the state could no longer overcome "the excessive maintenance costs" that went along with operating a century-and-a-half-old building. The announcement, in September 1969, that Eastern State would close within a year was met with sadness by the inmates who had called the imposing castle their home. According to a former guard, "A lot of them won't admit it, but they sat down in their cell and cried when this place was going to be shut down. They didn't want to go to Pittsburgh, they didn't want to go to Belfont…they wanted to stay at Eastern."[442] By January 1970, that was no longer an option, and all but a handful of inmates left behind

Eastern State Penitentiary

The last state prisoners leave Eastern State. *Photo courtesy of the Urban Archives, Temple University.*

Eastern State's central guard tower today. *Photo courtesy of Dr. Jennifer Murphy.*

The Return of Rehabilitation

Photo courtesy of Dr. Jennifer Murphy.

as a maintenance force were dispersed among the commonwealth's other institutions. Three months later, even this small contingent of men was also transferred. Though Eastern State housed a few hundred inmates following a riot at the city's Holmesburg prison, by the end of 1971, the once world-famous institution stood empty, a sad reminder of the hopes and dreams of a small group of Philadelphians who believed that this unique building could remake men's souls.

CONCLUSION

Following its closure in 1971, Eastern State was all but abandoned. Though the city appointed a caretaker to periodically visit the site, in reality the building sat unused and abused. Various proposals to redevelop the penitentiary surfaced throughout the 1970s and 1980s, including developing a juvenile justice center, a shopping center or even luxury condominiums (conveniently retaining the penitentiary's massive walls). Eventually, all of these proposals fell apart for one reason or another: lack of state or municipal financing, not enough interested developers, demographic changes in the neighborhood, et cetera. Sometime during the 1970s, the city began dumping outdated equipment on the site, creating a surreal wasteland of office equipment between blocks five and six (fortunately, much of this has since been cleared). In addition, vandals and thieves ransacked the site, stealing the penitentiary's copper piping and wooden cell doors and breaking many of the original windows. Finally, Mother Nature added her two cents: plants and fallen leaves clogged Eastern's drainage systems, which backed up and flooded various parts of the penitentiary, accelerating its decay.

Despite the fact that that Eastern State was named a National Historic Landmark in 1965, it was not until 1988 that a task force was formed to prevent the commercial redevelopment of the site and celebrate Eastern State's historical importance. Three years later, the Pew Charitable Trusts issued a grant to begin stabilization efforts, and three years after that, Eastern State Penitentiary Historic Site, Inc. opened the penitentiary for daily tours. In the years since, Eastern State Penitentiary has received national and international attention as an incredibly unique historical attraction.

As I suggested in the introduction, Eastern State's story is about continuity rather than change. Reviewing the last five chapters makes it clear that, whether in the nineteenth or twentieth century, the penitentiary's administrators faced a host of difficult problems. Eastern State's history is not *just* the bloody and shocking story of criminals and their keepers. It is the beginning of a debate about "modern" methods of curtailing crime. Eastern State's founders and administrators sought the magical balance of two related forces—penitence and punishment—in their search for the perfect republican society promised by the Revolution. As I suggested in the introduction, this is a debate that still rages today. And perhaps that is what Eastern State has to teach us: as far as we think we've come, we still have a very long way to go.

NOTES

CHAPTER 1

1. George Bancroft, *History of the United States From the Discovery of the Continent*, Vol. 1 (New York: D. Appleton and Company, 1884), 558.
2. Anthony Babington, *The English Bastille: A History of Newgate Gaol and Prison Conditions in Britain 1188–1902* (New York: St. Martin's Press, 1971), 61.
3. Finn Hornum, "Prison Labor: General Background and Early Years," *Historic Structures Report*, 36.
4. Harry Elmer Barnes, *The Evolution of Penology in Pennsylvania: A Study in American Social History* (Montclair, NJ: Patterson Smith, 1968), 39.
5. Jack D. Marietta and G.S. Stone, *Troubled Experiment: Crime and Justice in Pennsylvania, 1682–1800* (Philadelphia: University of Pennsylvania Press, 2006), 75.
6. Janet Semple, *Bentham's Prison: A Study of the Panopticon Penitentiary* (Oxford, UK: Clarendon Press, 1993), 79.
7. J.M. Moynahan and Earle K. Stewart, *The American Jail: Its Development and Growth* (Chicago: Nelson Hall, 1980), 22.
8. D.L. Howard, *John Howard: Prison Reformer* (London, UK: Christopher Johnson, 1958), 17.
9. Ibid., 39.
10. Ibid., 41; and Randall McGowen, "The Well-Ordered Prison," in Norval Morris and David J. Rothman, eds., *The Oxford History of the Prison: The Practice of Punishment in Western Society* (New York: Oxford University Press, 1998), 79.
11. Howard, *John Howard*, 42.
12. Max Grunhut, *Penal Reform: A Comparative Study* (London, UK: Oxford University Press, 1948).
13. Mark Colvin, *Penitentiaries, Reformatories, and Chain Gangs: Social Theory and the History of Punishment in Nineteenth-Century America* (New York: St. Martin's Press, 1997), 49.
14. McGowen, "Well-Ordered Prison," 79.
15. Ibid., 80.
16. Marietta and Stone, *Troubled Experiment*, 75.
17. Michael Meranze, *Laboratories of Virtue: Punishment, Revolution, and Authority in Philadelphia, 1760–1835* (Chapel Hill: University of North Carolina Press, 1996), 22.
18. Marietta and Stone, *Troubled Experiment*, 35.
19. Negley K. Teeters, *The Cradle of the Penitentiary: The Walnut Street Jail at Philadelphia, 1773–1835* (Philadelphia, PA: n.p., 1955), 18.
20. Harry Elmer Barnes, *The Story of Punishment: A Record of Man's Inhumanity to Man*, 2nd edition (Montclair, NJ: Patterson Smith Publishing Corp, 1972), 64.
21. *Statutes at Large of Pennsylvania*, Vol. XII, 280–281, in Teeters, *Cradle of the Penitentiary*, 27.
22. Negley K. Teeters, *They Were in Prison* (New York: The John C. Winston Co., 1937), 22–23.

23. Richard Vaux, *Brief Sketch of the Origin and History of the State Penitentiary for the Eastern District at Philadelphia* (Philadelphia: McLaughlin Brothers, 1872), 13.
24. Caleb Lownes, *An Account of the Alteration and Present State of the Penal Laws of Pennsylvania; Containing Also an Account of the Gaol and Penitentiary House of Philadelphia and the Interior Management Thereof* (Lexington, MA: J. Bradford, 1794), 4–5.
25. Benjamin Rush, quoted in Teeters, *They Were in Prison*, 25.
26. Quoted in Teeters, *They Were in Prison*, 3.
27. Teeters, *They Were in Prison*, 91.
28. Ibid., 5.
29. Ibid., 122.
30. Ibid., 29.
31. William White to John Howard, letter in Harry Elmer Barnes, "The Historical Origins of the Prison System in America," *Journal of the American Institute of Criminal Law and Criminology* 12, 1 (May 1921): 44.
32. *Extracts and Remarks on the Subject of Punishment and Reformation of Criminals* (Philadelphia, PA: Zachariah Poulson, 1790), 4.
33. Thorstein Sellin, "Introduction," in Gustave de Beaumont and Alexis de Tocqueville, *On the Penitentiary System and Its Application in France* (Carbondale: Southern Illinois Press, 1979), xxix.
34. Michele Taillon Taylor, "Building the Pennsylvania System: 1818–1829," *HSR*: 44.
35. Joseph J. McCadden, "Roberts Vaux and His Associates in the Pennsylvania Society for the Promotion of Public Schools," *Pennsylvania History* III, 1 (Janurary 1936): 14.
36. Teeters, *They Were in Prison*, 63.
37. John Thomas Scharf, *Thompson Westcott History of Philadelphia, 1609–1884* (L.H, Everts & Company, 1884), 1830.
38. William White, "Memorial No. 4," reproduced in Teeters, *They Were in Prison*, 452–53.
39. Negley K. Teeters and John D. Shearer, *The Prison at Philadelphia, Cherry Hill: The Separate System of Penal Discipline, 1829–1913* (New York: Columbia University Press for Temple University Press, 1957), 18.
40. Taylor, "Building the Pennsylvania Sysytem," 48.
41. Stuart M. Blumin, "Residential Mobility Within the Nineteenth-Century City," in *The Peoples of Philadelphia: A History of Ethnic Groups and Lower Class Life, 1790–1940*, edited by Allen F. Davis and Mark H. Haller (Philadelphia: University of Pennsylvania Press, 1998), 47.
42. Elizabeth M. Geffen, "Industrial Development and Social Crisis, 1841–1854," in *Philadelphia: A 300 Year History*, edited by Russell Weigley (New York: W.W. Norton, 1982), 309.
43. Michael Feldberg, "Urbanization as a Cause of Violence: Philadelphia as a Test Case," in Davis and Haller, *Peoples of Philadelphia*, 57.
44. Roger Lane, *Violent Death in the City: Suicide, Accident & Murder in 19th Century Philadelphia* (Cambridge, MA: Harvard University Press, 1979), 60.
45. Feldberg, "Urbanization as a Cause," 56.
46. David R. Johnson, "Crime Patterns in Philadelphia, 1840–70," in Davis and Haller, *Peoples of Philadelphia*, 98.
47. Ibid., 109.
48. Michael Feldberg, *The Turbulent Era: Riot and Disorder in Jacksonian America* (New York: Oxford University Press, 1980), 15.
49. Daniel Walker Howe, *What Hath God Wrought: The Transformation of America* (New York: Oxford University Press, 2007), 167.
50. Nicholas B. Wainwright, "The Age of Nicholas Biddle," *Philadelphia: A 300 Year History*, 281.
51. Ibid., 282.
52. Beaumont and Tocqueville, *On the Penitentiary System*, 45.
53. William Crawford, *Report on the Penitentiaries of the United States* (Montclair, NJ: Patterson Smith, 1969), 15.
54. Harriet Martineau, *Retrospect of Western Travel*, Vol. I (New York: Harper & Brothers, 1838), 128.
55. Teeters, *Cradle of the Penitentiary*, 112.
56. Ibid., 111.

57. Sandra Tateman and Riger W. Moss, *Biographical Dictionary of Philadelphia Architects: 1700–1930* (Boston, MA: G.K. Hall & Company, 1984), 342–43.
58. Teeters and Shearer, *Prison at Cherry Hill*, 57.
59. Tateman and Moss, *Biographical Dictionary*, 343.
60. Norman Johnston, *The Human Cage: A Brief History of Prison Architecture* (Philadelphia: The American Foundation, Inc., 1973), 30.
61. John Haviland, quoted in Jeffrey Cohen, "Choosing and Refining the Design, 1818–1829," *HSR*: 53.
62. Ibid., 54.
63. Teeters and Shearer, *Prison at Cherry Hill*, 43.
64. Norman Johnston, *Crucible of Good Intentions: Eastern State Penitentiary* (Philadelphia: Philadelphia Museum of Art, 2000), 32.
65. David G. Cornelius, "Heating," *HSR*: 100.
66. Ibid., 23.
67. Faye Ringel, "Building the Gothic Image in America: Changing Icons, Changing Times," *Gothic Studies* 4, 2 (November 2002): 147.
68. Jeffrey A. Cohen, "Choosing and Refining the Design, 1818–1829," *HSR*: 56.
69. Teeters and Shearer, *Prison at Cherry Hill*, 20.
70. Ibid., 21.
71. Ibid.
72. Ibid., 23.
73. Ibid., 36.
74. Finn Hornum, "Prison Labor: General Background and Early Years," *HSR*: 38.
75. Teeters and Shearer, *Prison at Cherry Hill*, 36.
76. Johnston, *Crucible of Good Intentions*, 29.
77. Jeffrey Cohen, "Fabric Summary: Construction, Alterations, and Uses of Space," *HSR*: 282.
78. Teeters and Shearer, *Prison at Cherry Hill*, 38.
79. Ibid., 38–39.

CHAPTER 2

80. Norman Johnston, "Introduction," in *Report on the Penitentiaries of the United States*, reproduced from the 1835 edition (Montclair, NJ: Patterson Smith, NJ: 1969), xi.
81. Ibid., 2.
82. Teeters and Shearer, *Prison at Cherry Hill*, 186.
83. William Crawford, "Appendix," in *Report on the Penitentiaries*, 8; and Johnston, *Crucible of Good Intentions*, 49.
84. Michele Taillon Taylor, "Neighborhood and Prison Management during the Early Eighteenth Century," *HSR*: 151.
85. "Cellblock Seven," *HSR*, 302.
86. Vaux, *Brief Sketch*, 99.
87. Johnston, *Crucible of Good Intentions*, 49.
88. Teeters and Shearer, *Prison at Cherry Hill*, 186.
89. *Extracts and Remarks on the Subject of Punishment and Reformation of Criminals* (Philadelphia, PA: Zachariah Poulson, 1790), 4.
90. Vaux, *Brief Sketch*, 6.
91. Barnes, *Evolution of Penology*, 291.
92. Charles Dickens, *American Notes* (London: Penguin Books, 2002), 113.
93. *Fourteenth Annual Report of the Inspectors of the Eastern State Penitentiary* (Philadelphia: Joseph & William Kite, 1843), 4; quoted in Robert Daniels Tuttle, "The Personal Services in The Eastern State Penitentiary of Pennsylvania, 1829–1870" (master's thesis, University of Chicago, 1946), 11.
94. Dorothea L. Dix, *Remarks on Prisons and Prison Discipline in the United States*, 2nd edition (Philadelphia: Joseph Kite & Co., 1845), 72.

95. Leslie C. Patrick-Stampp, "Prisoners' Presence and Perspectives," *HSR*: 112.
96. This figure is derived from the 1840 census, which reported that the illiteracy rate in Philadelphia was roughly 2 percent of the adult male population.
97. *Tenth Annual Report of the Inspectors of the Eastern State Penitentiary* (Philadelphia: Joseph & William Kite, 1843).
98. John C. McWilliams, *Two Centuries Corrections in Pennsylvania: A Commemorative History* (Harrisburg: Pennsylvania Historical and Museum Commission, Miller, J.G., 1998), 17.
99. Mary L. Dodge, *"Whores and Thieves of the Worst Kind": A Study of Women, Crime, and Prisons, 1835–2000* (DeKalb: Northern Illinois University Press, 2002), 13.
100. *Thirteenth Annual Report of the Eastern State Penitentiary of Pennsylvania* (Philadelphia: Mifflin & Parry, 1842), 15.
101. Dickens, *American Notes*, 116.
102. Beaumont and Tocqueville, *On the Penitentiary System*, 46.
103. Finn Hornum, "Penal Philosophy," *HSR*: 62.
104. Samuel Walker, *Popular Justice: A History of American Criminal Justice* (New York: Oxford University Press, 1980), 66–68; quoted in Hornum, "Penal Philosophy," 63.
105. "Rules for the Visiting Committees of the Eastern State Penitentiary and Philadelphia County Prison."
106. Teeters and Shearer, *Prison at Cherry Hill*, 31.
107. Finn Hornum, "Prison Governance and Administration, 1829–1865," *HSR*: 65.
108. E.S. Abdy, *Journal of a Residence and Tour in the United States of North America*, Vol. III (London, John Murray, 1835), 149
109. George Ryno, *Buds and Flowers: Of Leisure Hours*, quoted in Patrick-Stampp, "Prisoners' Presence," 138.
110. *Eighteenth Annual Report of the Board of Inspectors of the Eastern State Penitentiary of Pennsylvania* (Philadelphia: Ed Barrington, 1847), 11.
111. Geffen, "Industrial Development and Social Crisis," 335.
112. Teeters and Shearer, *Prison at Cherry Hill*, 88.
113. Dix, *Remarks on Prisons*, 71.
114. Letter to George Thompson, Esq., from Matthew Hammond at the APS.
115. William Parker Foulke, "Remarks on Cellular Separation: Read by Appointment of the American Association for the Improvement of Penal and Reformatory Institutions, at the Annual Meeting in New York, November 29, 1860," in Richard Vaux, *The Pennsylvania System of Separate Confinement Explained and Defended* (Philadelphia: J.B. Chandler, 1867), 36.
116. Finn Hornum, "Statement of Penological Significance," *HSR*: 15.
117. Hornum, "Penal Philosophy," 60.
118. Dennis Brian, *Sing Sing: The Inside Story of a Notorious Prison* (Amherst, NY: Prometheus Boos, 2005), 15.
119. Christopher Adamson, "Toward a Marxian Penology: Captive Criminal Populations as Economic Threats and Resources," *Social Problems* 31, 4 (April 1984): 446.
120. Crawford, "Appendix," 19.
121. McWilliams, *Two Centuries Corrections*, 19.
122. Vaux, *Brief Sketch*, 94.
123. "Things as They Are in America: Philadelphia," *Chambers Journal of Popular Literature, Science and Arts* 36 (September 1854): 169.
124. "Prince Napoleon in Philadelphia," *Philadelphia Inquirer*, August 2, 1861.
125. Martineau, *Retrospect of Western Travel*, 123.
126. Beaumont and Tocqueville, *On the Penitentiary System*, 84.
127. Dickens, *American Notes*, 122–23.
128. *A Concise History of the Eastern Penitentiary of Pennsylvania* (Philadelphia: Neall & Massey, 1835), 34.
129. Ibid.
130. Ibid., 156.
131. Samuel Wood, quoted in Teeters and Shearer, *Prison at Cherry Hill*, 97.
132. Teeters and Shearer, *Prison at Cherry Hill*, 97.
133. *A Concise History*, 39.

134. Ibid., 40.
135. Letter to George Thompson, Esq.
136. Dickens, *American Notes*, 114.
137. Ibid., 116.
138. Ibid., 115.
139. "The Quaker City," *New York Times*, December 26, 1872, 3.
140. "Prison Labor," *Philadelphia Inquirer*, June 7, 1877, 1.
141. "Dickens' Prisoner," *New York Times*, October 14, 1878, 8.
142. Abdy, *Journal of a Residence*, 144.
143. Robert Harding, letter, October 27, 1844.
144. Adolph B. Benson, ed., *America of the Fifties: Letters of Frederika Bremer* (New York: American-Scandinavian Foundation, 1924), 154.
145. "Things as They Are in America: Philadelphia," *Chambers Journal of Popular Literature, Science and Arts* 36 (September 1854): 169.
146. Dickens, *American Notes*, 114.
147. "Dickens' Prisoner," 8.
148. "City Intelligence," *Philadelphia Inquirer*, July 29, 1868, 8.
149 "The Quaker City," *New York Times*, December 26, 1872, 3.
150. "An Adroit Escape from the Eastern Penitentiary," *New York Times*, October 13, 1852, 3.
151. Letter to George Thompson, Esq.
152. Ibid.
153. Warden's Daily Journal, November 12, 1835, Record Group 15, Pennsylvania State Archives.
154. Ibid.
155. Ibid.
156. "Suicide—Accident and Death—The Celebration of Christmas," *New York Times*, December 25, 1854, 1.
157. Warden's Daily Journal.
158. Ibid.
159. *A Concise History*, 24–25.
160. Newspaper Clipping held in Bulletin Collection, Urban Archives, Temple University, undated.
161. Warden's Daily Journal.
162. McWilliams, *Two Centuries Corrections*, 18.
163. Warden's Daily Journal, January 5, 1840.
164. *A Concise History*, 24.
165. *Fourth Annual Report of the Board of Inspectors of the Eastern State Penitentiary of Pennsylvania* (Philadelphia: Society for Alleviating the Miseries of Public Prisons, 1833), 9.
166. *A Concise History*, 48.
167. Ibid., 49.
168. Harry Elmer Barnes, "The Economics of American Penology as Illustrated by the Experience of the State of Pennsylvania," *Journal of Political Economy* 29, 8 (October 1921): 622.
169. Crawford, *Report on the Penitentiaries*, 13.
170. Ibid., 11.
171. Martineau, *Retrospect of Western Travel*, 136.
172. *Ninth Annual Report of the Board of Inspectors of the Eastern State Penitentiary of Pennsylvania* (Philadelphia: William Brown, 1838), 8.
173. Martineau, *Retrospect of Western Travel*, 128.
174. Ibid., 133.
175. "An Unfounded Rumor," *Philadelphia Inquirer*, July 29, 1868, 8.
176. Finn Hornum, "Statement of Penological Significance," *HSR*: 13.
177. E.V. Elwell to Albert Jackson, letter, April 18, 1862, State Penitentiary for the Eastern District of Pennsylvania Records, American Philosophical Society.

CHAPTER 3

178. Teeters, *They Were in Prison*, 401.
179. "Eastern Penitentiary," *Philadelphia Inquirer*, September 5, 1872, 2.
180. "Penal Solitude," *Philadelphia Inquirer*, November 1, 1881, 2.
181. "In Solitude," *Philadelphia Inquirer*, November 3, 1881, 2.
182. Teeters and Shearer, *Prison at Cherry Hill*, 318.
183. "In Solitude," 2.
184. Cassidy 1897 Investigation, Pennsylvania State Archives, RG-15, p. 4.
185. Land, *Violent Death in the City*, 69.
186. Ibid., 89.
187. Edith Abbot, "The Civil War and the Crime Wave of 1867–70," *Social Service Review* 1 (March 1927): 216.
188. Rendigs Fels, "American Business Cycles, 1865–79," *American Economic Review* 41, 3: 325–49.
189. James McKenn, "Evolution of Penal Methods and Institutions," in *Factors in American Civilization: Studies in Applied Sociology* (New York: D. Appleton and Company, 1893), 263.
190. Christina Romer, "Spurious Volatility in Historical Unemployment Data," *Journal of Political Economy* 94, 1 (1986): 1–37.
191. "Cellblock Two," *HSR*: 288.
192. "Enlarging the Penitentiary," *Philadelphia Inquirer*, March 24, 1877, 2.
193. "United States Prisoners," *Bourbon News*, February 28, 1902, 5.
194. Johnston, *Crucible of Good Intentions*, 84.
195. Ibid.; and Teeters and Shearer, *Prison at Cherry Hill*, 221.
196. Teeters and Shearer, *Prison at Cherry Hill*, 221.
197. McWilliams, *Two Centuries Corrections*, 14.
198. *Our History: Pioneer in United States Prison Labor*, http://www.pci.state.pa.us/pci/cwp/view.asp?a=3&q=82379 (accessed May 16, 2008).
199. Clair Wilcox, *The Report of the Pennsylvania State Parole Commission* (New York: Arno Press, 1974), 34.
200. McWilliams, *Two Centuries Corrections*, 15.
201. Ibid., 15.
202. "Gone," *Philadelphia Inquirer*, August 2, 1871, 4.
203. Ibid.
204. "Attempted Escape of Two Convicts," *New York Times*, June 16, 1874, 1.
205. Vaux, *Brief Sketch*, 65.
206. "Convicts Over Prison Wall," *New York Sun*, August 27, 1908, 2.
207. Cassidy 1897 Investigation, 72.
208. "Convicts Over Prison Wall," 2.
209. "Escape By Secret Ladder," *New York Times*, August 21, 1913, 6.
210. "Fight in a State Prison," *New York Times*, November 12, 1873, 1.
211. "Beheaded by His Cell-Mate," *Evening World*, June 5, 1900, 1.
212. "Found Dead in Their Cell," *New York Times*, March 18, 1881, 1.
213. "Suicide in a Penitentiary," *New York Times*, February 12, 1882, 1.
214. "Insubordination," *Philadelphia Inquirer*, April 25, 1873, 2.
215. "A Convict Picking Cell Locks in the Eastern Penitentiary," *New York Times*, January 5, 1874, 1.
216. "Insubordination," 2.
217. "Insane Convicts at Eastern Penitentiary," *Philadelphia Inquirer*, February 15, 1881, 2.
218. "Another Idler," *Philadelphia Inquirer*, March 1, 1881, 8.
219. Cassidy 1897 Investigation, 25.
220. "Another Idler," 8; and "Timely Discovery Results in the Ousting of the Warden," *San Francisco Call*, October 5, 1903, 1.
221. Cassidy 1897 Investigation, 83.
222. "Insane Convicts," 2.
223. *Memorials of Judges, Inspectors, Wardens, Physicians, and Philanthropists Approving the Recommendation of the Board of Public Charities of the Instance and the Prisons and Poorhouses of Pennsylvania* (Philadelphia: A.C. Bryson & Co., 1874), 5.

224. Ibid., 6.
225. Gordon 1897 Investigation, Pennsylvania State Archives, RG-15, p. 517.
226. Ibid., 519.
227. Ibid., 521.
228. Teeters and Shearer, *Prison at Cherry Hill*, 108.
229. James C. Biddle 1897 Investigation, Pennsylvania State Archives, RG-15, pp. 299–303.
230. Ibid.
231. "Judge Gordon Writes a Scathing Letter," *Philadelphia Inquirer*, April 14, 1897, 1.
232. Ibid., 5.
233. "Eastern Penitentiary: The Inspectors Write a Letter to the Governor," *Philadelphia Inquirer*, April 22, 1897, 1.
234. Ibid.
235. "The Penitentiary Revelation," *Philadelphia Inquirer*, May 1, 1897, 6.
236. Teeters and Shearer, *Prison at Cherry Hill*, 211.
237. Zebulon Brockway, quoted in James McKenn, "Evolution of Penal Methods and Institutions," 246.
238. Harry Elmer Barnes, quoted in McWilliams, *Two Centuries Corrections*, 26.
239. Finn Hornum, "Reactions to the New Developments in Penology," *HSR*: 169.
240. Finn Hornum, "Statement of Penological Significance," *HSR*: 13.
241. Teeters, *They Were in Prison*, 208.
242. *The Eastern State Penitentiary of Philadelphia* (Philadelphia: Eastern State Penitentiary, 1916), 9.
243. McWilliams, *Two Centuries Corrections*, 25.
244. Teeters and Shearer, *Prison at Cherry Hill*, 109.
245. Barnes, *Evolution of Penology*, 300; quoted in Teeters, *They Were in Prison*, 392.
246. Teeters, *They Were in Prison*, 393.
247. Ibid., 374.
248. 1897 Investigation, Pennsylvania State Archives, RG-15, p. 3.
249. Andrew Maloney 1897 Investigation, Pennsylvania State Archives, RG-15, p. 125.
250. Conrad B. Day, 1897 Investigation, Pennsylvania State Archives, RG-15, p. 190.
251. 1897 Investigation, Pennsylvania State Archives, RG-15, p. 295.
252. "Warden Cassidy: Former Convicts Have a Pleasant Word to Say About Him," *New York Daily Tribune*, April 8, 1900, 4.
253. "Segregation of Prisoners," *New York Times*, March 19, 1900, 5.
254. "Waited in Vain for Chief Wilkie," *Philadelphia Inquirer*, September 22, 1903, 4.
255. "D.W. Bussinger Elected to Succeed M.J. Cassidy," *Philadelphia Inquirer*, May 18, 1900, 3.
256. "Skill Shown in Prison," *New York Tribune*, June 7, 2003, 3–4.
257. "Convicts Operated Mint in Eastern Penitentiary," *Philadelphia Iniquirer*, September 14, 1903, 1.
258. Ibid.
259. Ibid.
260. "Timely Discovery Results in the Ousting of the Warden," *San Francisco Call*, October 5, 1903, 1.
261. "Disease Bred in Prison," *New York Times*, October 31, 1903, 1.
262. "The Oldest Living Convict," *Philadelphia Inquirer*, March 4, 1878, 2.
263. "Begins Prison Term at 93 for the Stealing of Chickens," *New York Times*, February 15, 1922, 12.
264. "Self-Sustaining," *Philadelphia Inquirer*, October 26, 1889, 3.
265. "Boston Girl Weds Inmate of Prison," *Washington Times*, April 12, 1909, 1.
266. "Wants to Marry in Jail," *Evening Times*, March 5, 1901, 5.
267. "Made Visits to Prisoners," *Philadelphia Inquirer*, October 26, 1889, 3.
268. "Everybody's Column," *Philadelphia Inquirer*, December 24, 1902, 8.
269. "Fleecing Convicts," *Philadelphia Inquirer*, July 1, 1881, 2.
270. "Penal Solitude," *Philadelphia Inquirer*, November 1, 1881, 2.
271. "Severe Criticism for Penitentiary," *Philadelphia Inquirer*, December 5, 1903, 2.
272. "Makes Plea for Prison Inmates," *Los Angeles Herald*, December 22, 1906, 8.
273. "Eastern Penitentiary," *Philadelphia Inquirer*, September 5, 1872, 1.
274. "Skill Shown in Prison," *New York Tribune*, June 7, 1903, 3–4.
275. Ibid.

276. Finn Hornum, "Prison Labor, 1866–1923," *HSR*: 224.
277. Dorothy Gondos Beerds, "The Centennial City, 1865–1876," in Weigly, *Philadelphia*, 433.
278. Hornum, "Prison Labor," 222.
279. Barnes, *Evolution of Penology*, 251; quoted in Hornum, "Prison Labor," 223.
280. Teeters and Shearer, *Prison at Cherry Hill*, 92.

CHAPTER 4

281. Hannah Kent Schoff, *The Wayward Child: A Study in the Causes of Crime* (Indianapolis, IN: The Bobbs-Merrill Company, 1915), 21.
282. Elsie Hough, *Eastern State Penitentiary Historic Site Oral History Collection*.
283. Schoff, *Wayward Child*, 21.
284. Brian, *Sing Sing*, 90.
285. B. 8266, *A Tale of a Walled Town And Other Verses* (Philadelphia: J.B. Lippincott Company, 1921), 105.
286. Newspaper clipping, Bulletin Collection, August 23, 1919.
287. Ibid., September 13, 1919.
288. Ibid., undated.
289. Ibid.
290. Johnston, *Crucible of Good Intentions*, 90.
291. Newspaper clipping, Bulletin Collection.
292. Ibid.
293. Richard Fulmer, *Eastern State Penitentiary Historic Site Oral History Collection*.
294. Newspaper clipping, Bulletin Collection, April 25, 1923.
295. Harry G. Toland, *Gentleman Trooper: How John C. Groome Shaped America's First State Police Force* (Westminster, MD: Heritage Books, 2007), 62.
296. John C. Groome, "The Riot Call," *Saturday Evening Post*, January 25, 1930, 16.
297. "Found Arms and Drugs in Cells of Prison," *New York Times*, April 24, 1923, 25.
298. "Prison was Run by Convict Clique," *New York Times*, April 22, 1923, 22.
299. Ibid.
300. Newspaper clipping, Bulletin Collection, June 12, 1923.
301. Ibid., May 3, 1924.
302. Ibid.
303. Ibid., August 4, 1924.
304. Ibid., August 17, 1927.
305. Groome, "The Riot Call," 16.
306. Newspaper clipping, Bulletin Collection, May 19, 1923.
307. Ibid., undated.
308. Ibid., July 21, 1923.
309. Johnston, *Crucible of Good Intentions*, 90.
310. Toland, *Gentleman Trooper*, 66.
311. Johnston, *Crucible of Good Intentions*, 91.
312. Newspaper clipping, Bulletin Collection, June 5, 1924.
313. Ibid., July 11, 1924.
314. Ibid., May 19, 1923.
315. "Rode with Convicts in Dash to Liberty," *New York Times*, July 16, 1923, 1.
316. "Convicts go to Sea in a Speed Launch," *New York Times*, July 17, 1923, 21; and "Six Escaped Convicts Seen," *New York Times*, July 21, 1923, 2.
317. Newspaper clipping, Bulletin Collection, November 27, 1923.
318. Ibid., July 2, 1926.
319. Ibid., January 2, 1925.
320. Johnston, *Crucible of Good Intentions*, 92.
321. "Asks Investigation of Convict's Beating," *New York Times*, November 29, 1923, 44.

322. Joseph J. Corvi and Steve J. Conway, *Breaching the Walls* (Media, PA: Personal Legends Publishing, 2002), 109; and Willie Sutton and Edward Linn, *Where the Money Was: The Memoirs of a Bank Robber* (New York: The Viking Press, 1976), 187.
323. Sutton and Linn, *Where the Money Was*, 154.
324. Both Sutton's and Corvi's memoirs should be taken with a grain of salt; neither of the books is an approved source for tour content at Eastern State Penitentiary, for good reason. The books not only contradict one another, but they are also oftentimes self-contradictory and were written by people who had reputations for embellishment. Still, it is worth noting that both authors depict Warden Smith in strikingly similar terms.
325. "Capone's Coming Out Party," *Time* XV, 12 (March 24, 1930).
326. Johnston, *Crucible of Good Intentions*, 91.
327. "5 Convicts Escape Through a Sewer," *New York Times*, July 22, 1934.
328. Warden's Daily Journal, February 13, 1940; February 14, 1940.
329. Sutton Interrogation, Eastern State Historic Site, 1945 Tunnel Collection.
330. Corvi and Conway, *Breaching the Walls*, 110.
331. Quentin Reynolds, *I, Willie Sutton* (New York: Farrar, Strauss and Giroux, 1953), 172.
332. Corvi and Conway, *Breaching the Walls*, 115.
333. "Report on Cell #68, Block 7," Eastern State Historic Site, 1945 Tunnel Collection.
334. This is one of the *many* reasons to doubt Sutton's version of events, at least as presented in *I, Willie Sutton*. Sutton argued that Klinedinst was already in cellblock seven at the time he supposedly recruited Klinedinst to dig the tunnel, and Sutton argued that the tunnel took approximately half a year to build. Most other sources give the time as about twelve months, which is certainly a more reasonable estimate given the length and dimensions of the tunnel.
335. Corvi and Conway, *Breaching the Walls*, 114.
336. Norman Johnston, *Escapes From Eastern State Penitentiary* (Philadelphia: Eastern State Penitentiary Historic Site, n.d.), 14–15.
337. Ibid., 17.
338. Corvi and Conway, *Breaching the Walls*, 112.
339. Ibid., 118.
340. Ibid., 119.
341. Ibid., 133.
342. Ibid.
343. Reynolds, *I, Willie Sutton*, 174.
344. Ibid., 175.
345. While all of Eastern State's neighbors interviewed for the oral histories mentioned how comfortable they were with living in proximity to a state penitentiary, one shared a particularly pungent memory. The guard towers on each of Eastern State's four corners have no indoor plumbing, and guards were not allowed to leave their posts during their shifts. Eastern State's guards therefore relieved themselves in buckets. According to Raymond Holstein, who lived a few blocks from the penitentiary, the guards used to empty the buckets over the wall. Asked if he knew of anyone being hit, Holstein said, "No," but he did assert, "You could obviously smell what was going on when you went by."
346. Tom Owens, *Eastern State Penitentiary Historic Site Oral History Collection*.
347. Thomas Ruth, *Eastern State Penitentiary Historic Site Oral History Collection*.
348. Raymond Holstein, *Eastern State Penitentiary Historic Site Oral History Collection*.
349. George Mingle, *Eastern State Penitentiary Historic Site Oral History Collection*.
350. George Zieliniski, *Eastern State Penitentiary Historic Site Oral History Collection*.
351. Ray and Steve Bednarek, *Eastern State Penitentiary Historic Site Oral History Collection*.
352. Elsie Hough, *Eastern State Penitentiary Historic Site Oral History Collection*.
353. William Zielinski, *Eastern State Penitentiary Historic Site Oral History Collection*.
354. Richard Fulmer, *Eastern State Penitentiary Historic Site Oral History Collection*.
355. Joe Corvi, *Eastern State Penitentiary Historic Site Oral History Collection*.
356. Johnston, *Crucible of Good Intentions*, 92.
357. Newspaper clipping, Bulletin Collection.
358. "Kills Ex-Cell Mate in Prison Courtyard," *New York Times*, June 1 1922, 12.

359. Newspaper clipping, Bulletin Collection.
360. Ibid., November 29, 1940.
361. Ibid., June 29, 1948.
362. Ibid., September 13, 1951.
363. Cliff Redden, *Eastern State Penitentiary Historic Site Oral History Collection*.
364. Newspaper clipping, Bulletin Collection, March 3, 1936.
365. "The Fabric Summary: Cell Block Five," *HSR*: 298.
366. "Jailbait," *Time*, August 18, 1947.
367. "Asks Investigation of Convict's Beating," *New York Times*, November 29, 1923, 44.
368. "Kills Ex-Cell Mate in Prison Courtyard," *New York Times*, June 1 1922, 12.
369. "Indict Warden for Attacking Convict," *New York Times*, January 10, 1924, 23.
370. Warden's Daily Journal, May 18, 1940.
371. Johnston, *Crucible of Good Intentions*, 92.
372. Ibid., 304.
373. Warden's Daily Journal, March 8, 1948; March 22, 1940.
374. Richard Fulmer, *Eastern State Penitentiary Historic Site Oral History Collection*.
375. Cliff Redden, *Eastern State Penitentiary Historic Site Oral History Collection*.
376. Richard Fulmer, *Eastern State Penitentiary Historic Site Oral History Collection*.
377. Toland, *Gentleman Trooper*, 63.
378. Johnston, *Crucible of Good Intentions*, 89.
379. George Mingle, *Eastern State Penitentiary Historic Site Oral History Collection*.
380. Joe Corvi, *Eastern State Penitentiary Historic Site Oral History Collection*.
381. Warden's Daily Journal, March 21, 1942.
382. Joe Corvi, *Eastern State Penitentiary Historic Site Oral History Collection*.
383. Cliff Redden, *Eastern State Penitentiary Historic Site Oral History Collection*.
384. Merv Richards, *Eastern State Penitentiary Historic Site Oral History Collection*. This point was driven home when the researcher asked Dr. Richards facetiously if they should put together a cookbook of recipes for meals served at the penitentiary. He answered, "Not unless you didn't like the people you wanted to buy it."
385. Susan McNaughton, "Pep the Dog: Rumor or Reality," *Correctional Newsfront*.
386. Joe Corvi, *Eastern State Penitentiary Historic Site Oral History Collection*.
387. Richard H. Fulmer, "The House: The Twentieth Century History of Eastern State Penitentiary," unpublished manuscript in the author's personal collection, 161. What Corvi does not mention is that this may have been retaliation for a riot that broke out in 1961, when a number of guards were taken hostage and beaten. Apparently, following the riot, guards from Eastern State's sister institution, Graterford, assisted with the cleanup and were appalled to find that many of the inmates were allowed to keep pets in their cells. According to "The House," Fricker's cat was released or killed shortly after the riot, as were a number of other inmates' pets.
388. "Pinchot Names Former Inmate Trustee of the State Penitentiary," *New York Times*, January 13, 1932, 8.
389. "Abe Buzzard Turns to Gospel Service," *New York Times*, April 30, 1924, 20.
390. "Ex-Convict Accused of Jekyll-Hyde Life," *New York Times*, February 20, 1933, 16.
391. Sutton and Linn, *Where the Money Was*, 179.

CHAPTER 5

392. Pennsylvania Department of Justice, *Eastern State Correctional Diagnostic and Classification Center* (Philadelphia: Department of Justice, 1954); quoted in Johnston, *Eastern State Penitentiary*, 96.
393. "Prisoners' Riot at Eastern State Pen Stamped Out," *Pottstown Mercury*; quoted in Fulmer, "The House," 138.
394. Murray Illson, "Unrest Seething in Many Prisons; Despite Changes After Recent Riots, Tensions Are High, National Survey Shows Cures for Uprisings in Penal Institutions Throughout the Nation Still Pose a Problem," *New York Times*, February 12, 1953, 12; and McWilliams, *Two Centuries Corrections*, 37.

395. Finn Hornum, *Eastern State Penitentiary Historic Site Oral History Collection*.
396. Johnston, *Crucible of Good Intentions*, 97.
397. Fulmer, "The House," 152.
398. "Solitary Cells at Pen to Go," Bulletin Collection, August 27, 1953.
399. Mervin Richards, *Eastern State Penitentiary Historic Site Oral History Collection*.
400. "Woman Jailed for Smuggling Dope to Convict," *Philadelphia Inquirer*, Bulletin Collection, April 29, 1959.
401. "3 Held in Sale of Drugs at Jail," Bulletin Collection, September 26, 1961.
402. Roosevelt Grant, *Eastern State Penitentiary Historic Site Oral History Collection*.
403. "50 Convicts Get AA's Help in Controlling Addictive Drinking," Bulletin Collection, December 4, 1968.
404. "Assistant DA Lists 'Luxuries' At Eastern Penitentiary," Bulletin Collection, March 29, 1959.
405. Roosevelt Grant, *Eastern State Penitentiary Historic Site Oral History Collection*.
406. Joe Corvi, *Eastern State Penitentiary Historic Site Oral History Collection*.
407. "Prison Chess Players Win But Pass Up 'Away' Games," *Evening Bulletin*, Bulletin Collection, April 27, 1965.
408. "Eastern Pen Plays Host to Philadelphia Chess League," *Philadelphia Bulletin*, Bulletin Collection, May 7, 1967.
409. Ray and Steve Bednarek, *Eastern State Penitentiary Historic Site Oral History Collection*.
410. "'Penthouse Pete' Finds Leather Art Beats Safecracking to Get Wealthy," Bulletin Collection, July 11, 1954.
411. Corvi and Conway, *Breaching the Walls*, 126.
412. "Prisoners Give $568 to Salvation Army," Bulletin Collection, undated.
413. "Convicts Give $822 to March of Dimes," Bulletin Collection, undated; and "Convicts Give $519.92 to March of Dimes," Bulletin Collection, January 31, 1955.
414. "Convicts Like to Give Blood: Feel They're Doing Good," Bulletin Collection, July 5, 1959.
415. "Ugly Thief Needs New Face So Convicts Sponsor Surgery," Bulletin Collection, January 29, 1955. There were limits to the penitentiary's largesse, however. In 1957, inmate Bernard Wagner was denied a new set of teeth by the penitentiary's administrators, so he sued. Unfortunately for Wagner, Judge Walter R. Sohn of the Dauphin County Court ruled that the court lacked the authority to compel the penitentiary to give Mr. Wagner new teeth.
416. Fulmer, "The House."
417. Richard Fulmer, *Eastern State Penitentiary Historic Site Oral History Collection*.
418. Fulmer, "The House," 188.
419. Richard Fulmer, *Eastern State Penitentiary Historic Site Oral History Collection*.
420. Tom Finn, *Eastern State Penitentiary Historic Site Oral History Collection*.
421. "Cellmate Slain at Eastern Pen," Bulletin Collection, November 6, 1953.
422. "Convict Slain in Furious Fight at the Eastern Pen," Bulletin Collection, April 13, 1958.
423. "Convict Found Slashed Dies in State Prison," Bulletin Collection, undated.
424. "3 Guards Injured Subduing Prisoner," Bulletin Collection, undated.
425. "Convict Charged in Prison Stabbing," Bulletin Collection, March 9, 1967.
426. Cliff Redden, *Eastern State Penitentiary Historic Site Oral History Collection*.
427. Rachel Zoll, "American Prisons Become Political, Religious Battleground Over Islam," *San Diego Union Tribune*, June 4, 2005.
428. Willie Smith, *Eastern State Penitentiary Historic Site Oral History Collection*.
429. Fulmer, "The House," 153.
430. "Black Muslim Complains of Persecution in Prison," Bulletin Collection, April 5, 1964.
431. Ibid.
432. "Eastern State Prison to Build $220,000 Chapel-Auditorium," Bulletin Collection, August 13, 1961.
433. Roosevelt Grant, *Eastern State Penitentiary Historic Site Oral History Collection*.
434. "Negro Minister Like Latest Pulpit as Prison Chaplain," Bulletin Collection, August 16, 1967.
435. Ray and Steve Bednarek, *Eastern State Penitentiary Historic Site Oral History Collection*.
436. Eastern State was not alone in this regard. A year after it closed as a state penitentiary, the country was rocked by the infamous Attica riot. Though fewer than half of Attica's population,

white and black, rioted, racial tensions were clearly a major factor. The riot was in part caused by the shooting death of black radical George Jackson, as well as notoriously poor living conditions at the prison. Passersby shouted racial epithets at the rioters, and New York Governor Nelson Rockefeller, who tried to negotiate with the rioters, was called a "nigger lover" for his efforts.
437. The description of this event, unless otherwise cited, comes from Fulmer, "The House," which is an excellent in-depth study of the personalities and policies of Eastern State during the twentieth century.
438. Willie Smith, *Eastern State Penitentiary Historic Site Oral History Collection*.
439. Johnston, *Crucible of Good Intentions*, 97.
440. Warden Herbert Smith's Report to the Board of Trustees, April 11, 1945, *Eastern State Penitentiary Historic Site History Collection*.
441. Johnston, *Crucible of Good Intentions*, 97.
442. Ray and Steve Bednarek, *Eastern State Penitentiary Historic Site Oral History Collection*.

INDEX

A

American Philosophical Society 42
American Society for Visiting Catholic Prisoners 69
Auburn System 26

B

blacks 33
Blundin, Mrs. 38
Boston Prison Discipline Society 26
Brierly, Joseph 99, 106
Bussinger, Daniel W. 66, 67, 68

C

Capone, Al 85
Cassidy, Michael 49, 55, 58, 60, 61, 64, 65, 66, 73
chess 99
Christians 105

D

Death Row 98
de Tocqueville, Alexis 20, 32, 33, 43, 114, 116
Dickens, Charles 31, 38, 39, 40, 41
Dix, Dorothea L. 31
Dwight, Louis 26

E

Elmira Reformatory 63
escape 7, 13, 16, 20, 21, 42, 43, 46, 55, 56, 57, 81, 82, 83, 85, 86, 87, 88, 89, 91, 102, 105, 106, 107

F

food 13, 14, 31, 38, 61, 76, 78, 82, 94

Four Horsemen 78, 79
Franklin, Benjamin 16
Franklin Institute 24

G

Gordon, James Gay 60, 61, 62, 64
Groome, John C. 7, 78, 79, 80, 81, 82, 83, 85, 91, 92, 96

H

Harding, Robert 42
Haviland, John 24, 25, 26, 52
Holmesburg 89, 98, 109
homosexuals 92
Howard, John 13, 14, 19, 24

J

Jews 105

K

Klinedinst, Clarence 86, 87, 88

L

Langheimer, Charles 40, 41
legislature 20, 21, 26, 59, 62
Lynds, Elam 36

M

Maisenhelder, Norman 102
McKenty, Robert 7, 75, 76, 77, 78, 79, 80, 81, 82, 90
Muslims 104

P

Penn, William 12, 28

INDEX

Pennsylvania Prison Society 73, 79. *See also* Society for Alleviating the Miseries of Public Prisons
Pennsylvania System 20, 24, 26, 27, 28, 31, 33, 34, 36, 39, 40, 42, 45, 46, 47, 48, 54, 55, 62, 63, 66, 68, 72, 73, 75, 92, 95, 96, 97, 116
Pep 94, 122
Prisoners' Relief Society of Washington 77
Progressive Era 63

R

riot 58, 67, 76, 96, 104, 106, 107, 109, 122, 123
Rush, Benjamin 16, 18

S

shower bath 44
Smith, Edward S. 54
Smith, Herbert 7, 83, 85, 89, 91, 96
Smith, Robert 15
Society 31, 35, 47, 117
Society for Alleviating the Miseries of Public Prisons 16, 18, 19, 20, 21, 31, 32, 34, 40, 48, 64, 73. *See also* Pennsylvania Prison Society
Society of Friends 12
sports 93, 94, 98, 105
Strickland, William 23, 24, 25, 26, 27
Sutton, Willie 10, 83, 85, 86, 87, 88, 89, 95

T

Townsend, Edward 59, 64

V

Vaux, Richard 16, 31, 51, 64

W

Walnut Street Jail 15, 16, 19, 20, 21, 22, 23, 24, 68
Western State Penitentiary 23, 24, 25, 26, 27, 33, 54, 63, 79, 81, 96
Wheelbarrow Law 15, 16
White, Archibald 59, 60
White, William 16, 18, 19
women 5, 6, 13, 20, 33, 92, 100
Wood, Samuel 29, 35, 38, 40

ABOUT THE AUTHOR

Dr. Paul Kahan received his BA from Alfred University in 2001, an MA in modern history and literature from Drew University in 2004 and, most recently, a PhD in U.S. history from Temple University. This is his first book. Learn more about Dr. Kahan and his work at www.paulkahan.com.

Visit us at
www.historypress.net